ILLUMINATING THE LIFE OF THE
BUDDHA

ILLUMINATING THE LIFE OF THE
BUDDHA

*An Illustrated Chanting Book from
Eighteenth-Century Siam*

NAOMI APPLETON
SARAH SHAW
AND
TOSHIYA UNEBE

Bodleian Library
UNIVERSITY OF OXFORD

First published in 2013 by the Bodleian Library
Broad Street
Oxford OX1 3BG

www.bodleianbookshop.co.uk

ISBN: 978 185124 283 2

Text © Naomi Appleton, Sarah Shaw and Toshiya Unebe
All images, unless specified, © Bodleian Library, University of Oxford, 2013

Cover design by Dot Little
Designed and typeset by JCS Publishing Services Ltd in 10.5 on 14pt Times New
Roman
Printed and bound by Great Wall Printing Co. Ltd., Hong Kong on 157gsm 'Gold
East' matt art paper

British Library Catalogue in Publishing Data
A CIP record of this publication is available from the British Library

Contents

Illustrations

Illustrated folios of the manuscript

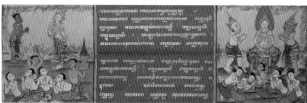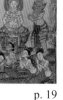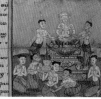

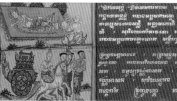

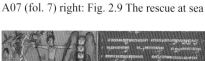

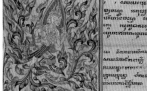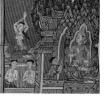

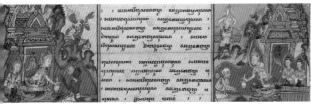

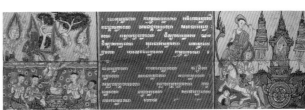

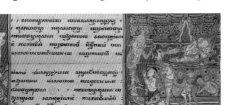

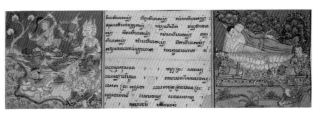

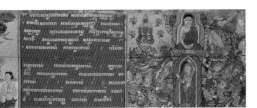

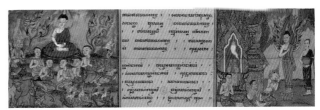

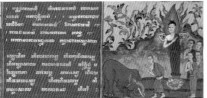

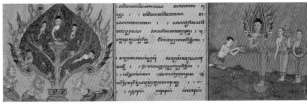

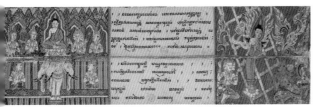

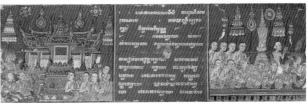

Map of the manuscript

		Face A	
A01 (fol. 1)		[label to Thomson]	
A02 (fol. 2)		[blank]	
A03 (fol. 3)	*Siricudāmaṇi-Jātaka*	Text 1: *Vinayapiṭaka: Suttavibhaṅga: Pārājika*	*Siricudāmaṇi-Jātaka*
A04 (fol. 4)		continues . . .	
A05 (fol. 5)		continues . . .	
A06 (fol. 6)	*Temiya-Jātaka*	*Pārājika* ends	*Temiya-Jātaka*
A07 (fol. 7)	*Janaka-Jātaka*	Text 2: *Suttantapiṭaka: Dīghanikāya: Brahmajālasutta*	*Janaka-Jātaka*
A08 (fol. 8)		continues . . .	
A09 (fol. 9)		continues . . .	
A10 (fol. 10)	*Suvaṇṇasāma-Jātaka*	*Brahmajāla* ends	*Suvaṇṇasāma-Jātaka*
A11 (fol. 11)	*Nemi-Jātaka*	Text 3: *Abhidhammapiṭaka 1: Dhammasaṅgaṇī*	*Nemi-Jātaka*
A12 (fol. 12)	*Mahosadha-Jātaka*	*Abhidhammapiṭaka 2: Vibhaṅga*	*Mahosadha-Jātaka*
A13 (fol. 13)	*Bhūridatta-Jātaka*	*Abhidhammapiṭaka 3: Dhātukathā*	*Bhūridatta-Jātaka*
A14 (fol. 14)	*Candakumāra-Jātaka*	*Abhidhammapiṭaka 4: Puggalapaññatti*	*Candakumāra-Jātaka*
A15 (fol. 15)	*Nārada-Jātaka*	*Puggalapaññatti* ends	*Nārada-Jātaka*
A16 (fol. 16)	*Vidhura-Jātaka*	*Abhidhammapiṭaka 5: Kathāvatthu*	*Vidhura-Jātaka*
A17 (fol. 17)	*Vessantara-Jātaka*	*Abhidhammapiṭaka 6: Yamaka*	*Vessantara-Jātaka*
A18 (fol. 18)	Birth	*Abhidhammapiṭaka 7: Mahāpaṭṭhāna*	Four signs
A19 (fol. 19)	Great departure	Text 4: *Sahassanaya*	Leaving family
A20 (fol. 20)		continues . . .	
A21 (fol. 21)		continues . . .	
A22 (fol. 22)		continues . . .	
A23 (fol. 23)		continues . . .	
A24 (fol. 24)	Hair cutting	*Sahassanaya* ends	Three strings
A25 (fol. 25)	Milk-rice offering	Text 5: *Mahābuddhaguṇa* (§1 Arahant) begins . . .	Victory over Māra
A26 (fol. 26)		continues... (§2 Sammāsambuddha)	
A27 (fol. 27)		continues . . .	
A28 (fol. 28)		continues . . .	
A29 (fol. 29)		continues . . .	
A30 (fol. 30)		continues . . .	
A31 (fol. 31)		continues... (§3 Vijjācaraṇasampanno)	
A32 (fol. 32)		continues... (§4 Sugata; §5 Lokavidū)	
A33 (fol. 33)		continues . . .	
A34 (fol. 34)		continues . . .	
A35 (fol. 35)		continues . . .	
A36 (fol. 36)		continues . . .	
A37 (fol. 37)		continues . . .	
A38 (fol. 38)		continues . . .	
A39 (fol. 39)		[blank]	

Face B

B01 (fol. 40)		[blank]	
B02 (fol. 41)		*Mahābuddhaguṇa* continues . . . (§5 Lokavidū)	
B03 (fol. 42)		continues . . .	
B04 (fol. 43)		continues . . .	
B05 (fol. 44)		continues . . .	
B06 (fol. 45)		continues . . .	
B07 (fol. 46)		continues . . .	
B08 (fol. 47)		continues . . .	
B09 (fol. 48)	First sermon	*Mahābuddhaguṇa* ends	Kapilavatthu
B10 (fol. 49)	Elephant & monkey	Text 6: *Mahābuddhaguṇavaṇṇanā*	Taming elephant
B11 (fol. 50)		continues . . .	
B12 (fol. 51)		continues . . .	
B13 (fol. 52)		continues . . .	
B14 (fol. 53)		continues . . .	
B15 (fol. 54)		continues . . .	
B16 (fol. 55)		continues... (§6 Anuttara)	
B17 (fol. 56)		continues . . .	
B18 (fol. 57)		continues . . .	
B19 (fol. 58)		continues . . .	
B20 (fol. 59)		continues . . .	
B21 (fol. 60)		continues... (§7 Purisadammasārathi)	
B22 (fol. 61)		continues... (§8 Devamanussānaṃ Satthar)	
B23 (fol. 62)		continues . . .	
B24 (fol. 63)		continues... (§9 Buddha; §10 Bhagavant)	
B25 (fol. 64)		continues . . .	
B26 (fol. 65)	Miracles at Sāvatthī	*Mahābuddhaguṇavaṇṇanā* ends	Mango offering
B27 (fol. 66)	Teaching in heaven	Text 7: *Uṇhissavijaya*	Descent from heaven
B28 (fol. 67)		continues . . .	
B29 (fol. 68)		continues . . .	
B30 (fol. 69)		continucs . . .	
B31 (fol. 70)		continues . . .	
B32 (fol. 71)		continues . . .	
B33 (fol. 72)		continues . . .	
B34 (fol. 73)		continues . . .	
B35 (fol. 74)	Cremation	*Uṇhissavijaya* ends	Division of relics
B36 (fol. 75)		[blank]	
B37 (fol. 76)		[blank]	
B38 (fol. 77)		[blank]	

The numbers in brackets indicate the foliation according to the continuous numbering system used by the Bodleian Libraries, which does not take the two sides of the manuscript into account. If ordering images of the manuscript from the Bodleian Libraries please use these numbers. (Table prepared by Toshiya Unebe)

Preface

I first encountered MS. Pali a. 27 (R) in the early summer of 2010, when I was looking for a suitable cover image for my book on *jātaka* stories. Sarah Shaw recommended it to me, for she too had used a painting from it as a cover image, for her translation of *jātaka* stories. I immediately fell in love with the manuscript, and Sarah and I mused about what a wonderful book it would make. A few months later I met Toshiya Unebe at a conference in Bangkok, and got into conversation about the same manuscript, which he had been wanting to work on since a trip to the UK several years earlier. In my Bangkok hotel room that evening I sent an email to Gillian Evison, head of the Oriental Section at the Bodleian Libraries, proposing that the three of us write a book about MS. Pali a. 27 (R). This is the result.

Our three-way collaboration has been very fruitful. Although the final book contains single-authored chapters, the initial research was a collaborative exercise and each of us has contributed in some way to each other's portion. We all brought our own unique expertise and interests to the manuscript, so that, for example, Sarah Shaw's amazing detective work on the history of the manuscript and experience of modern chanting traditions is neatly complemented by Toshiya Unebe's thorough reading and study of the textual contents and ongoing study of temple murals. The project allowed me to investigate further the role of *jātaka* stories, which formed the subject of my doctoral studies at Oxford, in Southeast Asian material and visual culture. We hope that the resulting book communicates something of the fascination we all have with this intriguing and beautiful artefact.

Mindful of the wide audience that this manuscript deserves, we have tried to keep foreign terms to a minimum, and have glossed them where they first appear. A glossary of key terms is also provided at the back of the book. There is no universal standard for transcribing words from the Thai language into the Latin alphabet. In this book, the transliteration is roughly based on the Royal Thai General System of Transcription. However, we may not always follow it, depending on common practice found in Buddhist studies or actual Thai society. We have referred to the manuscript by face (A and B) and opening number, rather than using the

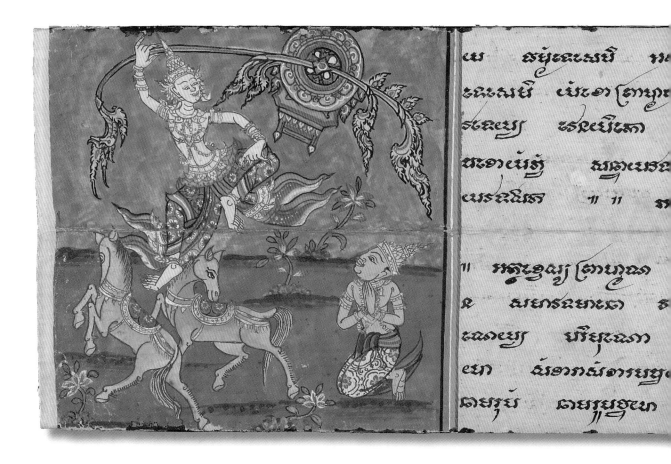

0.1 Illustrated folio from the manuscript showing the *Temiya-Jātaka*, discussed on pages 19–22. MS Pali a. 27 (R), A06 (fol.6)

terms *recto* and *verso* or numbering consecutively from the first opening to the last, as is the Bodleian's convention for manuscripts of this type. Our method takes into account the fact that the manuscript has two separate sides, which in terms of images divides the Bodhisatta lifestory from the Buddha lifestory. (We use the Pāli 'Bodhisatta' in preference to the Sanskrit 'Bodhisattva' throughout this book since we are dealing with Southeast Asian Buddhism, where the scriptural and liturgical language is Pāli.) In addition, our system counts all openings, including blank ones, such as A01, to which is attached a label. A full 'map' of the manuscript, showing the textual and visual contents, may be found on pages xii–xiii.

We have been greatly helped in our research by many colleagues. Particular thanks must go to Arthid Sheravanichkul for information on many aspects of the Thai *jātaka* tradition, and for the initial suggestion that the opening images depict a story from the *Paññāsa Jātaka*, which then prompted Toshiya Unebe to identify the exact story. Toshiya Unebe has also been greatly aided and inspired by Kazuko Tanabe's work on *samut khoi* traditions. Peter Skilling has been very hospitable to all of us on visits to Bangkok, and kindly read a draft of the full book and

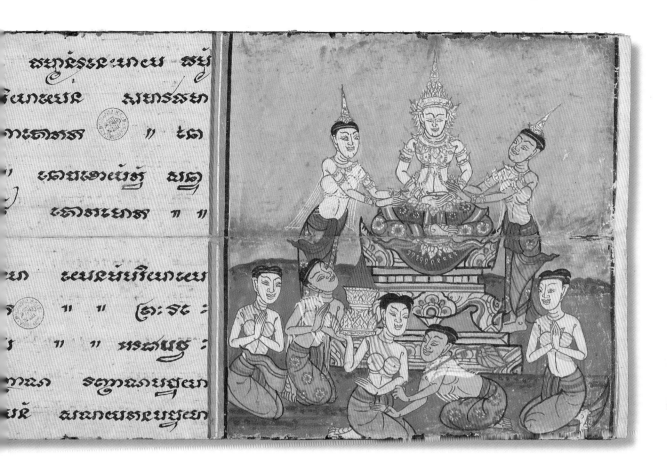

offered many pertinent comments and corrections. L.S. Cousins and an anonymous reader for the publisher also offered several valuable suggestions. Ven. Thiab Malai's kind help facilitated Toshiya Unebe's research in Thonburi, and the abbots and monks of Wat Ratchasittharam, Wat Thong Thammachat, Wat Dusidaram and Wat Suwannaram generously assisted with research and permission for photography. Yohei Shimizu provided additional images, and Disapong Netlomwong, curator of the National Museum, Bangkok, provided information about the Siricudāmaṇi cabinet as well as assistance with permissions. Elizabeth Harris offered extensive help concerning the Sri Lankan period in the manuscript's history, and Pamela Clemit provided an expert eye as we were reading the letter that accompanies the manuscript; Grevel and Amanda Lindop were also helpful in deciphering this letter. In addition, the whole project would have been inconceivable without the expertise and resources generously shared by Jacqueline Filliozat.

Staff at the Bodleian Libraries have also been invaluable, in particular those from the Indian Institute Library and Special Collections. Gillian Evison's wealth of knowledge and enthusiasm has been a

huge encouragement to us. Jana Igunma, the curator of Thai, Lao and Cambodian manuscripts at the British Library, and Nikolai Serikoff of the Wellcome Library have also been very helpful. A great debt is also owed to Samuel Fanous and Janet Philips at Bodleian Publishing, the former for his support and enthusiasm for our proposal, and the latter for patiently following the book into production.

This book would not have been possible without the generous financial support of the British Academy and the Kajima Foundation for the Arts. In addition, Toshiya Unebe's research has been financially supported by the Japan Society for the Promotion of Science. We are grateful to these institutions for allowing MS. Pali a. 27 (R) the wide audience that it deserves.

Naomi Appleton, Cardiff
April 2012

❦ 1 ❧

Introduction

Sarah Shaw

A visitor to a temple hall in Thailand during a ceremony sees first, perhaps, the shrine representing the Buddha, surrounded by smaller figures of the Buddha and his attendants. Along the side walls, from the floor upwards, are often depicted narratives of adventure and incident, painted in bright colours on the jade-green forest, the background of much temple art. Frequently, these are *jātaka*s, stories that describe the Bodhisatta, the Buddha in many past lives before his last. According to the stories, aeons ago he made a vow to be a Bodhisatta, meaning 'the wise being' or 'the being attached to awakening'. This commitment is to become a Buddha and so help other sentient beings cross the 'ocean' of existence (*saṃsāra*) and find liberation from suffering. The stories describe his search for the ten perfections: generosity, morality, renunciation, wisdom, vigour, forbearance, truthfulness, resolve, loving kindness and equanimity. These qualities will enable him to understand and gather resources so that when he becomes enlightened he will be able to teach others. The last ten *jātaka*s (*Mahānipāta/* Thai: *Tosachat*) are usually chosen to communicate this quest: in each, the Bodhisatta 'perfects' a particular quality.[1] Also on temple and exterior walls are likely to be pictures representing the Buddha's last life, awakening and teaching. These two related narratives, dating from the earliest texts, have historically provided some of the principal ways that Southern Buddhists, lay and monastic, have come to appreciate the teaching.

If there is chanting taking place, monks may be present at the front, facing the entrance and the assembly. They are considered custodians of the teaching, representing the community (*saṅgha*). While they are chanting, they sometimes use a guide. It might be a *samut khoi*, a folding book, placed on a table before them, with its pictures, if illustrated, sometimes shown to the laity. This embodiment of the teaching is considered auspicious, and from the eighteenth century has provided a ground for calligraphy and art in what was known then as Siam, a region roughly corresponding to modern Thailand.[2]

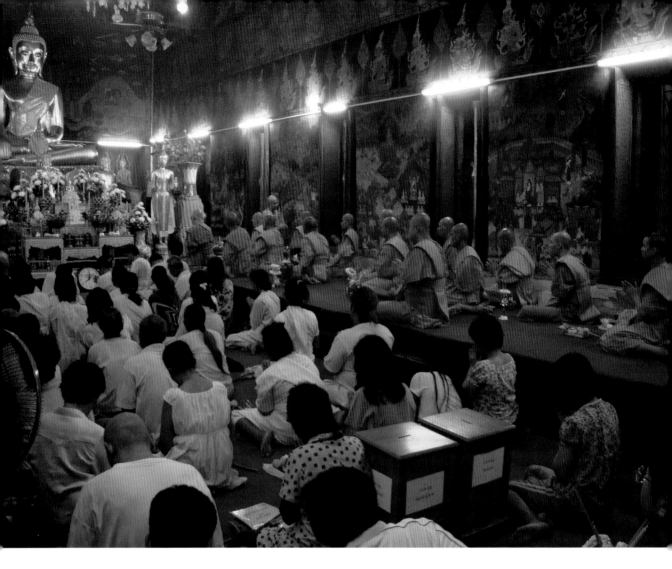

1.1 Makhapuja in the *uposatha* hall at Wat Ratchasittharam, Thonburi. Scenes from the final life of the Buddha and the *Vessantara-Jātaka* are painted on the interior walls. Monks in orange robes and laypeople in white are seated facing the main Buddha image. Photograph by Yohei Shimizu

Samut khoi

It is these scenes that are so finely and dramatically painted within the Bodleian manuscript that is the subject of this book. A *samut khoi* is a class of paper book, often with concertina folds, usually made with white or off-white *khoi* (mulberry) paper. Both sides of the extended concertina are usually employed. Manuscripts of long thin panels, bound or sewn with two holes, are found throughout Southeast Asia, following the shape of loose-leaf ancient and modern palm-leaf or birch-bark manuscripts.[3] The first examples of folding books date from the sixteenth and seventeenth centuries. They became particularly popular, however, from the eighteenth century, as repositories for various short formulations of the Buddha's teachings, used primarily in temple contexts. Often more highly decorated than loose-leaf manuscripts, they usually open in a book-like way, thus making them more manageable for page turning during ceremonies.

The Bodleian manuscript, MS. Pali a. 27 (R), has a simple black lacquered cover with four-petalled gilded flowers set in roundels, and book-like openings inside. Measuring 660 mm x 95 mm, it is heavy but portable. It is striking in many regards. It has, for instance, used the concertina method

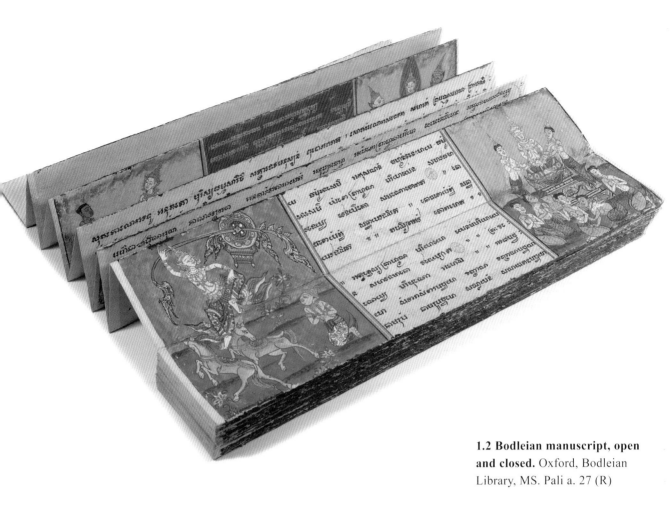

1.2 Bodleian manuscript, open and closed. Oxford, Bodleian Library, MS. Pali a. 27 (R)

that characterizes this form to skilful effect. Along face A are pictures illustrating the preparation for Buddhahood, when the Bodhisatta acquires over many lifetimes the qualities needed for teaching and Buddhahood. So, one panel shows one lifetime perfecting a particular quality: of generosity, for instance, in the *Vessantara-Jātaka*, loving kindness in the *Sāma-Jātaka*. All of these 'perfections' are considered important for everyone to cultivate, and their virtues are frequently extolled in chant: for the Bodhisatta, who has made a vow to be a Buddha, they give the strength and understanding to help others on the path to liberation. Some of his past lives, and the perfections or qualities he learns through them, are discussed in detail in Chapter 2. Face A also includes a separate narrative of the early life of the Buddha, while still a Bodhisatta, up to his enlightenment.

The manuscript has also introduced a literal 'turning point': face B starts with the Buddha teaching his first discourse. This movement to the other face of the book highlights the radical change Buddhahood involves: all of this side shows his teaching career. This part of the life is particularly important to Southern Buddhists, and reflections on the Buddha constitute a meditation practice known as the recollection of the Buddha (*Buddhānussati*), the first aspect of the 'Triple Gem'. Attributes of the Buddha are chanted daily by monks and laity as a way of arousing confidence, freedom from fear and cheerfulness. Indeed, bringing to mind the achievements of both the Bodhisatta and the Buddha is central to Southern Buddhist meditative practice and daily chant. The final life and its pictures, not usually shown in Siamese *samut khoi*s of this period, are discussed in Chapter 3.

Another feature of daily practice is the recollection of the qualities of the Buddha's teaching (*dhammānussati*), the second attribute of the 'Triple Gem'. So any copy of the teaching is significant and treated with care: many monasteries have *samut khoi*s, kept in purpose-built wooden boxes to protect them from insect infestation and decay, and to show respect to these representations of the Buddha's words. Their presence is thought to bring good fortune to the monastery, community and the area around. Donors commissioned the books, which were usually made in workshops as a 'merit-making' activity: it was felt that good karma for present and future rebirths would accrue to the commissioner, craftsman and temple by their construction. The gift of teaching is considered the greatest gift, and all benefit from these manuals preserving essential aspects of the Buddha's words.[4]

Such is the reverence for these manuals that some even remain unused: Southern Buddhists have some tradition of the efficacy of merit-making through art not intended to be viewed.[5] Many folding books are used during ceremonies and teaching, however. The last of the three elements of the 'Triple Gem', the *saṅgha*, represented by the order of monks, is also an object of meditation (*saṅghānussati*). All aspects of the Triple Gem are

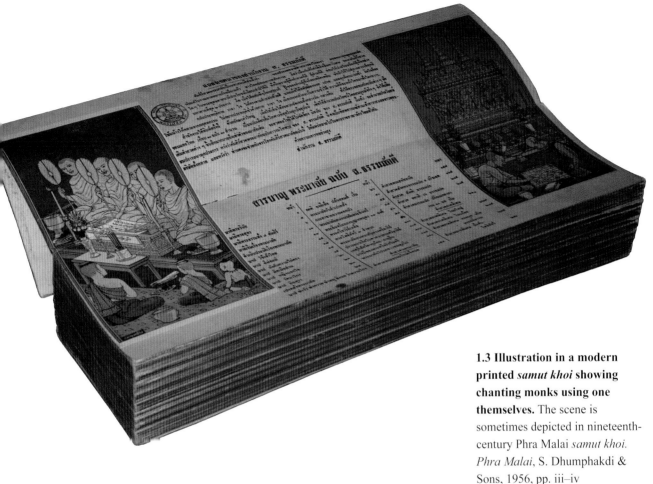

1.3 Illustration in a modern printed *samut khoi* showing chanting monks using one themselves. The scene is sometimes depicted in nineteenth-century Phra Malai *samut khoi*. *Phra Malai*, S. Dhumphakdi & Sons, 1956, pp. iii–iv

considered interrelated, and all are represented to some degree within these works, including the Bodleian manuscript, through art, usage or text.

Knowing this background is helpful in understanding the unusual features of the Bodleian manuscript, and why it would have been considered so special by those who commissioned and used it. Jacqueline Filliozat terms it '. . . the most interesting of all the illustrated Siamese manuscripts in British libraries, by virtue both of its philological importance and of its artistic value'.[6]

The written part of the page

The magnificent artwork of Siamese manuscripts represents a flowering of a sophisticated and delicate artistic tradition. It is sometimes forgotten, however, that the aesthetic and content of the *samut khoi* are not solely pictorial. Commanding the centre of each opening is the written text, often inscribed in elegantly executed and spaced script, with, where they occur, drawings, decorations or painted pictures in a subordinate though eye-catching role, flanking the sides.[7] The written text is usually a repository of the teaching, with texts chanted according to their popularity in a particular

region. These are often distillations of the Buddhist teachings, particularly the philosophical *Abhidhamma*, some ritual texts, as well as meditations around the Buddha, his teachings and his followers. The middle way and the eightfold path taught by the Buddha include a complete route to awakening: right view, right intention, right speech, right action, right livelihood, right effort, right mindfulness and right concentration. These path factors are described as related: good behaviour, compassion, the cultivation of wisdom and meditation are felt to support one another. Chants about aspects of the teaching, many still in popular usage in modern Thailand, are given in *samut khoi*s. The texts in this *samut khoi* will be discussed in Chapter 4, along with other aspects of this manuscript's composition and historical background.

Oral literature: the visual meets the verbal

In order to understand the way artwork complements written texts, it is useful to consider the method by which, historically, Buddhist texts have been transmitted. Buddhism, in common with other Indic traditions, was a memorized and recited tradition for many centuries before the advent of writing; indeed, it has never lost its emphasis on the heard and chanted text.[8] A 'book' such as this manuscript, at the intersection of the oral and the written, is perceived not only as a sacred object, but also as a working manual of memory links to other texts, and chants, many in regular use, felt to distil the essence of the teaching for oral communication. Buddhist *Sutta*s (discourses) begin with the words, 'Thus have I heard', an emphasis evident in the many variations of chant styles and differing uses of chant. Some monks dedicate their lives to perfecting different chant styles and others to memorizing the whole teaching: the entire collection takes three months to chant. For Southern Buddhists, hearing chanting and teaching is felt to purify the heart and mind, bringing good fortune and being itself a meditative practice. Learning texts and different kinds of chants are central to Southeast Asian monastic training. So some of the 'root' texts in these 'books', summarizing whole works in short formulae, employ material dating from the earliest times, when they would key the chanter into a particular recited text. These root chants act as pre-computer search mechanisms: *aide-mémoires* through which the chanter, and those listening, can access other aspects of the teaching. As we shall see in Chapter 4, many of these are still chanted today; some have meditative as well as ritual and teaching associations.

The lettering

The texts are composed in Pāli, a form of early Indo-Aryan that never had a 'natural' script, as texts were transmitted to a number of areas orally before

writing arrived. So the script, now technically termed thick Khom, is local, thought by some to be of Cambodian origin, though this is now debated. It is widely used in Siamese texts. Southeast Asia is not usually thought to have a calligraphic tradition, but, as this manuscript attests, with its thick and evenly spaced lettering, often gold, on brightly coloured central panels, artistic prominence is accorded to the appearance and beauty of the letters. Scripts vary regionally, but the Khom script seems from this period to have been regarded as special, perhaps explaining its frequent use in Siamese manuscripts: it is also associated now with extensive esoteric and magical symbology.[9]

The pictures

For many, it is the pictures, where they occur, that most inspire. By the eighteenth century the coming together of paper, pigments, gum, painting techniques and inked lines offered all kinds of new opportunities for artistic expression.[10] But the word 'illustration' in a Western sense, as an extension of a written narrative, is not always applicable, as text and image do not necessarily match. Indeed, *jātaka* manuscripts do not use *jātaka* pictures. Instead, if there is decoration, they feature floral decorative motifs or other adornments; *jātaka* pictures only appear in written texts with different content.[11] So, in this manuscript, pictures are not adjuncts to written text: on the contrary, it seems they *are* texts, complementing or supplementing the written kind. The verbal texts, as we have seen, give encapsulations of the teaching. The incidents shown in the *jātaka* pictures seem comparable: Peter Skilling notes that they 'are not illustrations: they exist in their own right, as amplifications of the power and perfections of the Buddha'.[12]

In this regard, manuscript art has its own vivid life and vocabulary. Temple art often displays a highly complex range of incidents: say, in the *Mahājanaka-Jātaka*, recounted in Chapter 2, the Bodhisatta's birth, leave taking, sea journey, shipwreck, rescue, arrival in his own kingdom and final renunciation. The whole story, in which the Bodhisatta develops the perfection of vigour, is shown. From an early period, however, *jātaka* scenes in manuscript art tend to offer one or two condensed images: so the above tale is usually shown by the rescue of the Bodhisatta by a goddess, with the shipwreck below, even though the latter occurred seven days earlier in the tale. While there are undoubtedly artistic reasons for this, the evocation of one story through one or two emblematic scenes suggests that the pictures act as reminders to the monks or people teaching of the whole narrative and specific quality of each tale. Rather as in the Western medieval choir-books, psalters and missals, visual as well verbal images suggest larger texts and stories.[13] To return to our earlier analogy, the pictures offer visual 'search terms', or links, to intricate pictorial and

verbal narratives.[14] The lifestory pictures also have extended associations: each posture associated with the biography of the Buddha is dense with allusion, with, as seen in Chapter 3, a different posture associated with each event.[15]

In such ways, this *samut khoi* embodies an interface between oral, written and visual traditions: the verbal text keys into a larger memory of the texts; the visual text keys into favourite stories and symbols.[16] Through chant guides, summaries of teachings and visual stories, this *samut khoi* offers a repertoire of directions to monks encouraging practitioners on their path to liberation.

Book, manuscript or sacred object?

The *samut khoi* challenges the boundaries of what we mean by a 'book'. Visual and written material work at a transition point, in a different way from older forms, to serve the needs of donors wishing to gain merit, and monastic orders as they chant and teach. Shaped by practical considerations,

1.4 'Days of the week' Buddha statues at Wat Kanlayanamit, Thonburi. So important is the lifestory of the Buddha in Southern Buddhist practice that a posture associated with a different life event is given for each day of the week. Thai Buddhists worship the image relating to the day on which they are born. Photograph by Toshiya Unebe

the Bodleian manuscript is an economical guide to the teaching, with visual and verbal cues pointing to connections to other texts and pictures. As it teaches the way to the release from suffering, diverse routes through an encompassing world are described and enjoined. It is from this perspective that the two pictorial narratives in this *samut khoi* need to be seen. The *samut khoi* as a form has gone largely unrecognized, bringing together as it does a fertile blend of the calligraphic, the pictorial, the verbal and the pedagogic in a manageable book. From its demonstration of the adventures of the Bodhisatta, searching through many lives for the perfections that will help him teach others, to those of the fully awakened Buddha as he teaches, this unique *samut khoi* offers a rare and beautiful example of its type.

∾ 2 ∾

The past lives of the Buddha

NAOMI APPLETON

When recounting the biography of the Buddha, we might begin with his birth in northeast India in the fifth century BCE. However, narrations of his lifestory in Buddhist texts and images often begin with his many previous lives, which are preserved in *jātaka*s, 'birth stories'. Many hundreds of these birth stories are recorded in Buddhist scriptures and later collections throughout the Buddhist world. Eleven such stories are depicted on face A of the Bodleian manuscript, preceding the illustration of the Buddha's final life.

According to the Pāli tradition in which Thai Buddhism situates itself, the Buddha's long lifestory involves the pursuit of ten 'perfections' (*pāramī* or *pāramitā*) that are required for Buddhahood. These perfections are giving, morality, renunciation, wisdom, vigour, forbearance, truthfulness, resolve, loving kindness and equanimity. The Buddha-to-be, known at this stage as the Bodhisatta ('Awakening Being') must work to complete each of these qualities within himself before he can become the Buddha ('Awakened One'). *Jātaka* stories are believed to narrate the Bodhisatta's efforts in acquiring these perfections.

Ten of the birth stories found in the paintings of MS. Pali a. 27 (R) are from the Pāli collection known as the *Jātakatthavaṇṇanā*, or 'Commentary on the *jātaka*'. This text has scriptural verses at its core, with the stories largely preserved in a prose commentary that was probably finalized in the fifth century CE. The 547 stories in this collection are not ordered chronologically but are preserved, for mnemonic reasons, in order of increasing number of verses. Thus the first chapter contains all the stories that only contain a single verse, the second chapter those that contain two verses, and so on until the final chapter of the text, which contains ten long, verse-filled stories of particular elegance and depth. Presumably because of their position at the end of the text, a tradition has emerged that these final ten stories narrate the final ten lives of the Bodhisatta, in which he cultivated each of the ten perfections required for Buddhahood. These ten

stories are therefore the main ones chosen for illustration in temples and manuscripts, including the Bodleian manuscript. In addition to these ten, the first two images in the manuscript portray a birth story which is not found in the *Jātakatthavaṇṇanā* but is part of a larger Southeast Asian tradition of recounting *jātaka* stories.

The Bodhisatta, the hero of these birth stories, does not become Buddha until the moment in his final life when he attains awakening (*bodhi*). His attainment of awakening is shown in the final illustration on face A of the manuscript. Thus the manuscript draws a clear line between the hero's time as Bodhisatta (on face A) and his time as Buddha (on face B). In this chapter we will consider only the previous lives of the Buddha; the next chapter will deal with the Buddha's final life, including his last years as Bodhisatta.

The ten great birth stories

As the *jātaka* genre developed in Southeast Asia, the ten birth stories that made up the final chapter of the *Jātakatthavaṇṇanā* gradually became a separate unit in their own right. In the Southeast Asian tradition the stories are named after the characters identified with the Bodhisatta,[1] and these ten Bodhisatta lives are celebrated in text, image and ritual recitation. An inscription at Sukhothai dated to 1380 indicates that recitation of the ten lives was considered very meritorious.[2] Contemporary Thai tradition preserves a mnemonic made up of the first syllables of the story titles – Te-Ja-Su-Ne-Ma-Bhu-Ca-Na-Vi-Ve – which is both a reminder of the Bodhisatta's long and difficult path to Buddhahood and a means of channelling protective power.[3] In addition, a popular chant includes the ten heroes of these *jātaka*s among the virtuous attributes of the Buddha.[4]

The reason for the great prominence of these ten birth stories is their association with the final ten births of the Bodhisatta and his acquisition of the ten perfections that are required for the attainment of Buddhahood. The perfection associated with each story according to the Thai tradition can be seen in Table 1. Because the tradition of associating the ten perfections with the ten stories is later than the text itself, the way in which each perfection is supposed to be demonstrated is not always very clear. In addition, in the introductory portion to each story, when we meet the Buddha and hear his reasons for telling the story of his past life, different reasons and themes are often given. For example, the power of the truth to alter the course of nature is demonstrated in the *Sāma-Jātaka*, which is nonetheless associated with loving kindness, and told by the Buddha to demonstrate the importance of looking after one's parents.

Table 1: The ten *jātaka*s and the perfections	
Name of Story / Bodhisatta	**Perfection**
Temiya	renunciation
Janaka	vigour
Suvaṇṇasāma	loving kindness
Nemi	resolve
Mahosadha	wisdom
Bhūridatta	morality
Candakumāra	forbearance
Nārada	equanimity
Vidhura	truthfulness
Vessantara	generosity

Although each of the ten *jātaka*s is still known in Southeast Asia, recalled in chants and images and retold in modern media, one story in particular has become central to Thai culture. The *Vessantara-Jātaka*, the final story of the *Jātakatthavaṇṇanā*, is believed to narrate the Buddha's antepenultimate life (his penultimate life being spent in a heaven realm). The story tells of Prince Vessantara's determination to perfect his generosity: despite banishment and the entreaties of his family he gives everything away, including his children and wife. Generosity is a key ideal in Thai Buddhism and this story is easily the most popular *jātaka* story in Thailand today. Plays, processions and chanting ceremonies celebrating Vessantara's story are central to Thai festive culture. The brahmin Jūjaka, who asks Vessantara to give him his children as slaves, has even become the object of veneration, since he is believed to have received the ultimate gift. Amulets or tattoos depicting Jūjaka are said to bring wealth and success.[5]

Non-classical *jātaka*s

As well as the great Pāli scriptural collection, in Southeast Asia there is a tradition of telling birth stories that are not found in that text, but which follow it in style and format. Such stories are collected loosely under the title *Paññāsa Jātaka*, which literally means 'Fifty Birth Stories', although few collections match up exactly to that number. The collections, in Pāli or in Southeast Asian vernaculars, demonstrate a strong focus on the bodily gift-giving and self-sacrifice of the Bodhisatta, a theme that is less popular in the classical *jātaka*s.[6] In temple murals particular favourites from the *Paññāsa Jātaka* collections are sometimes chosen to accompany illustrations of the ten great *jātaka*s.[7] This also appears to have happened in the Bodleian manuscript, where the images of the ten great birth stories are preceded by another story, the *Siricudāmaṇi-Jātaka*.[8] This tale, a story

of graphic bodily sacrifice, nonetheless provides a serene opening to the manuscript, since the act of bodily harm – the Bodhisatta being sawn in half by demons – is not explicitly depicted. The inclusion of this story probably reflects the preference of the manuscript's patron, who may have wished to include a story of bodily sacrifice, which was considered an important aspect of the Bodhisatta's career, despite its absence from the ten great birth stories.[9]

The gods

Gods play an important role in several of the birth stories found in this manuscript. In Buddhism, gods occupy various heavenly realms and enjoy long life, divine pleasures and superhuman powers. However, they are still subject to death and rebirth in a different realm (even as an animal or in the hells), and so they too are in need of Buddhist teachings to help them to escape the realm of rebirth altogether by achieving *nibbāna*. Good acts lead to rebirth as a god, and so the gods generally have a positive character, though they can also have very human faults.

Gods and goddesses feature in almost all of the birth stories depicted in this manuscript, and they contribute to the narrative in different ways. In the *Temiya-Jātaka* and *Sāma-Jātaka* a goddess who was the hero's mother in a previous life helps to save her former son. In the *Janaka-Jātaka* the goddess of the sea – Maṇimekhalā – saves the Bodhisatta from a shipwreck. In the *Nemi-Jātaka* the citizens of King Nemi do good acts, are reborn as gods, and then invite King Nemi to visit them in their heaven. He is sent for by Sakka, who is identified with the ancient Indian god Indra. Sakka is king of the Tāvatiṃsa Heaven, the rebirth realm associated with generosity, morality and faith. He is a key supporter of Buddhism and appears also in the *Candakumāra-Jātaka* to disrupt an immoral sacrifice. A god from the realm of the *Brahmā*s, a high heaven that is associated with meditative prowess, comes to the aid of the princess in the *Nārada-Jātaka*. This god is identified as Nārada, a divine sage who features prominently in Hindu texts such as the *Purāṇa*s as well as in Jain narratives. That gods support the Bodhisatta emphasizes his greatness, and when the Bodhisatta himself is born as a god – as in the *Nārada-Jātaka* – we are also reminded of the impermanence of divine birth and the superiority of the goal of Buddhahood.

As well as gods and goddesses, various types of spirit deities feature in these stories. The most prominent of these are the *nāga*s, or snake deities, which are believed to live in elaborate palaces under the water. The Bodhisatta is born as a *nāga* in the *Bhūridatta-Jātaka*, and demonstrates that despite their limitations *nāga*s can act wisely and with restraint. A *yakkha* is a more frightening type of spirit deity, though these can also be moral in the right circumstances, as we see in the *Vidhura-Jātaka*. *Supaṇṇa*s

2.1 (*opposite*) Wat No Putthangkun (Wat Makham No), Suphanburi Province, Thailand, mid-nineteenth century. This mural, dated to 1848, shows how scenes from the *jātaka*s can flow into one another across the full space of a temple wall. At the top we see a goddess rescue Janaka from a shipwreck and place him on a stone slab in a park. Below this is the *Sāma-Jātaka*, with scenes showing the king shooting Sāma, the king informing Sāma's parents that he has killed their son, and Sāma's parents lamenting beside their son's prostrate body. Below the *Sāma-Jātaka* is the striking image of Temiya swinging a chariot over his head, and to the left of that is the younger Temiya being attacked by an elephant. Within the palace walls we see Temiya's father engaged in the business of state. Photograph by Toshiya Unebe

and *garuḷa*s, divine birds that are the enemies of the *nāga*s, also have a minor role in these stories. Thus the *jātaka*s are not only concerned with the human realm, but also the various categories of deity and demon that surround us, providing plenty of scope for imaginative illustrations. It is notable that although many *jātaka*s involve the Bodhisatta taking birth as an animal, no such stories are included here.

Depicting the *jātaka*s

Jātaka stories have been depicted on Buddhist monuments since at least the first century BCE, when they adorned the stone gateways and railings that surrounded the *stūpa* monument at Bharhut in Madhya Pradesh. The nearby site of Sanchi also boasted numerous engravings, and at the south Indian sites of Kanaganahalli, Nagarjunakonda and Amaravati, *jātaka*s are found depicted on slabs from the early centuries CE. In addition to these carvings and engravings, mural paintings of the stories can be found in cave temples, such as those at Ajanta, near Aurangabad in Maharashtra. The tradition of illustrating the Buddha's past lives at sacred sites continued as Buddhism spread out of India, and the stories remain a popular subject for illustration to this day.

A tradition of depicting the final ten *jātaka*s as a coherent group dates back to around the eleventh century in Mon temples of Lower Burma.[10] In Thailand the earliest surviving temple murals of the ten *jātaka*s are from the end of the seventeenth or beginning of the eighteenth century, in the patriarch's residence at Wat Phutaisawan in the old capital Ayutthaya and the *uposatha* hall of Wat Chong Nonsi in Bangkok.[11] From this time onwards, the ten *jātaka*s were a popular subject for temple murals, cloth banners, lacquered scripture cabinets and manuscript art.[12] Manuscripts illustrated with the stories date from at least the early eighteenth century and flourished into the nineteenth century, when they gradually lost popularity and were replaced by images of another narrative, the story of Phra Malai.

In temple murals there is great scope for composite scenes, showing many different episodes of a story across the length of a wall (see Fig. 2.1). In manuscripts, where the stories were traditionally depicted in just one or two images, the artists had to be more selective. Certain key scenes became representative of the whole story, and were often reproduced in many manuscripts in a strikingly similar fashion. Often these scenes are the pivotal moments in the narrative, such as Vessantara's gift of his children, or Temiya waving a chariot over his head as he enjoys moving for the first time in sixteen years. In order to give a flavour of the typical scenes, a selection of images from other manuscripts is provided alongside MS. Pali a. 27 (R) in the pages that follow.

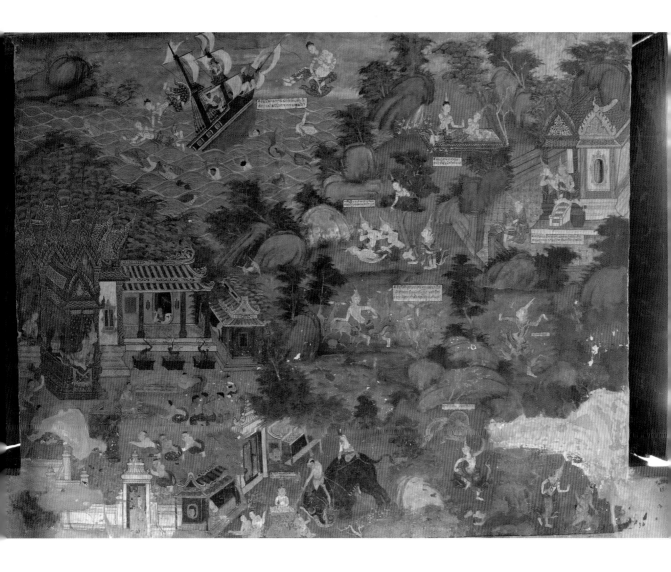

The manuscripts

MS. Pali a. 27 (R) belongs to a larger genre of eighteenth-century manuscripts from central Thailand, which typically contain collections of liturgical texts accompanied by illustrations of the ten birth stories. The presence of *jātaka* images alongside apparently unrelated texts is probably due to the sacred potency of the ten perfections as discussed above. Although MS. Pali a. 27 (R) does not narrate the stories behind its *jātaka* images, these can be easily recreated from the Pāli scriptural sources. The following pages contain short summaries of each story, made from the *Paññāsa Jātaka* in the case of Siricudāmaṇi and the *Jātakatthavaṇṇanā* for the others.[13]

In order to show how MS. Pali a. 27 (R) fits into a wider tradition of *jātaka* depiction, the following pages also contain some comparable images from manuscripts held in the British Library. IO Pali 207 is a folding book

similar to MS. Pali a. 27 (R), illustrated with the ten birth stories as well as scenes from monastic life and paired figures in devotional postures. Ginsburg dates it to the late eighteenth century.[14] It is characterized by very plain light-coloured backgrounds, and thus it creates a very different impression to the bold floral skies of the Bodleian manuscript. Or. 14255 is of a similar age, and also depicts some generic worship scenes in addition to the ten birth stories. This manuscript's artist seems to have had a passion for painting plant life, which appears in almost every scene, creating a complex but delicate image. Or. 16100 and Or. 16552 are examples of the later style of central Thai *samut khoi*, with a thinner script, taller dimensions and the inclusion of the Phra Malai story. Both date from the late nineteenth century and give a flavour of how traditions of narrative depiction developed over time.

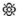

Siricudāmaṇi-Jātaka

One day the monks sat discussing the Buddha's great generosity. The Buddha explained that not only now, but also in the past, he had given great gifts. At their request, he told the birth story of King Siricudāmaṇi.

In the past . . .

King Siricudāmaṇi – the Bodhisatta – ruled in Vārāṇasī, and he was very generous. One day he was reflecting on his gift-giving and became unsatisfied with the fact that all his gifts had been external to the body. He conceived a wish to give a bodily gift, and resolved that whatever a supplicant might ask for – his eye, heart or the whole of his body – he would willingly give it. At that moment, there was a mighty earthquake and all the gods, including Sakka and Great Brahmā, applauded. Sakka's throne became hot, and he decided that it was time to give Siricudāmaṇi the opportunity for a bodily gift.

Disguised as a brahmin (a member of the Indian priestly caste) with only half of his body, Sakka entered King Siricudāmaṇi's palace. The king, delighted, asked him what he wanted, and Sakka requested the other half of the king's body. Siricudāmaṇi immediately sent for his son, whom he consecrated as king. He then made a powerful statement of truth about the omniscience of the *buddha*s, and as a result of this statement two *yakkha*s (demons or spirit deities) appeared, fearsome in appearance, carrying a saw. The king welcomed them warmly, and declared that he would make this gift for the sake of attaining Buddhahood.

Siricudāmaṇi instructed the *yakkha*s to begin cutting him in half. They began to saw his head down the middle, as courtiers wailed in lamentation. Hearing the noise they were making, Siricudāmaṇi's wife and son came to

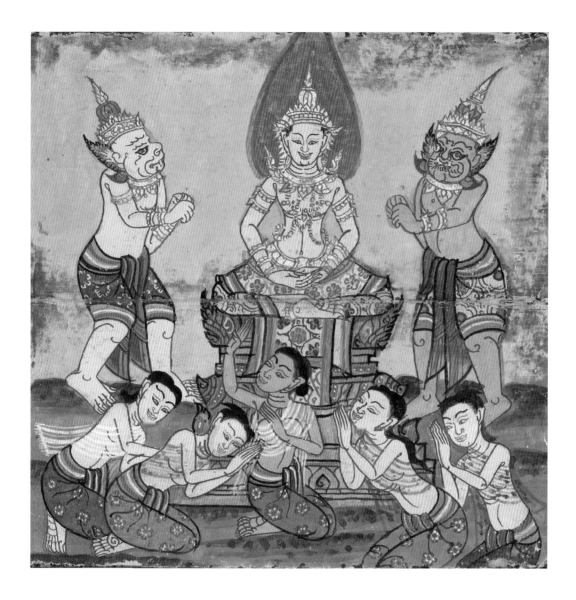

see what was going on, and threw themselves at his feet, begging him to reconsider. As blood trickled from the king's forehead onto the saw, he told the assembled people to be generous and moral, and not to grieve. By the time the saw reached the king's neck, he was in excruciating pain, but he recollected his desire for Buddhahood and stood firm in his resolve. In due course the *yakkha*s completed their task, and Sakka took one half of the king's body, joined it to his own half, and paced up and down as the gods applauded.

After the gift was thus completed, Sakka returned the king's half-body to Siricudāmaṇi and restored him like a golden statue. Having restored him to life, Sakka paid his respects to the king's extraordinary generosity, before departing for his heavenly abode. The king continued to give great gifts, as did his citizens, and after death they were all reborn in heaven realms.

2.2 The *yakkhas* approach.
The two *yakkha*s who will saw Siricudāmaṇi's body in half stand either side of him, as he sits calmly on his throne. Their hands suggest the holding of a saw, but no saw is depicted, implying that the artist did not want to begin the manuscript with a violent or inauspicious image. Below the king the women of the court lament his imminent death. Oxford, Bodleian Library, MS. Pali a. 27 (R), A03 right (fol. 3)

2.3 The sawing of King Siricudāmaṇi, northern Thai lacquered wooden cabinet, 1795. This depiction of the king being sawn in half, on a scripture cabinet from northwest Thailand now housed in the Nan National Museum, is a more graphic realization of the violent act than that found in the Bodleian manuscript. Photograph by Yohei Shimizu, by permission of the Nan National Museum, Fine Arts Department, Thailand

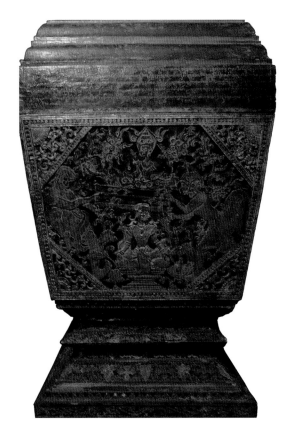

2.4 Sawing in half as a hell torment, late eighteenth or early nineteenth century. In this manuscript image of hell (depicted as part of the *Nemi-Jātaka*) a man is sawn in half as a form of torture. Note that the hands are in the same position as the *yakkha*s' hands in MS. Pali a. 27 (R). This is not a common image, and it provides a crucial link in the iconographic web for the Bodleian manuscript. Wellcome MS. Thai-Pali 4, © Wellcome Library, London

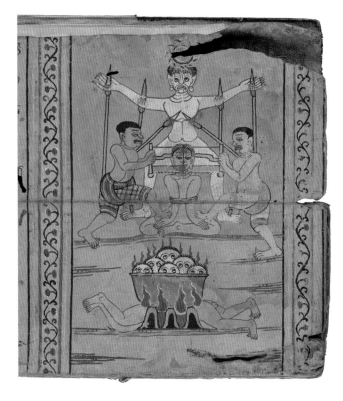

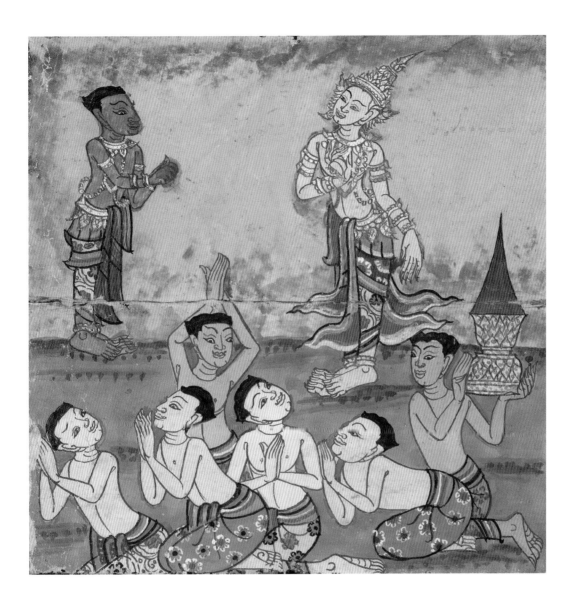

Temiya-Jātaka

The Buddha told the birth story of Prince Temiya, also known as the birth story of the mute cripple (*Mūgapakkha-Jātaka*), to show that even in the past he had renounced a kingdom with great determination.

In the past . . .

The king of Kāsī had no son, and so his chief wife used a truthful declaration of her virtue to persuade the gods to take action. Sakka encouraged a fellow god – the Bodhisatta – to take birth in Queen Candā's womb, and once born the baby was named Temiya. One day the king of Kāsī was playing

2.5 Sakka pays respects. The god Sakka, still in human rather than divine form but nonetheless recognizable from his green colour, praises the Bodhisatta's generosity, while men make respectful gestures below. Oxford, Bodleian Library, MS. Pali a. 27 (R), A03 left (fol. 3)

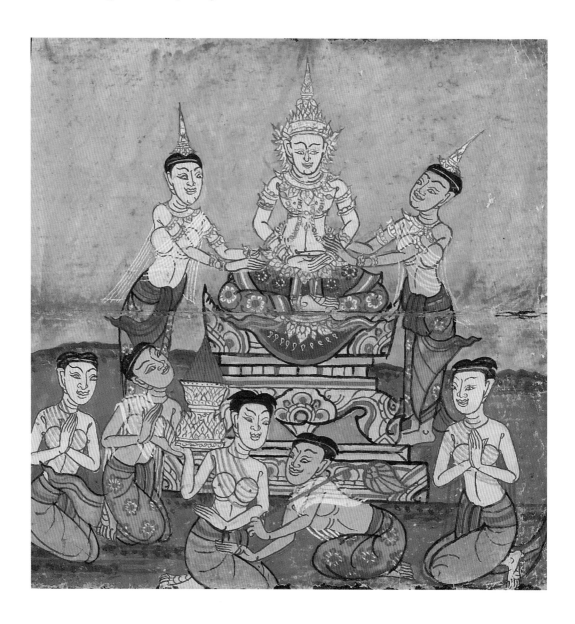

2.6 The temptation of the women. Temiya sits motionless and expressionless on a throne surrounded by scantily clad young women who have been offered a substantial reward if they can get him to move or speak. Oxford, Bodleian Library, MS. Pali a. 27 (R), A06 right (fol. 6)

with his baby son when some criminals were brought in for sentencing. He ordered a series of gruesome punishments, to the shock of his son, who became worried about his father's karmic load. Later baby Temiya began to reflect, and remembered that he too had been a king in a previous life, and had passed sentences on criminals, and that as a result he had suffered torments in hell for 80,000 years. On the advice of a goddess who had been his mother in a previous life and now inhabited a parasol placed over baby Temiya, the prince resolved to pretend to be deaf, mute and crippled, in order to avoid inheriting the kingship.

During his childhood the royal household tested Temiya, trying to provoke any movement or sound. When he was a baby they withheld milk,

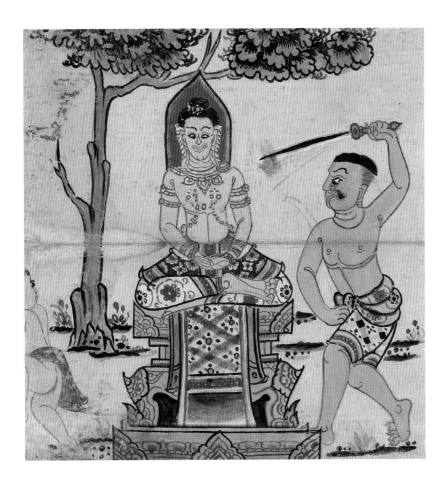

2.7 The test of the sword, late eighteenth century. Although the temptation of the women and the swinging of the chariot are the most commonly depicted scenes, manuscripts also show some of the other tests endured by the prince. Here Temiya sits calmly as a man threatens to kill him. In the bottom left of the picture we see one of Temiya's childhood friends running away in fear. London, British Library, MS. IO Pali 207, fol. 1, left image. © British Library Board

and when he was a child they tempted him with sweetmeats and toys. They frightened him with snakes, elephants, fire, sword-wielding bandits and loud noises. They covered him in sugar and left him to be eaten by insects. They stopped washing him, leaving him to sit in his own excrement. Finally, when Temiya was sixteen, they tempted him with young women, but still Temiya remained silent and motionless, all the time reflecting that the tortures of hell are far greater than anything inflicted upon him in the palace.

Finally his parents gave up and sent Temiya outside the city to be buried. However, while the charioteer was busy digging a grave, Temiya got up off the chariot, stretched, rubbed at his limbs, and then lifted the chariot over his head and spun it around. He converted the charioteer with a sermon on the benefits of friendliness, and went into the forest to practise meditation. Informed of this dramatic turn of events, his family and all the citizens of Kāsī renounced the household life and joined him in his divinely built hermitage. A series of kings invaded the empty city of Kāsī, but each then visited Temiya's hermitage and renounced their worldly life. After living the religious life, they were all – even the animals – reborn in heaven realms.

2.8 (*overleaf*) Temiya swings the chariot. In this iconic display of strength, Temiya appears to be dancing as he waves the chariot over his head as if it was a toy. The charioteer kneels in a gesture of respect and watches in awe, while the two horses in the foreground look startled by the sudden movement. The strong sense of motion and agility contrasts dramatically with the sixteen years Temiya endured sitting motionless in the palace. Oxford, Bodleian Library, MS. Pali a. 27 (R), A06 left (fol. 6)

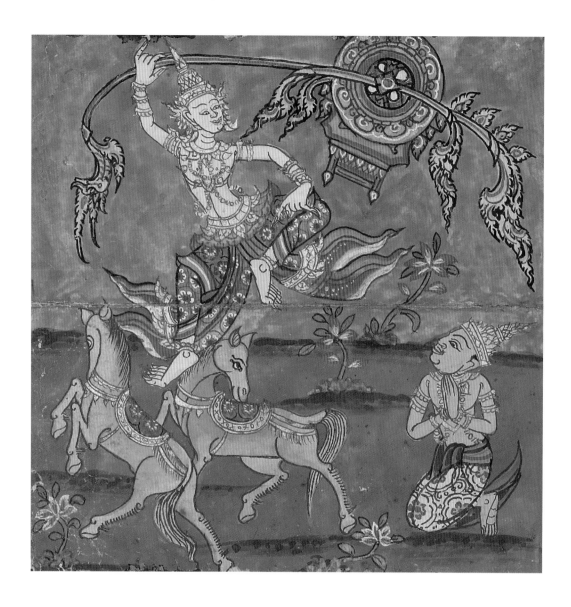

Janaka-Jātaka

The birth story of Janaka was told by the Buddha to his assembled monks when they were discussing the Great Renunciation, the occasion on which he left behind family and wealth to seek Buddhahood.

In the past . . .

The king of Videha, Ariṭṭhajanaka, was overthrown by his brother Polajanaka. Ariṭṭhajanaka's pregnant widow escaped and travelled to a nearby kingdom where she gave birth to a son, the Bodhisatta, and named him Mahājanaka. When Mahājanaka was grown, he learnt of his true identity and resolved

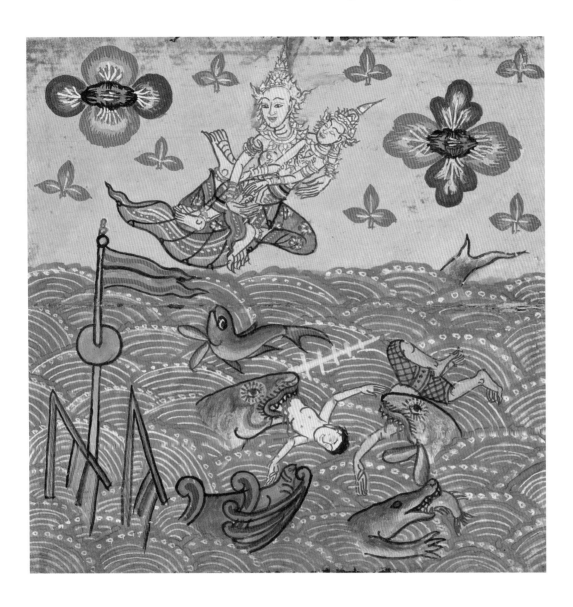

to recapture his father's kingdom. In order to raise money for his military campaign he joined a merchant caravan and set out to sea. The overloaded ship broke up and began to sink, but as his companions fell wailing into the sea to be eaten by the monstrous creatures that inhabited it, Mahājanaka remained steadfast. He clung to the mast for as long as he could, and then leapt into the sea and began to swim for shore. After seven days Maṇimekhalā, goddess of the sea, spotted him and asked him why he was swimming so determinedly when he had no chance of reaching land. Mahājanaka replied that at least he was trying his best. Impressed by this answer, Maṇimekhalā plucked Mahājanaka from the sea and carried him to Mithilā, the capital city of Videha. There she left him sleeping on a stone in a park.

2.9 The rescue at sea.
Maṇimekhalā rescues Janaka and carries him in a yellow sky dotted with floral motifs. Below, part of Janaka's ship is still visible as it sinks below the waves, and several of his companions are being eaten by a variety of ferocious sea creatures. Oxford, Bodleian Library, MS. Pali a. 27 (R), A07 right (fol. 7)

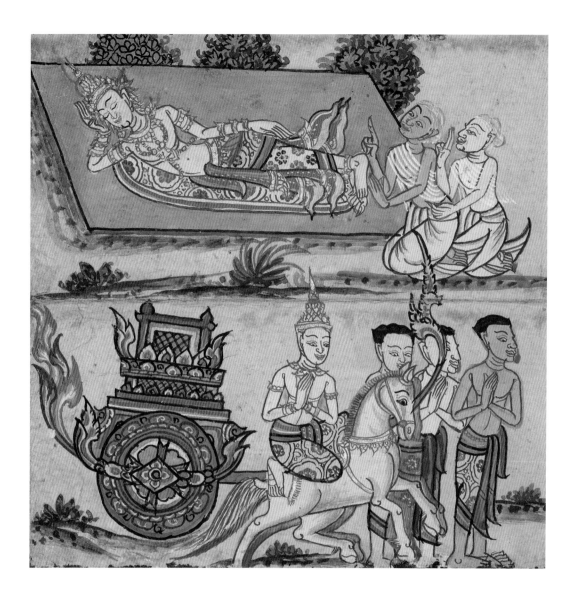

2.10 Janaka is selected as king.
In the top half of the image, Janaka rests on a stone slab in the park, while two brahmins inspect his feet for the auspicious signs of kingship. Below, the royal chariot stands ready to take Janaka to the palace. Oxford, Bodleian Library, MS. Pali a. 27 (R), A07 left (fol. 7)

Meanwhile, Polajanaka had died, leaving no heir, declaring that whoever could please his daughter or solve a series of tests would rule. Finding nobody in the city capable of doing so, the courtiers prepared the royal chariot and sent it forth to find the next king. The chariot, without a driver, travelled straight to the park and stopped in front of the stone on which Mahājanaka lay sleeping. The brahmin priests inspected Mahājanaka's feet for auspicious marks, and declared him to be capable of ruling over all of the four continents. He accepted the kingship, accompanied them to the palace, and proceeded to please the princess and solve the riddles, further proving his right to rule.

After ruling for many years and fathering a son, one day Mahājanaka was travelling in a park when he saw a mango tree laden with fruit. He ate

2.11 Janaka renounces, late eighteenth century. In another key scene from the story, Janaka puts on the robes of an ascetic (here depicted as Buddhist monastic robes) and leaves behind his weeping wife (*below*) to pursue meditation. This conclusion to the story emphasizes that, although Janaka's energetic determination won him a kingdom and a wife, the real test of his strength was in leaving both behind and dedicating himself to the religious life. London, British Library, MS. IO Pali 207, fol. 3. © British Library Board

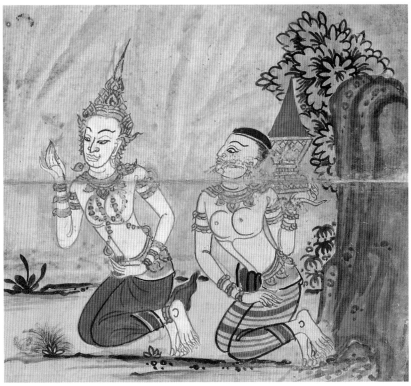

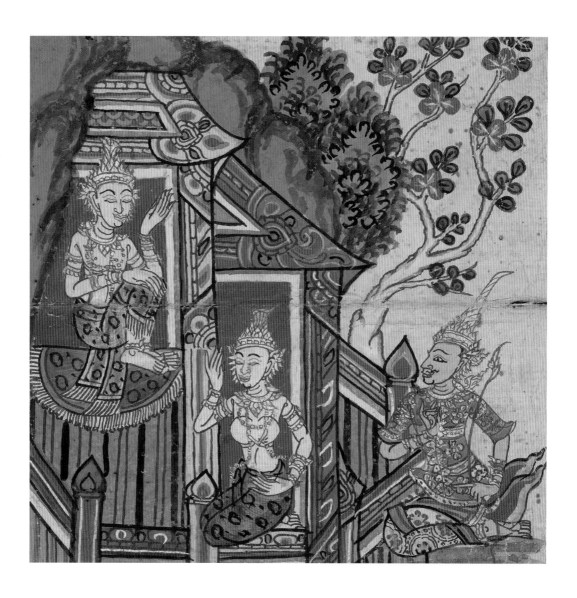

2.12 Informing the parents.
The king, still clutching his bow, informs Sāma's parents that he has killed their son. The couple are clothed in the animal skin robes of ascetics, and their closed eyes communicate their blindness as they sit in lamentation. Oxford, Bodleian Library, MS. Pali a. 27 (R), A10 right (fol. 10)

one of the mangos, after which a crowd of people followed suit, stripping the tree bare and breaking its branches. Reflecting on the sorry state of the fruiting tree, and the green flourishing of a barren tree nearby, Mahājanaka compared the trees to the royal and ascetic lifestyles. He resolved to become an ascetic. Renouncing his kingdom, and escaping his distraught wife, he retired to the Himalayas. There he practised meditation, and upon his death he went to a heaven realm.

Suvaṇṇasāma-Jātaka
The birth story of Golden Sāma was told by the Buddha in reference to a monk who supported his parents. This monk, an only child, discovered that

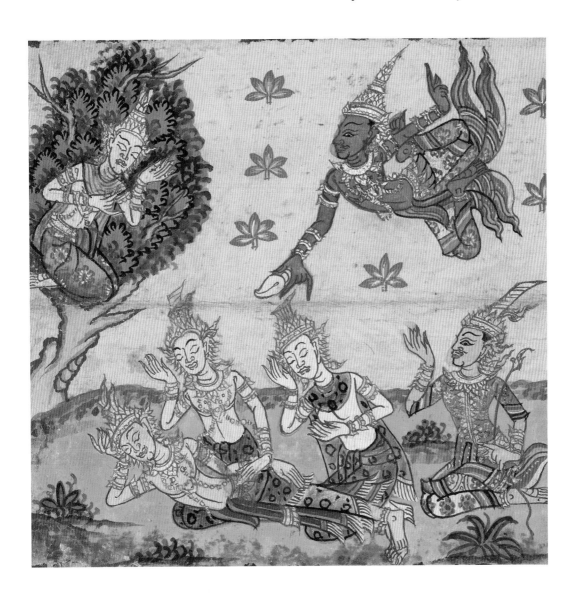

after he had left home his parents had been robbed and left penniless, so he began to share his almsfood with them.

In the past . . .

Two children of neighbouring villages were married to one another against their will, but resolved to live as forest renouncers. Although they were celibate, the god Sakka knew that they would need looking after, and so provided them with a son, the Bodhisatta, whom they named Golden Sāma. One day when the ascetic couple were out collecting fruits, they took shelter from a storm under a tree, but in so doing they disturbed a snake, who blinded them. This was the result of a past life in which they had been

2.13 The lament. Sāma lies motionless on the ground as his parents and the king kneel beside him in grief. In a nearby tree a goddess is also grieving. The statements of truth from Sāma's parents and the goddess will lead to his resurrection. The role of Sakka, shown descending from the sky with a conch shell, is not clear. **(continued overleaf)**

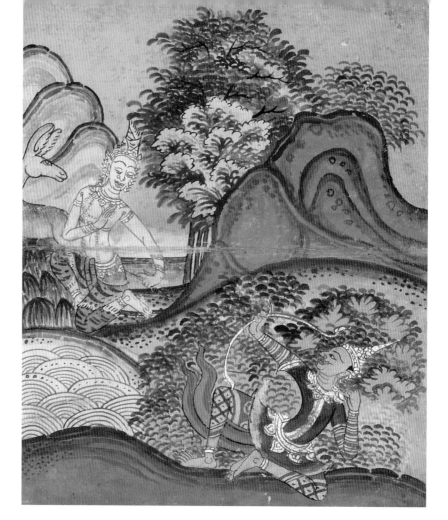

2.13 (continued). The shell indicates that he is administering ambrosia, as he does at the end of some other stories, but this episode is not included in the text nor in other depictions, so it appears that the artist has borrowed the motif from another narrative. Oxford, Bodleian Library, MS. Pali a. 27 (R), A10 left (fol. 10)

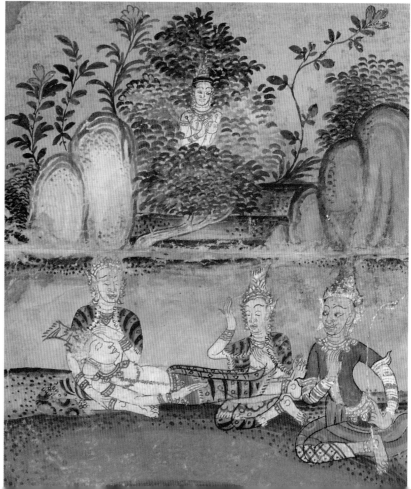

2.14 *Sāma-Jātaka*, late eighteenth century. In the right-hand image (*top*) of this depiction the king is hiding behind a bush by the river as he lets his arrow fly towards Sāma. A deer is present, but the foliage takes centre stage in this image. On the left (*bottom*), Sāma's parents and the king lament at his side, and behind them the goddess peers out from a tree. London, British Library, MS. Or. 14255, fol. 3. © British Library Board

a doctor and his wife. The doctor had cured a man from an eye disease, but though he was rich the man refused to pay the doctor's fee. Upon the advice of his wife, the doctor proceeded to give the man medicine that made him blind in one eye. As a result of this act, the two of them were blinded by the snake. Seeing that his parents had not returned home, Sāma went out to find them, and assured them that all would be well as he would care for them. This he did with great diligence.

One day when King Piḷiyakkha of nearby Vāraṇāsī was out hunting, he spotted Sāma surrounded by deer, fetching water for his parents. Wondering what sort of creature this might be, the king let forth a poisoned arrow, which struck Sāma and dispersed the deer. Lowering himself to the ground, Sāma began coughing up blood and wondering who could have shot him when he had no enemies. The king approached him and was shocked by Sāma's serenity, for the young man did not get at all angry with his attacker. Instead Sāma merely lamented that his death would lead inevitably to the death of his blind parents.

After Sāma fell unconscious, the king was so full of remorse that he went to Sāma's parents and offered to look after them himself. They asked to be led to their son's body. Sāma's mother then made an Act of Truth (a statement of truth so powerful that it can change the course of nature) about Sāma's virtue. Her husband did the same, as did a goddess in a nearby tree, who had been Sāma's mother in a previous life. As a result, the poison in Sāma's veins was rendered powerless and he regained consciousness. He gave the king a lesson about righteous conduct and they were all, at the end of their lives, reborn in heaven realms.

Nemi-Jātaka

One day the Buddha encountered a place in which he had undertaken great acts in a past life, and smiled. Asked by his attendant Ānanda to explain, the Buddha related the birth story of Nemi.

In the past . . .

King Makhādeva lived in the city of Mithilā and ruled Videha. For 84,000 years he had sported as a young man, for another 84,000 years he was viceroy, and for another 84,000 years he was king. When his barber informed him that his first grey hair had appeared, he installed his son as king and spent 84,000 years as a renouncer before dying and being reborn in a heaven realm. His son too followed this tradition of renouncing at the first grey hair, as did his son in turn, and others through a line of 84,000 princes minus two. Looking down from his heavenly abode, Makhādeva – the Bodhisatta – realized that he alone should complete the lineage, and so he was born as Prince Nemi.

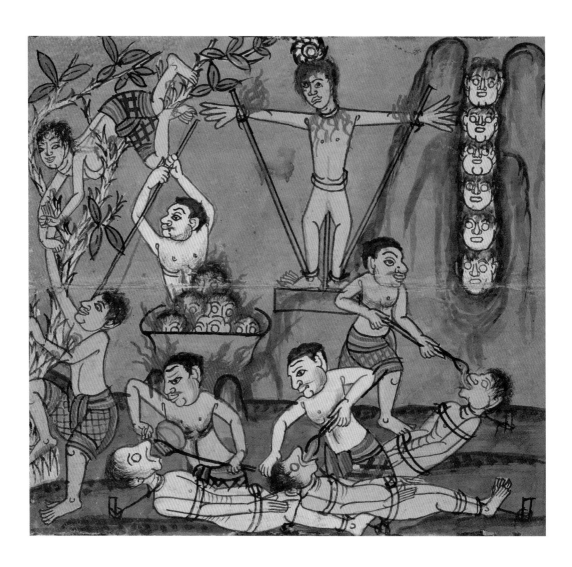

2.15 The torments of the hells.
Several traditional hell torments
are depicted, including the pulling
of tongues in punishment for false
or abusive speech and the thorn
tree that philanderers are forced
to climb. Hell torments appear to
have been a popular subject for
manuscript art, both in the context
of the *Nemi-Jātaka* and the story
of the monk Phra Malai's visits to
the hell realms. Oxford, Bodleian
Library, MS. Pali a. 27 (R), A11
left (fol. 11)

Nemi was a virtuous prince, and after his father renounced he became
a righteous king. He encouraged his citizens to do good deeds, and as
a result they were all born as gods after their deaths. One day the king
wondered, 'What is more fruitful: the holy life or giving alms?' The god
Sakka, feeling his throne grow hot, decided to answer his question, and
arrived at the palace to confirm that the life of a renouncer bears superior
fruit to generosity.

When Sakka returned to his heaven, the other gods requested a visit
from the king, so Sakka sent his charioteer – named Mātali – to fetch
Nemi. Mātali asked whether Nemi would prefer to travel via the hells or
the heavens, and Nemi replied that he would like to see both. First Mātali
took him to the hells, explaining at the king's request the karmic causes
for the horrific torments endured by the inhabitants. Urged by the gods

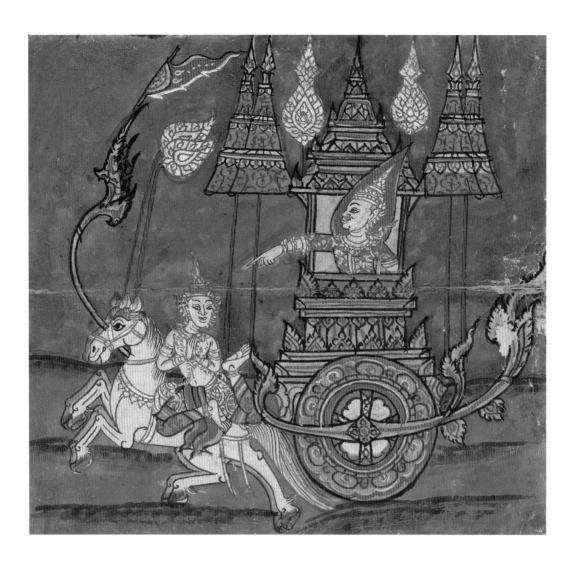

to hurry up, he then took Nemi on a tour of various heavens and up to the gateway of the Tāvatiṃsa Heaven. There Sakka and the other gods welcomed Nemi warmly.

Sakka offered Nemi divine pleasures, but the king declined, saying he would rather return to the world of men and continue to do good deeds. Mātali returned him to Mithilā, where he described the pleasures of heaven to his citizens, exhorting them to give alms in order to earn such a delightful rebirth. When his barber found his first grey hair, Nemi renounced the throne and went to a mango grove to meditate. It was this mango grove, and this memory, that prompted the Buddha's smile.

2.16 Nemi in the chariot. Seated in an elaborate chariot, King Nemi points at something below and left. Seated on the horse, Mātali turns towards Nemi to offer explanations for all that he sees. It is interesting that Nemi has a halo whereas Mātali (a god) does not. This is reversed in the very similar image depicting the seeing of the four signs (Fig. 3.6), in which the Bodhisatta has no halo but the charioteer does. Oxford, Bodleian Library, MS. Pali a. 27 (R), A11 right (fol. 11)

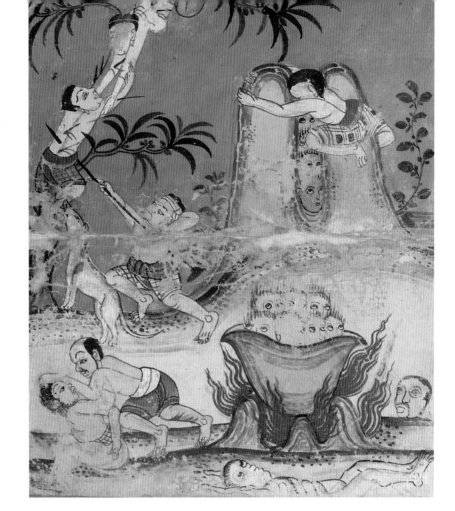

2.17 *Nemi-Jātaka*, late eighteenth century. The scene of Nemi visiting the hells (left-hand image, *above*) was the standard choice for eighteenth-century manuscripts. The composition of the hell scenes in these two manuscripts is strikingly similar, and suggests a standardized stock of hell-torment scenes. On the right-hand image of this manuscript (*below*) we find an additional figure: a messenger from the gods telling Mātali to hurry up and bring Nemi to the heavens. London, British Library, MS. Or. 14255, fol. 4. © British Library Board

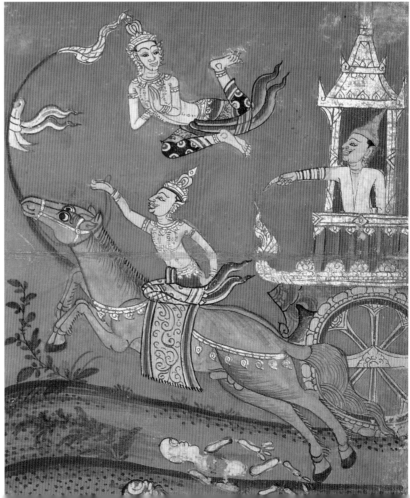

Mahosadha-Jātaka

The birth story of Mahosadha, or the birth story of the great tunnel (*Mahā-Ummagga-Jātaka*), was told by the Buddha about his great wisdom.

In the past . . .

King Vedeha ruled in Mithilā and had four wise ministers. One day he had a dream that foretold the birth of a fifth sage, even more wise than the others. On that day the Bodhisatta was born in the womb of a merchant's wife. Because he was born with a medicinal herb in his closed fist, he was named Mahosadha (Great Medicine). As a child he built a court of justice, and sat giving judgements to various petitioners.

2.18 Mahosadha defeats Kevaṭṭa. As Kevaṭṭa, the chaplain of the invading king, bends to retrieve a dropped jewel, Mahosadha presses his shoulders and hips towards the ground to create the impression that he is conceding the battle. The colourful banners indicate the royal patronage of these two wise ministers. Oxford, Bodleian Library, MS. Pali a. 27 (R), A12 left (fol. 12)

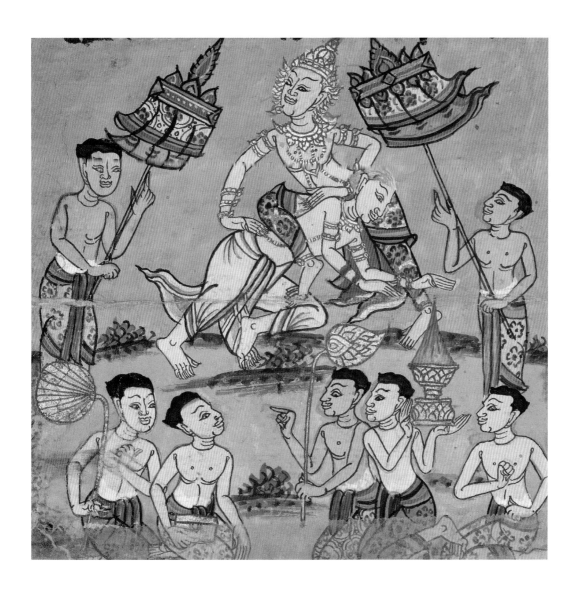

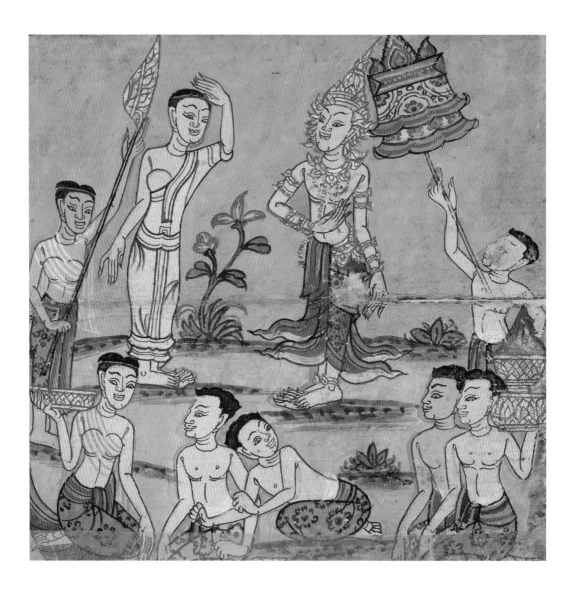

2.19 Mahosadha converses with Bherī. Using only hand gestures, the ascetic Bherī asks Mahosadha how well his new patron King Cūḷani treats him. With an open hand, she asks if the king is liberal. Responding with closed fist, he indicates the opposite. She touches her head to suggest he should become a shaven-headed ascetic if he is displeased with his position. (***continued opposite***)

Seven years after his dream, Vedeha sent courtiers out to find the fifth sage, and the child Mahosadha was brought to court. Mahosadha solved numerous riddles and dodged attempts by the other sages to remove him from favour. At the age of sixteen he found himself a wife, Amarā, who equalled him in wisdom. He took great care of the kingdom, making sure the city was well protected and sending out spies to neighbouring kingdoms.

One day one of Mahosadha's spies, a parrot, reported that King Cūḷani-Brahmadatta of Pañcāla was plotting with his chaplain Kevaṭṭa to conquer all of India. In due course Cūḷani laid siege to Mithilā, but Mahosadha ordered that the attacking army be shown just how much food, water and

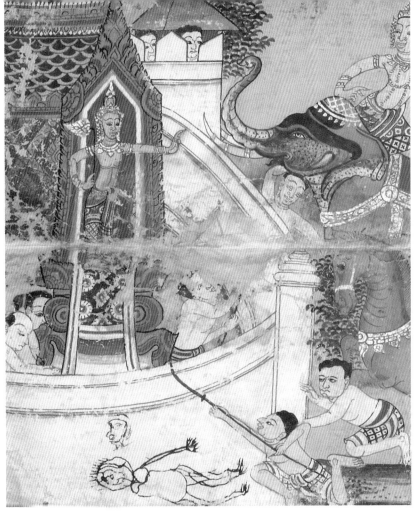

2.20 *Mahosadha-Jātaka*, **late eighteenth century.** In contrast to the two scenes depicted in MS. Pali a. 27 (R), here we find some more violent episodes from the story. On the left (*top*) the city of Mithilā is under siege, and Mahosadha stands fearless in the centre, commanding the invading army to stop. On the right (*bottom*), Mahosadha has trapped the enemy king in a great tunnel and threatens him with a sword. After he has frightened the king into submission, he offers him the sword in an act of reconciliation. Although these images show a wise way of using force that minimizes the actual use of violence, the martial aspect of Mahosadha's wisdom is emphasized far more greatly here than in the images chosen for the Bodleian manuscript. London, British Library, MS. Or. 14255, fol. 5. © British Library Board

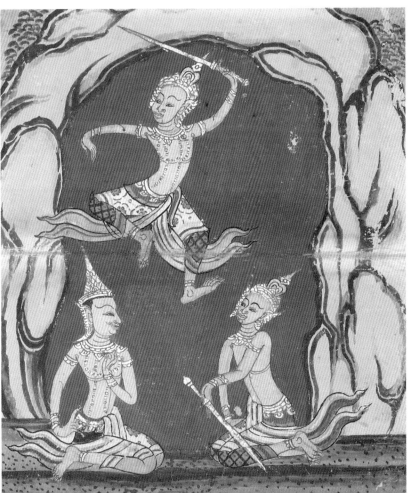

2.19 (*continued*). He responds by touching his belly, to indicate the many dependants he has to support. Bherī later praises Mahosadha to the king and all the citizens. Oxford, Bodleian Library, MS. Pali a. 27 (R), A12 right (fol. 12)

firewood was stored within the city walls. As a last resort, Kevaṭṭa suggested a meeting between himself and Mahosadha, with the one who bows first admitting defeat on behalf of their royal patrons. However, Mahosadha tricked Kevaṭṭa by dropping a gem on the ground. When Kevaṭṭa bent down to pick it up Mahosadha held him down and declared victory.

Kevaṭṭa concocted another plan: to entice King Vedeha to Pañcāla with an offer of marriage to King Cūḷani's beautiful daughter, and then kill him. With the help of his parrot spy and the enemy king's mynah bird, Mahosadha learnt of the plan. He went to Pañcāla ahead of the king, prepared a suitable palace for Vedeha's visit, and secretly constructed a large tunnel between that palace and the palace of King Cūḷani. While Cūḷani's army surrounded Vedeha's residence, Mahosadha sent courtiers to fetch Cūḷani's mother, wife, son and daughter into the tunnel. He consecrated the marriage of King Vedeha and the princess, and sent them all to Mithilā. The next morning Cūḷani attacked, and Mahosadha revealed that Vedeha had already gone, with Cūḷani's family as prisoners. Cūḷani submitted to Mahosadha, and the two became friends.

After Vedeha died, Mahosadha became adviser to Cūḷani. At first the king paid him no honour, but after the intervention of a female ascetic called Bherī, Cūḷani admitted that Mahosadha was worth more to him that his own life, for wise men are to be highly valued.

Bhūridatta-Jātaka

The birth story of Bhūridatta was told by the Buddha about the importance of keeping the *uposatha* holy day.

In the past . . .

King Brahmadatta had two children by a *nāga* (serpent deity) woman: a son named Sāgara-Brahmadatta and a daughter named Samuddajjā. In due course the latter was married to the king of the *nāga*s and bore him four sons: Sudassana, Datta, Subhaga and Ariṭṭha. Datta, who was the Bodhisatta, gained a reputation for being wise, and the god Sakka added Bhūri ('extensive') to his name in recognition that his wisdom was as broad as the earth. Bhūridatta regularly went to the world of men to observe the *uposatha* holy day, and at the end of his observance *nāga* maidens would celebrate with music and dancing.

One day a man was out hunting with his son when he encountered Bhūridatta seated on an ant-hill. Bhūridatta was worried that the man might betray his location to a snake charmer and so invited him to live in the *nāga* realm. Despite Bhūridatta's great generosity and the luxury of the *nāga* palaces, the man became discontented and asked to return to the human realm.

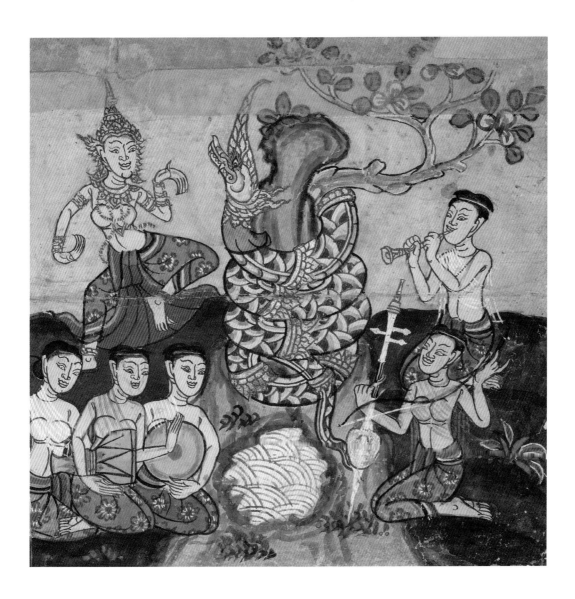

Meanwhile, another man got into debt and escaped to the forest, where he performed services for an ascetic. The latter was so pleased with him that he gave him a snake-charming spell that he had been taught by a *garuḷa* (divine bird, enemy of the *nāga*s). This spell was called Ālambāyana, and the man took the spell and the name and went to make his living as a snake charmer. In due course he came across some *nāga*s, who were so terrified on hearing the charm that they fled, leaving a valuable jewel behind. Ālambāyana picked it up and continued on his way. Next he met the hunter, and offered to exchange the jewel for information about the whereabouts of a *nāga*. The hunter pointed out the ant-hill where Bhūridatta was observing the holy day. Ālambāyana captured Bhūridatta, and the latter was so determined to retain his morality that he refrained from using any force to escape.

2.21 Bhūridatta observes the *uposatha*. Five *nāga* maidens play musical instruments and one dances (with the extended fingers typical of Thai dance) in celebration of the end of Bhūridatta's observance of the holy day. They are all in the form of human women, whilst Bhūridatta displays his serpentine form, as he rests coiled around an ant-hill. Oxford, Bodleian Library, MS. Pali a. 27 (R), A13 right (fol. 13)

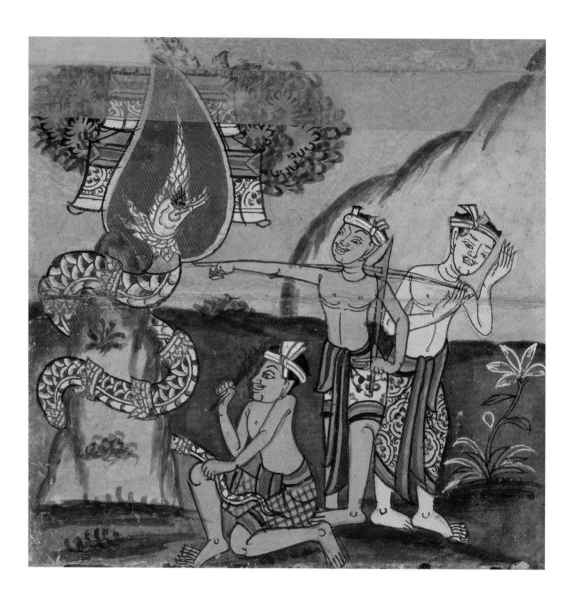

2.22 Bhūridatta is captured.
The hunter, still carrying his weapons, points out Bhūridatta to the snake charmer Ālambāyana, while his son Somadatta laments this terrible act of betrayal. Ālambāyana is in the process of trapping Bhūridatta, clutching his tail with one hand and magical herbs with the other. Oxford, Bodleian Library, MS. Pali a. 27 (R), A13 left (fol. 13)

When Bhūridatta went missing Samuddajjā sent her other three sons to look for him. Sudassana followed the tracks of Ālambāyana all the way to the city of Vārāṇasī, where Bhūridatta was about to perform for the king, who by this time was Sāgara-Brahmadatta, his uncle. Sudassana frightened Ālambāyana into releasing Bhūridatta, and a family reunion ensued.

While he was recovering from this adventure, Bhūridatta heard that his brother Ariṭṭha was teaching a false doctrine – that of the four castes, the Vedas, and the efficacy of animal sacrifice. He gave a long lesson on the true state of the world and the best way to ensure a happy future. At the end of his life he and a host of *nāga*s were reborn amongst the gods.

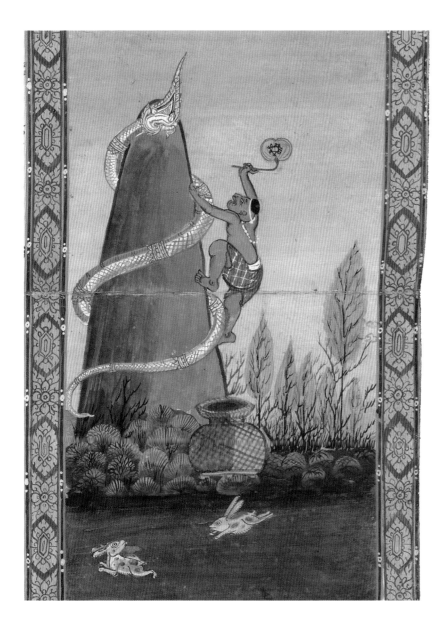

2.23 Bhūridatta is captured, 1894. In this typical nineteenth-century depiction of the story, we see only the snake charmer capturing Bhūridatta, using not the magical herbs of earlier depictions, but a fan with a magical diagram (*yantra*) inscribed upon it. London, British Library, MS. Or. 16100 fol. 5, right image. © British Library Board

Candakumāra-Jātaka

The birth story of Prince Canda, also known as the birth story of Khaṇḍahāla, was told by the Buddha in reference to Devadatta's attempt to kill him. Devadatta had ordered an archer to go and shoot the Buddha, and then return along a certain road, down which he sent two more archers to kill the first, four to kill the two, eight to kill the four, and sixteen to kill the eight; in this way he hoped to cover up his actions. But because of the Buddha's great power the archers were all converted and saved. In the past too Devadatta had been willing to kill many in order to kill the Buddha.

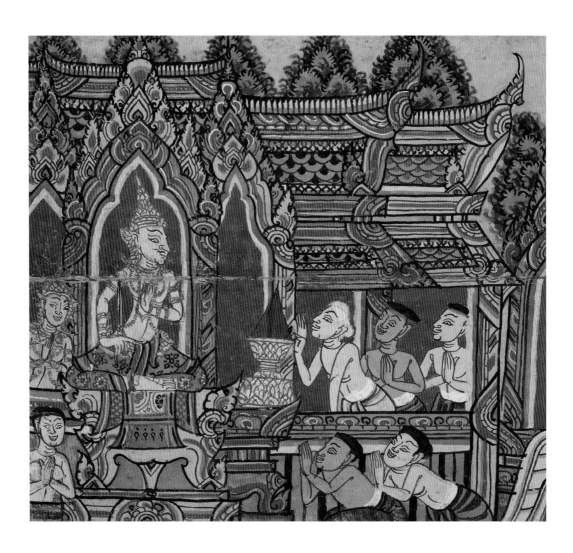

2.24 The persuasion of the king. The king sits on his throne, looking in the direction of the brahmin Khaṇḍahāla, who is leaning towards him and gesturing in instruction. Behind and below Khaṇḍahāla, the four gentlemen selected for sacrifice entreat the king to change his mind. Oxford, Bodleian Library, MS. Pali a. 27 (R), A14 left (fol. 14)

In the past . . .

King Ekarāja ruled in what is now known as Vārāṇāsī, and his son Canda (the Bodhisatta) was viceroy. The king's brahmin adviser, Khaṇḍahāla (Devadatta in a previous life), did not like Prince Canda, because he had prevented him earning a steady income from courthouse bribes. One day, the king dreamt of the heaven realms, and asked Khaṇḍahāla how he might get to heaven. Seizing this opportunity for revenge, Khaṇḍahāla advised the king that the only way to get to heaven was to carry out a fourfold sacrifice: a sacrifice of four each of his sons, daughters, wives, citizens, bulls, horses and elephants. The proposal of this huge sacrifice – a cover for Khaṇḍahāla's hatred of Canda alone – led to uproar in the city, but the king agreed to the plan and assembled the victims.

The king's parents tried to dissuade him from carrying out such a cruel sacrifice, but the king took no notice. Canda entreated his father to instead

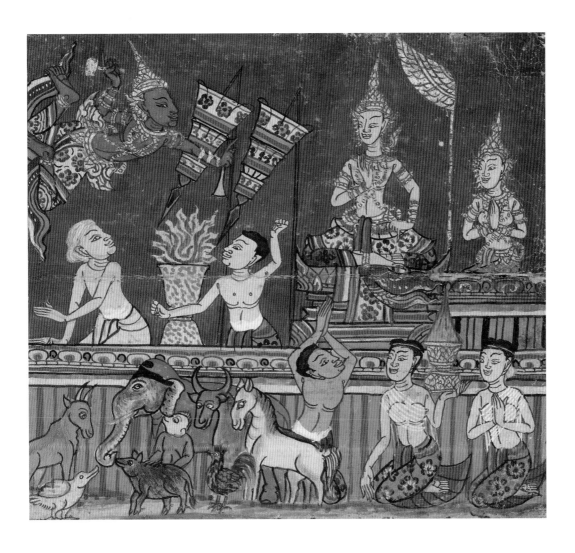

give himself and his brothers to Khaṇḍahāla as slaves, or banish them to the forest, rather than killing them. The king's heart softened and he had all the sacrificial victims released, but Khaṇḍahāla intervened with a persuasive speech and once again the victims were rounded up. The king changed his mind a second time at the entreaty of his grandson, Canda's son, but once again Khaṇḍahāla managed to restore the king's commitment to the sacrifice.

Amidst the great lamentation of the assembled people, Khaṇḍahāla forced Canda to his knees, and held a sword to his throat. In a final desperate attempt to prevent the sacrifice, Canda's wife, Candā (the Buddha's wife in a previous life) called upon the gods for help. The god Sakka appeared, wielding a large hammer, and destroyed the sacrificial post, terrifying the king. The populace stoned Khaṇḍahāla to death, but Canda prevented them from killing his father. He generously continued to support Ekarāja's needs in exile, and ruled the kingdom justly. All those who had supported the sacrifice or approved of it went to hell.

2.25 Sakka disrupts the sacrifice. A horizontal band denotes the sacrificial arena, within which Canda sits calmly as Sakka arrives with a golden hammer to disrupt the sacrifice. To his left a woman, probably Candā, makes a gesture of respect. Near the sacrificial fire a man chases after the brahmin Khaṇḍahāla, whilst outside the sacrificial arena three onlookers make respectful gestures, and animals await their fate. (***continued overleaf***)

2.25 (*continued*). Of the animals, only the horse, elephant and ox are mentioned in the text: the inclusion of the other animals indicates the artist's enjoyment of this subject. Oxford, Bodleian Library, MS. Pali a. 27 (R), A14 right (fol. 14)

2.26 Khaṇḍahāla is defeated, late eighteenth century. This image portrays a key underlying theme of the *Candakumāra-Jātaka*, namely the defeat of the evil brahmin Khaṇḍahāla, after whom the story is sometimes named. Khaṇḍahāla is a past life of the Buddha's cousin Devadatta, who caused a schism in the Buddhist community and tried several times to kill the Buddha. Here Sakka is not striking the sacrificial post (as is usual) but rather appears to be hitting Khaṇḍahāla himself, joined by two onlookers with sticks. London, British Library, MS. IO Pali 207, fol. 14, left image. © British Library Board

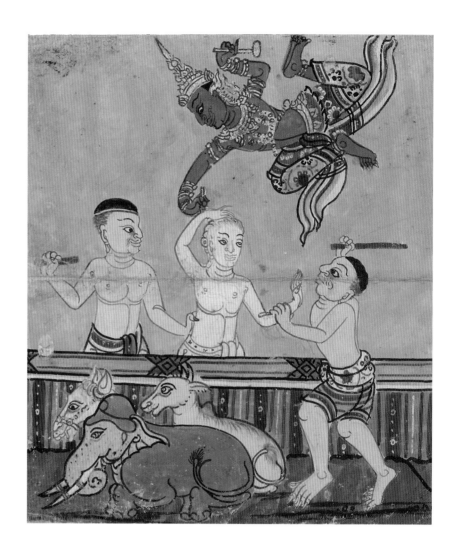

Nārada-Jātaka

The birth story of Nārada, or of Nārada and Kassapa, was told by the Buddha in reference to the conversion of Uruvela Kassapa, a leading ascetic, to Buddhism. The Buddha explained that also in the past he had converted Uruvela Kassapa from wrong views.

In the past . . .

King Aṅgati ruled righteously in Mithilā, and his only child, a daughter named Rucā, was noted for her generous conduct. One day, he was taken by his courtiers to visit an ascetic who was preaching in a nearby park. This ascetic, named Guṇa Kassapa, taught that actions did not have any results, and that escape from the cycle of rebirth happened at a predetermined pace. His teachings were bolstered by the stories of two audience members,

which appeared to confirm that past actions did not affect one's present birth: one claimed that he had spent his previous life chasing other people's wives yet had still been reborn into a wealthy family, while another had lived a virtuous life, only to be reborn as a slave. The king liked this fatalist teaching, as it allowed him to do whatever he pleased without fear of the consequences. He therefore began to ignore his royal duties and spend all his time dallying with the wives of his citizens.

Fearing for her father's karmic load, Princess Rucā related her own seven past lives in order to convince the king of the efficacy of karma. Long ago she had been a man who chased the wives of others, and had therefore been reborn in a hell, then as a variety of castrated animals, then as a neuter, then as a female. To further bolster her teaching, she then recounted to the king her future lives, in which she was destined to remain in female form

2.27 The arrival of Nārada.
The four-headed and four-armed Nārada Brahmā flies through the yellow sky amidst a sea of flames. A red halo further emphasizes his divine status. Contrary to most Thai depictions, he does not carry an ascetic's carrying-pole. Oxford, Bodleian Library, MS. Pali a. 27 (R), A15 left (fol. 15)

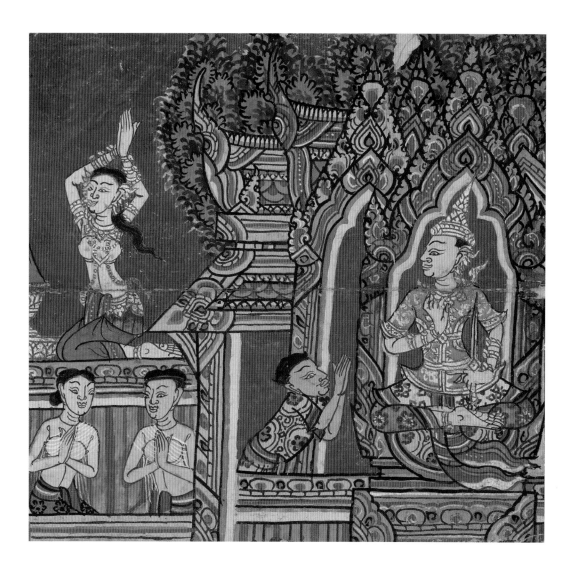

2.28 Rucā calls upon Nārada.
Princess Rucā calls upon the
gods to help dissuade the king
from the fatalist views that are
leading to his moral ruin. The
king sits on his throne, whilst
three figures make respectful
gestures as they await the
outcome of the princess's actions.
Oxford, Bodleian Library, MS.
Pali a. 27 (R), A15 right (fol. 15)

until her bad karma was eradicated, and only then take birth as a male god.
(As we later find out, she eventually becomes the Buddha's male attendant
Ānanda.) The king was not convinced by her story, nor by a night-long
sermon from her. In desperation, Princess Rucā entreated the gods to come
to her aid.

At that time the Bodhisatta was a god called Nārada, and he surveyed
the world to see who might need his assistance. Seeing Rucā's entreaties,
he disguised himself as an ascetic and descended to the human realm. He
impressed the king with his supernormal powers, and then frightened him
with a description of the hell torments that awaited him. Eventually these
horrific descriptions convinced the king to abandon his wrong view, and
he begged Nārada for instruction in good conduct. Nārada advised and
admonished him, and then disappeared back to his heavenly abode.

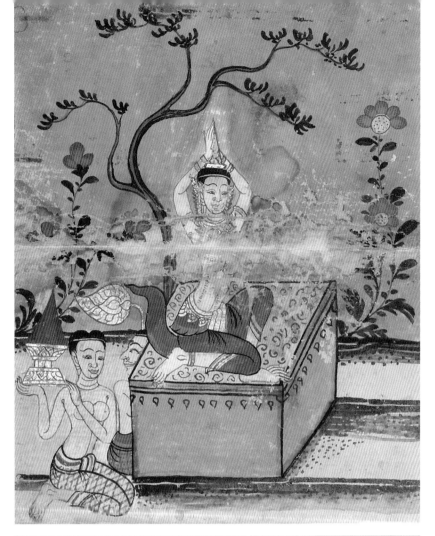

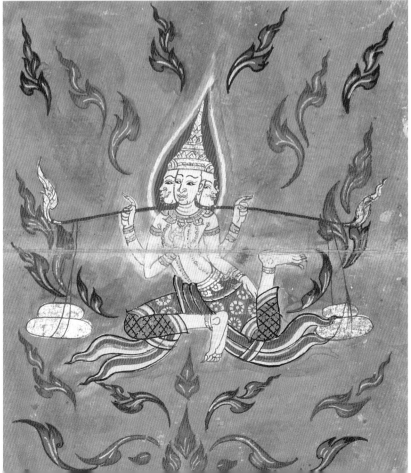

2.29 *Nārada-Jātaka*, **late eighteenth century.** On the left (*above*) Princess Rucā makes her entreaty to the god, seated amongst delicate plants. On the right (*below*) Nārada Brahmā descends from the heavens, his carrying-pole indicating his disguise as an ascetic. This manuscript does not show the king, leaving the focus firmly upon the princess, who is a past life of the Buddha's close personal attendant Ānanda. London, British Library, MS. Or. 14255, fol. 8. © British Library Board

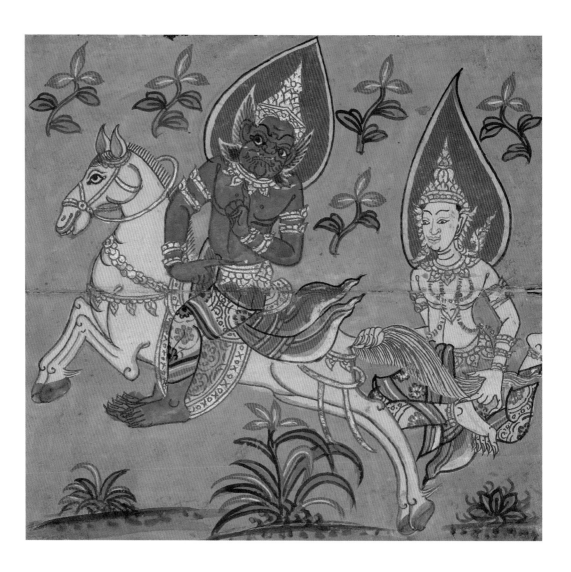

2.30 Puṇṇaka carries Vidhura away. Vidhura holds onto the tail of Puṇṇaka's magical steed as they set off through the sky, which is decorated with floral motifs. Vidhura remains calm and composed, despite his unusual mode of transport. Oxford, Bodleian Library, MS. Pali a. 27 (R), A16 right (fol. 16)

Vidhura-Jātaka

The birth story of Vidhura was told by the Buddha to explain that even in the past he had great wisdom and was persuasive in debate.

 In the past . . .

Four friends met four ascetics and decided to wait on them. Each ascetic described to their attendant the place in which they had spent their day: one had been in Sakka's heavenly palace, another in the world of the *nāga*s (serpent deities), another in the realm of the *supaṇṇa*s (divine birds) and the other in the palace garden of the human king Dhanañjaya. Each of the friends conceived a longing to reach the place they had heard about, and so after death one was born as Sakka, one as Varuṇa, king of the *nāga*s, one

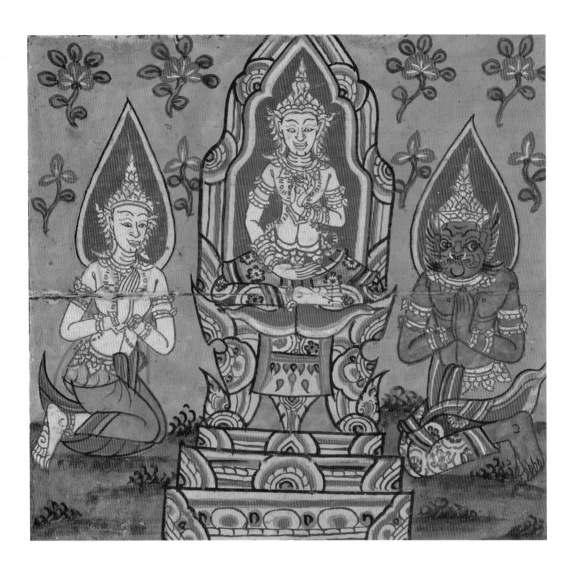

2.31 Vidhura gives a teaching.
Seated on a throne, Vidhura
gives a teaching to the *yakkha*
Puṇṇaka and a woman, probably
the *nāga* queen Vimalā, who
both kneel in a gesture of respect.
Oxford, Bodleian Library, MS.
Pali a. 27 (R), A16 left (fol. 16)

as king of the *supaṇṇa*s and one as the son of King Dhanañjaya. When the
prince was grown and had become king, he went to a park to meditate, and
there met his three former friends. They discoursed on their virtues, trying
to ascertain who had the greatest qualities. Unable to settle the matter, they
went to Vidhura the Wise, the Bodhisatta and adviser to King Dhanañjaya.
Vidhura solved the matter with ease, and the four praised him highly.

When Varuṇa the *nāga* king returned home, he told his wife about the
great wisdom of Vidhura, and she longed to meet him. Pretending to be
ill, she declared that only the heart of Vidhura could cure her. Distraught,
Varuṇa asked his daughter Princess Irandatī to try to attract a suitor who
could capture Vidhura. With her song and beauty she enticed the *yakkha*
(demon or spirit deity) general Puṇṇaka, and Varuṇa explained to him the
bride price.

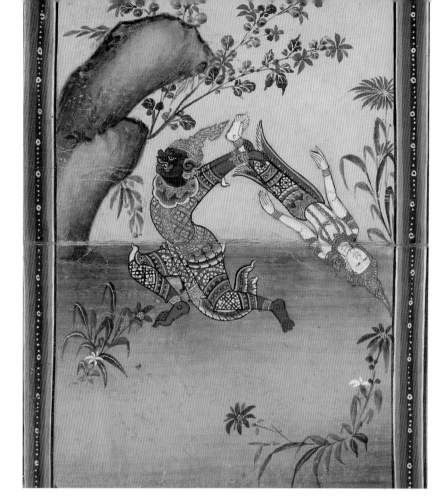

2.32 *Vidhura-Jātaka*, **late nineteenth century.** In this typical nineteenth-century depiction of the story Puṇṇaka is trying to kill Vidhura by swinging him from the ankles. As in the episode of the journey by horse, shown here on the right, Vidhura remains totally calm, and is unhurt. London, British Library, MS. Or. 16552, fol. 22. © British Library Board

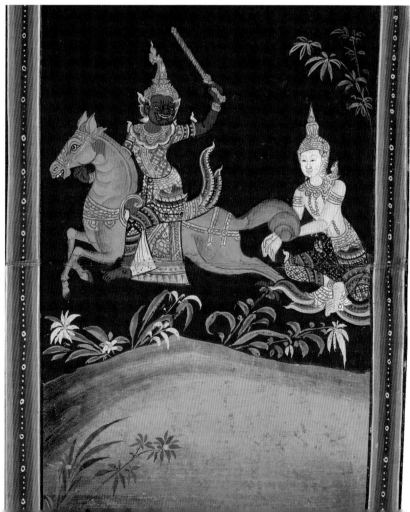

Disguised as a man, Puṇṇaka set out for King Dhanañjaya's palace, planning to win Vidhura from the king in a game of dice. Offering his magical steed and a powerful gem as the king's prize, he received a promise of the most precious of the king's possessions should he win. By his supernormal power Puṇṇaka beat the king, and took possession of Vidhura.

Puṇṇaka told Vidhura to hold onto his horse's tail, and together they flew off to the Black Mountain. There Puṇṇaka tried to frighten Vidhura to death, and when this failed he picked him up by the feet and prepared to throw him head-first at the ground. Vidhura chose this moment to ask Puṇṇaka's purpose, and hearing the whole story he suggested that Puṇṇaka hear a discourse on the truth before killing him. Puṇṇaka agreed, was converted to good conduct, and took Vidhura to Varuṇa's palace. There Vidhura pleased Varuṇa and his wife with a lesson on good conduct. Vidhura then returned to King Dhanañjaya and continued to instruct the king and court on all matters.

Vessantara-Jātaka

When the Buddha visited his home country, there was a miraculous shower of rain that only wetted those who desired to be wet. The Buddha explained that this was not the first time that a miraculous shower of rain had poured upon his kinsmen.

In the past . . .

King Sañjaya had a son, Vessantara. From the moment he was born Vessantara was exceptionally generous, and at the age of eight he even declared his willingness to give away his eyes, flesh or heart. At sixteen he was given a wife, Maddī, and consecrated as king. Soon they had a son and a daughter. Each month Vessantara visited the alms-halls on the back of his elephant and gave liberally.

In the nearby kingdom of Kāliṅga there was a drought. The people had heard about Vessantara's liberality as well as about his elephant, which was reputed to bring rain. The king of Kāliṅga sent envoys to Vessantara to ask for the elephant, and Vessantara gladly gave it away. His citizens were unhappy about this, and insisted that Sañjaya retake the throne and banish Vessantara to the forest. For one final day Vessantara gave lavish gifts, and then he and his family set off for the forest in a carriage. As soon as they had left the city some men asked for the horses, which Vessantara willingly gave. Gods took the form of stags and pulled the carriage, but soon another petitioner asked for the vehicle. Vessantara and his family continued on foot to a divinely built forest hermitage, which was to be their new home.

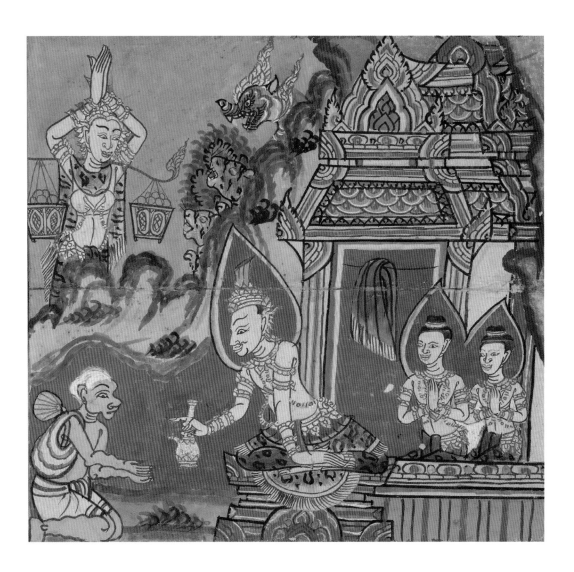

2.33 Vessantara gives away his children. While his wife Maddī is kept in the forest by gods disguised as wild beasts, Vessantara pours water on the hands of the brahmin Jūjaka to signify the gift of his two children, who sit reverently behind him in the hermitage. Oxford, Bodleian Library, MS. Pali a. 27 (R), A17 right (fol. 17)

In Kāliṅga the drought was ended by the arrival of the elephant. An old brahmin called Jūjaka lived there, and his young wife demanded that he find Vessantara and ask for a servant to help her with her domestic chores. When Jūjaka arrived at Vessantara's hermitage Maddī was out gathering fruits. Some gods took the form of wild animals to prevent her return, while Vessantara calmly gave Jūjaka his children as slaves. When Maddī returned she was heartbroken by the loss of her children, but rejoiced at her husband's generosity. The next morning Sakka went to the hermitage disguised as a brahmin and asked for Vessantara's wife. After Vessantara had given Maddī to him, Sakka immediately gave her back again, and praised Vessantara highly.

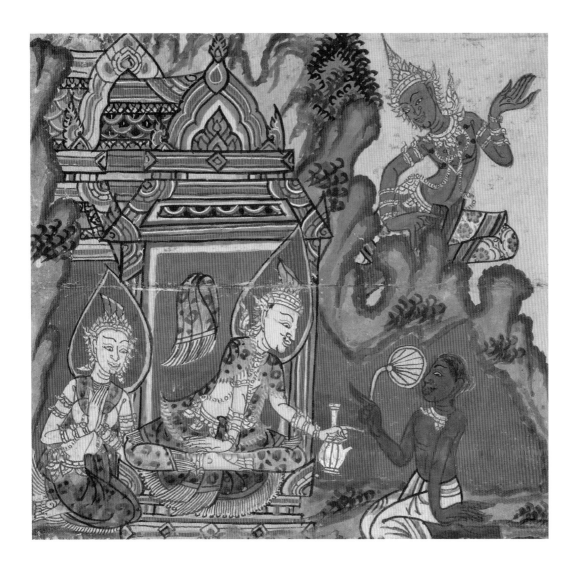

Meanwhile, Jūjaka got lost, and ended up in Vessantara's home country, where the children were recognized and ransomed by King Sañjaya. Jūjaka was given much wealth, and died shortly thereafter from overeating. Sañjaya entreated Vessantara to return to the city, but when Vessantara did so he wondered what gifts he would be able to give. In response Sakka rained down seven types of jewels on the city – another occasion on which miraculous rain had poured on the Buddha's kinsmen.

2.34 Vessantara gives away his wife. The god Sakka, shown in his celestial form in the upper corner, takes on the disguise of a brahmin and asks for Vessantara's wife. Vessantara is about to pour the water signifying his gift, as Maddī kneels to his right. Oxford, Bodleian Library, MS. Pali a. 27 (R), A17 left (fol. 17)

2.35 The reluctant children, late eighteenth century. The gift of the children is considered the climactic moment of the narrative, and often the entire illustration of the *Vessantara-Jātaka* is limited to this one episode, as in this manuscript. However, here we do not see willing children and a pitiable brahmin. Rather, the children beg their father tearfully to reconsider (right-hand image, *above*) and are tied up and led away by the nasty brahmin, who beats them with a stick (left-hand image, *below*). As is the case in some other image choices, it appears that the artist of MS. Pali a. 27 (R) deliberately chose more serene illustrations. London, British Library, MS. IO Pali 207, fol. 20. © British Library Board

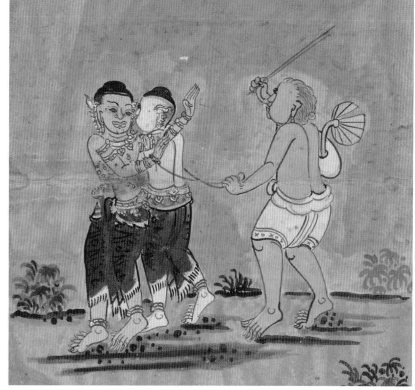

❧ 3 ❧

The final life of the Buddha

TOSHIYA UNEBE

'I am chief in the world: I am supreme, I am the eldest, there is no one
 higher than me.
This is my last birth, there will be no more re-becoming!'

Paṭhamasambodhi, verse 21

Tradition reports that immediately after the Bodhisatta ('Awakening
Being') was born from his mother's right side as Prince Siddhattha, son
of King Suddhodana of Kapilavatthu, he took seven steps and made the
proclamation cited at the head of this chapter. Thereafter he would live his
final life as a prince, an ascetic and, finally, as the Buddha. This would be
his 'last birth', meaning that he would never be born again in this world of
suffering. In other words, the baby Bodhisatta predicted that, after all his
efforts during countless previous lives, he would finally become a Buddha
('Awakened One') in this life.

As we saw in the previous chapter, the life of the Buddha illustrated in this
Bodleian manuscript begins with his many previous lives as Bodhisatta, not
with his birth as Prince Siddhattha. And until he finally attains awakening
at the age of thirty-five, after a six-year quest, he continues to be called
the Bodhisatta. Thus the 'final life of the Buddha' consists of his final life
as a Bodhisatta and his life as the Buddha for the forty-five years between
his awakening and his *parinibbāna* ('complete extinction': death with no
more re-becoming) at the age of eighty. The manuscript carefully depicts
his lives as Bodhisatta in thirty illustrations on one side and his life as the
Buddha in ten illustrations on the other side.

Temple murals in Thonburi

In Thailand, the *uposatha* (Thai: *ubosot*) halls of temples, where monks
gather to carry out religious ceremonies such as ordinations, are usually
richly decorated with murals. Temples in the old city of Thonburi, located

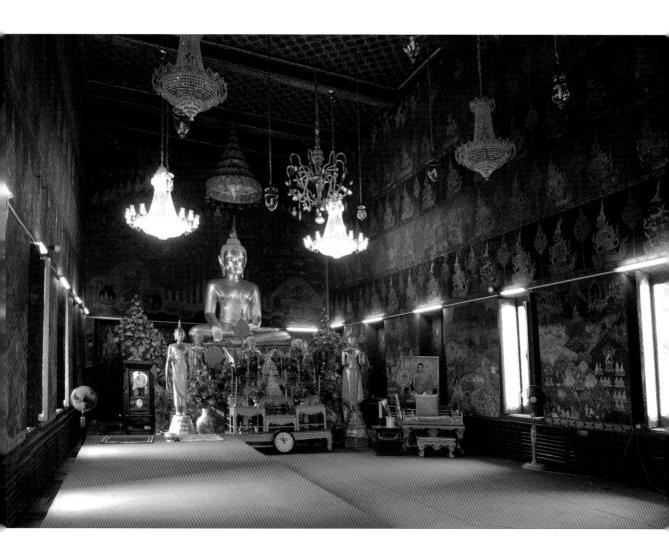

3.1 *Uposatha* hall, Wat Ratchasittharam, Thonburi. Elaborate murals are often found within the *uposatha* halls of temples in this region. Topics for illustration include the past lives of the Buddha, his final life and teaching career, and deities paying honour. Photograph by Toshiya Unebe

on the west bank of the Chao Phraya River facing the present capital city Bangkok, are particularly well known for such depictions.[1] The most prominent subjects are events in the final life of the Buddha, along with those of his previous lives, in particular the ten great birth stories.

Thonburi was the capital city of Siam from 1767 to 1782, during the reign of a single monarch, King Taksin, after the previous capital Ayutthaya had been sacked by the Burmese. Although the temples of Thonburi had mostly been founded in the late Ayutthaya period, and their murals were heavily restored during the Bangkok period, their depictions of the final life of the Buddha offer a fruitful comparison with the Bodleian manuscript, which was most likely created during this turbulent time of the second half of the eighteenth century. In this chapter, murals from four temples in Thonburi – Wat Ratchasittharam, Wat

Thong Thammachat, Wat Dusidaram and Wat Suwannaram – are shown for comparison.[2] The comparison between the Bodleian manuscript and temple murals of a similar period is particularly helpful, given the lack of other manuscripts depicting the final life of the Buddha. This omission of final-life images is in contrast not only to the temple murals in Siam, but also manuscript traditions in neighbouring Burma (Myanmar), where the life of the Buddha was commonly depicted.[3] In addition to the beauty of its illustration and artwork, the inclusion of images of the Buddha's life makes the Bodleian manuscript very special.

Illustrated episodes

The Bodleian manuscript illustrates the following eighteen episodes from the final life of the Buddha:

1	A18 left	The birth of the Bodhisatta
2	A18 right	The four signs
3	A19 right	Leaving his family
4	A19 left	The great departure
5	A24 left	Cutting off the hair
6	A24 right	The lesson of the three strings
7	A25 left	The offering of milk-rice
8	A25 right	The victory over Māra
9	B09 left	The first sermon
10	B09 right	The return to Kapilavatthu
11	B10 left	The offering from elephant and monkey
12	B10 right	Taming the elephant
13	B26 right	The offering of a mango
14	B26 left	The miracles at Sāvatthī
15	B27 left	Teaching his mother in Tāvatiṃsa Heaven
16	B27 right	The descent from Tāvatiṃsa Heaven
17	B35 left	The cremation
18	B35 right	The division of the relics

These episodes are mostly depicted in chronological order, although in two openings (A19 and B26) we find the order of events is from right to left. Also the two illustrations in folio B10 are not successive events and are misplaced from a chronological point of view.[4] They are probably placed together because of thematic associations.

With the exception of the last scene, in which the Buddha is naturally not present in any bodily form, each illustration depicts him in particular postures or with particular hand gestures. Rather than use the Indian technical term '*mudrā*', which was not traditionally used in Thailand,[5] we should call the postures '*pang*' (ปาง) in Thai, which means image of the Buddha 'in the time of' a specific event.[6] As in the case of Buddhist art of other countries, these postures have over time themselves acquired a rich vocabulary of meaning for their individual associations with a particular event in the Buddha's life. The specific meanings of some of the postures used in this manuscript seem to be particular to the regions in and around central Thailand.

Paṭhamasambodhi: the textual source

As mentioned above, scenes from the life of the Buddha have been a very popular subject for temple murals. It is said that the murals are based on a text called the *Paṭhamasambodhi*, an extra-canonical biography of the Buddha composed in Pāli, which has also circulated in vernaculars in Thailand, Laos, Cambodia and other Southeast Asian countries.[7]

Narrations of particular events in the life of the Buddha are scattered throughout many scriptures in the Pāli canon. However, there is no complete biography of the Buddha from his birth as Siddhattha – not to mention his previous lives – to his *parinibbāna* in the Pāli canon. The most comprehensive account of the life of the Buddha can be found in the introduction (*Nidānakathā*) to the 'Commentary on the *jātaka*' (*Jātakatthavaṇṇanā*). However, this text ends in the middle of the Buddha's life with the account of the donation of Jetavana monastery after his return to Kapilavatthu. In contrast to this, the *Paṭhamasambodhi* describes the Buddha's full life up to his *parinibbāna* and funeral. Although it is an extra-canonical composition, and one that is basically a patchwork, drawing on various sources, it is valuable as a rare example of a complete biography.[8]

We do not know anything about the origin of the *Paṭhamasambodhi*. As George Cœdès, a renowned scholar in Southeast Asian studies wrote, it may have been written in the middle of the fourteenth century in Sukhothai, but he regards this as just one of many possibilities. As he explains, the text was composed by making additions of new chapters to an original core, and this process continued until the end of the eighteenth century. As a result of this compositional history there exist many versions of the text. The version that is best known to the Thai people usually consists of twenty-nine chapters,[9] and this is based on a Pāli version that is the result of a revision made in 1845 by the Thai prince Paramānujit (religious name, Suvaṇṇaraṃsi) at the request of King Rāma III (r. 1824–51). This version is

sometimes called *Paṭhamasambodhivitthāra*, in other words the 'expanded' (*vitthāra*) version. It begins with the chapter that describes the marriage of the Buddha's parents, and continues past the Buddha's *parinibbāna* up to the disappearance of the Buddhist religion.[10]

As mentioned above, it is often said that depictions of the life of the Buddha on temple murals are based on the *Paṭhamasambodhi*. However, since many murals dated from the end of the eighteenth century clearly predate Prince Paramānujit's twenty-nine-chapter *Paṭhamasambodhi* and vernacular versions based on it, the artists must have been working with earlier recensions of the narrative. The illustrations on the Bodleian manuscript, which was produced in the mid- to late eighteenth century, also predate this version of the text.

Fortunately, however, a Pāli version of the *Paṭhamasambodhi* that is thought to be prior to the compilation by Prince Paramānujit has been edited by George Cœdès and published by the Pali Text Society. This version consists of fourteen chapters. It begins with the Bodhisatta's life in the Tusita Heaven which immediately precedes his final life and ends with his *parinibbāna*. The editor George Coedès wrote that this, or similar version(s) of the *Paṭhamasambodhi*, is represented in eighteenth-century manuscripts. Although not all the details of the Bodleian manuscript illustrations correspond to the description found in this version of the *Paṭhamasambodhi*, they often show clear affinity.

Among the eighteen scenes depicted in the Bodleian manuscript, 'The return to Kapilavatthu' in B09 and the four sequential events depicted in B26–B27 show remarkable similarity to the structure of the *Paṭhamasambodhi*. The former shows the newly awakened Buddha returning to his hometown, a time when he is supposed to have taught his wife, son and relatives the teachings he has divined for himself.

Of the many scenes of the Buddha's final life, why was the return to Kapilavatthu selected for illustration in this manuscript? Although this scene was one of the subjects of ancient Indian or Gandhāran art, it is not such a popular scene as to be naturally included in an eighteen-scene biography.[11] The Buddha's return to Kapilavatthu is described in the introduction (*Nidānakathā*) to the *Jātakatthavaṇṇanā*, but no particular stress is placed upon the event in that text. However, in contrast to the *Nidānakathā* and other Buddha biographies, the *Paṭhamasambodhi* devotes a full chapter among fourteen to this episode, with its twelfth chapter, *Pañcasatasakyarājapabbajā* (Ordination of the 500 members of the Sakya royal clan), fully describing the details of the Buddha's return to Kapilavatthu. Thus the text of the *Paṭhamasambodhi* and the illustration in the Bodleian manuscript correspond.

In the same way, the set of events depicted in B26–B27 is fully described in the end of the twelfth and the thirteenth chapter of the *Paṭhamasambodhi*,

Desanā (Teaching). It portrays the Buddha's teaching of his mother in the Tāvatiṃsa Heaven, along with many miracles the Buddha demonstrated before and after this teaching. This episode as a whole, and especially the miracle of the descent from the heaven, has been a very popular artistic motif from the time of Gandhāran art.[12] Although detailed descriptions of the events can only be found in commentaries and not in the Pāli canon itself, this set of events has a great significance in Southeast Asian countries.[13] Furthermore, the teaching scene is positioned centrally in temple halls. The location of the teaching, Tāvatiṃsa Heaven, is depicted up behind the main Buddha image. A variety of heavenly beings line the upper side walls as the audience (see Figs 3.1 and 3.33). It is likely that the teaching in the Tāvatiṃsa Heaven provided the basic concept of the *uposatha* hall plan as a whole.

Other sources

As might be expected, sometimes the text of the *Paṭhamasambodhi* and the illustrations in our manuscript do not correspond. For example, 'The lesson of the three strings', which is very particular to the Buddha's life events as depicted in Southeast Asian temples, is not found in the text of the fourteen-chapter version of the *Paṭhamasambodhi*. However, it does appear in the newer twenty-nine-chapter version and is also found in a footnote to the edition of the fourteen-chapter version. It is best not to think of this as a discrepancy, but rather as evidence that there was interaction between the

3.2 Miracle of the golden plate, Wat Thong Thammachat, Thonburi. One scene not featured in the Bodleian manuscript is the floating of the golden plate to the palace of the *nāga* king shortly before the Buddha's awakening, as shown in this mural. Photograph by Toshiya Unebe

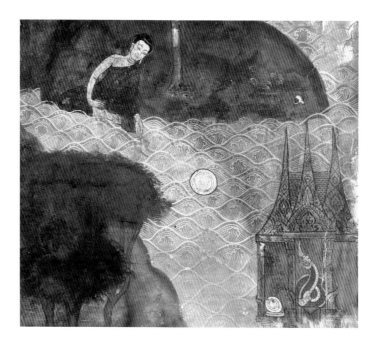

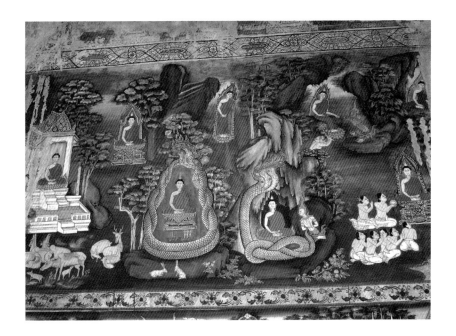

3.3 Seven weeks, Wat Khongkharam, Ratchaburi. Temple murals often depict a scene for each of the seven weeks after the Buddha's enlightenment. The Buddha spent each week in a different posture and/or place, enjoying the bliss of his awakening. Photograph by Toshiya Unebe

textual narrative and the visual narrative as they developed, and so this episode may simply come to appear later in the text than in the murals.

In some cases, although the text of the *Paṭhamasambodhi* fully describes certain events, the Bodleian manuscript gives no illustration of them. For example, after the Bodhisatta finally abandons his austerities and takes milk-rice, he floats the golden plate, given to him by a village woman, on the river. Then the plate miraculously floats upstream before sinking down to the palace of Kāla-nāgarāja (the serpent king named Kāla). Although this scene is described in the *Paṭhamasambodhi* and often depicted very beautifully in temple murals, the scene is missing in the Bodleian manuscript. In the same way, although the *Paṭhamasambodhi* devotes a full chapter to the events that took place in the seven weeks after the Buddha's awakening, and sometimes temple murals depict these events in great detail, they are not found in the Bodleian manuscript.

In a few cases, the selection of the scene is motivated by a factor other than the text. The two illustrations in B10, 'The offering from elephant and monkey' and 'Taming the elephant' are not described in the *Paṭhamasambodhi*. In the text of the fourteen-chapter version, there is just a reference to the name of the place (Pālileyyaka forest) where the elephant and monkey give their offerings; and another reference to the name of the elephant (Nāḷāgiri) that was sent to attack the Buddha. It is therefore likely that these episodes were known to the compiler of the *Paṭhamasambodhi*. Since these episodes are not fully described in the Pāli

canon, it is possible that they were not regarded as critical components of
the life of the Buddha in the textual tradition. However, they have been very
popular subjects for Buddhist art. One reason for their popularity is that
they are connected to the eight great miracles (*pāṭihāriya*), or eight great
places for pilgrimage.[14] In the *Mahāparinibbānasuttanta*, which relates
the events of the Buddha's last days, the Buddha himself recommended
to his followers four places of pilgrimage, that is to say, the sites of his
birth, awakening, first sermon and *parinibbāna*. They are considered to be
Lumbinī, Bodhgaya, Sarnath and Kusinagar/Kusinārā respectively. Later,
the places where the Buddha left for Tāvatiṃsa Heaven (Saheth-Maheth/
Sāvatthī) and where the Buddha descended from it (Sankissa/Sankassa)
are added. All these places are illustrated in the Bodleian manuscript
and what happened there is fully described in the *Paṭhamasambodhi*.
The remaining two places are usually considered to be where the two
events shown on B10 occurred, and in the context of pilgrimage they are
identified as Vaishali/Vesālī and Rajgir/Rājagaha respectively. Although
the later version of the *Paṭhamasambodhi* supplies the accounts of these
two events from passages found in Pāli commentaries and other sources,[15]
murals and other artistic expressions frequently precede scenes described
in this text rather than the other way around.

As we will examine later, in many illustrations in the Bodleian
manuscript, the Buddha is depicted in a posture showing that he is
performing miracles. This shows that the selection of the scene is related
to the Buddha's miracles and therefore also denotes places of pilgrimage.

Seeing the Buddha

When the Bodhisatta reached awakening and became the Buddha, he
exclaimed that there would be no more rebirth for him, and thus the prediction
that he made at his birth was fulfilled. He recollected his countless previous
births and his life as Prince Siddhattha, saying, 'Painful is birth again and
again.' Although this may sound pessimistic to contemporary readers, he
was not saying that his many lives were painful and meaningless. Only
through purposeful lives as the Bodhisatta, who fulfilled the qualities
known as the ten 'perfections', could he become the Buddha and lead many
other people to escape the cycle of rebirth and death. After his awakening,
the Buddha spent forty-five years travelling and teaching, and then he
closed his life and entered into *parinibbāna* at Kusinārā, calmly meditating
in front of his many disciples. This was his final life and he will never
return to this world.

However, before he passed away, the Buddha told his closest disciple
Ānanda that the *dhamma* (teaching) and the *vinaya* (discipline) that he
taught would become the teacher for those left behind. On another occasion

the Buddha said to the monks, 'He who sees the *dhamma*, sees me.'[16] These are words of encouragement for those who do not live in his presence. No matter how distant in time and space they are, the Buddhists who follow the *dhamma* feel that they are able to see the master.

Thus, for Buddhists, the Buddha is not seen as a teacher who died long ago. Bearing the Blessed One and his qualities in mind, or recollecting the Buddha through recitation of his *dhamma* became an essential practice for them. And, for that purpose, a particular passage that enumerates nine attributes (or epithets) of the Buddha has been commonly recited in Southeast Asian Buddhist countries. The passage is called *Buddhānussati* (Recollection of the Buddha) or *Buddhaguṇa* (Qualities of the Buddha), and an expanded version of this, on a grand scale – the *Mahābuddhaguṇa* – is the core text of the Bodleian manuscript.

The Bodleian manuscript illustrates beautifully various images of the Buddha that appeared in the minds of the people in the kingdom of Siam. And those who see the images of the Buddha in the manuscript will see that the Buddha's teaching (*dhamma*) has been well established in present-day Thailand.

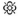

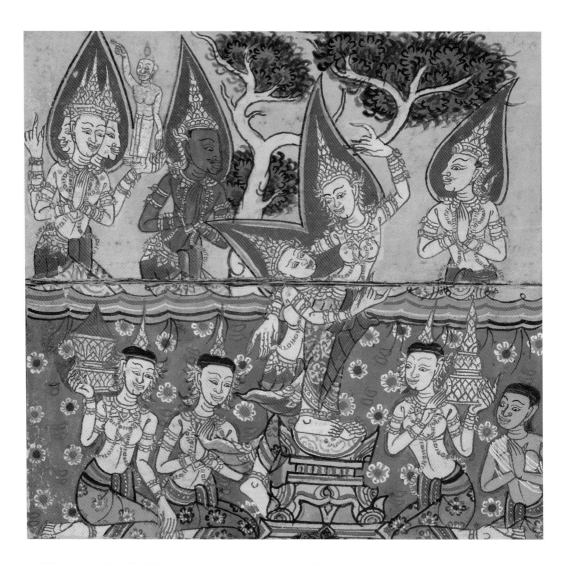

3.4 The birth of the Bodhisatta. In the centre Mahāmāyā is standing on a stool under a tree. She extends her left arm upwards, although temple murals usually depict her holding the tree with her right hand. A female attendant, probably Mahāpajāpatī, is supporting her. She and Mahāmāyā have nimbuses behind their heads, as do the deities behind the curtain. These deities are Sakka, who is always depicted as green, Brahmā, who has four faces and arms, and another unspecific deity. The deities and some of the attendants join their palms, making an *añjali*, the traditional gesture of respect. The Bodhisatta stands with his right arm pointing up and ahead on one of Brahmā's left palms. His posture is the same as the standing golden statue of the infant Bodhisatta called *pang prasut* ('[the image of the Buddha] in the time of the birth') in Thai, which is used during the Visākhā Pūjā (the festival celebrating the Buddha's birthday) in many countries. Oxford, Bodleian Library, MS. Pali a. 27 (R), A18 left (fol. 18)

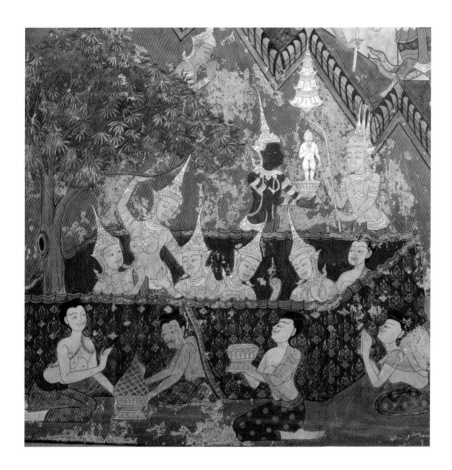

3.5 The birth of the Bodhisatta, Wat Ratchasittharam, Thonburi. In this similar scene from a temple mural, Mahāmāyā holds the tree with her right hand inside a screened-off area, while the golden infant Bodhisatta is held by Sakka under a parasol held by Brahmā. Photograph by Toshiya Unebe

The birth of the Bodhisatta

In the Tusita Heaven, where the Bodhisatta had transmigrated after his life as the prince of Sivi, Vessantara, he looked for the appropriate time, place, family and so on for his final rebirth in this world. He then descended into the womb of his mother, Queen Mahāmāyā, the wife of King Suddhodana of Kapilavatthu in Jambudīpa. Ten months later, according to custom, the queen departed for Devadaha to give birth to a baby at her parents' home. Between the two cities, there was a beautiful grove of flowering *sāla* trees called Lumbinī. When she stopped by the grove, a branch of a *sāla* tree bent down within her reach. Standing and holding the branch, she painlessly delivered a baby. The baby emerged from his mother's side like a preacher coming down from his preaching platform; he took seven steps to the north and proclaimed that he was supreme and would live his final life. It was on the full-moon day of the month of Visākha (May–June) that the Bodhisatta was born. Seven days after the birth, the Bodhisatta's mother, Queen Mahāmāyā, passed away and was reborn in the Tusita Heaven. Her sister Mahāpajāpatī became foster mother and looked after the baby prince, who was named Siddhattha, 'one who has accomplished his aim'.

3.6 The four signs. The Bodhisatta is depicted as a fully adorned figure with a moustache, sitting in a chariot drawn by two horses. His right hand forms a gesture by touching the tip of the thumb to the middle of other straight fingers. The charioteer on the white horse has a red nimbus and looks quite different from the one in the next scene. In the Bodleian manuscript, the faces, moustaches, body colours, clothes and ornaments of the Bodhisatta and the charioteer are not the same in every opening, in contrast to the monotonous representation of the Bodhisatta/Buddha after the hair-cutting scene (Fig. 3.11). The artist must have enjoyed the rare freedom allowed to him, and the inconsistency may be a device to avoid a fixed image of the Bodhisatta. A dead man lies on the ground; behind him sits a sick man. Behind the horse stand an old man holding a white bag, and a mendicant in an ochre robe carrying a bowl in a shoulder bag and fan. Oxford, Bodleian Library, MS. Pali a. 27 (R), A18 right (fol. 18)

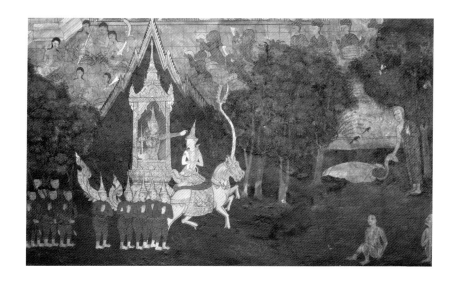

3.7 The four signs, Wat Thong Thammachat, Thonburi. The same scene in temple murals often has the Bodhisatta pointing forward with the index finger, as in this example. The scene then becomes almost identical to the standard representation of King Nemi on a chariot (Fig. 2.16). Photograph by Toshiya Unebe

The four signs

At the naming ceremony of the Bodhisatta, Prince Siddhattha, brahmins predicted that he would become either a Buddha or a great universal monarch (*cakkavattin*). Because of this prediction, the king kept the prince away from the four signs (an old person, a sick person, a corpse and a mendicant) that were predicted to lead him to renounce the world. King Suddhodana brought up the prince in the three palaces fit for the three seasons, which were filled with female attendants, musicians and dancers. At sixteen, the prince married a local princess, Yasodharā (Bimbādevī), who would later bear his only son, Rāhula. One day, when he went out for a ride in his chariot to a pleasure park, deities revealed an old man to him to foil the king's wish to shelter his son. As he was confused by the sight, he pulled back and shut himself up in the palace. Successively, he saw a sick man and a dead man in the same way. Finally, he saw a mendicant whose robes were neat and tidy. Impressed and encouraged by this sight, he went to the park and received the deities' blessing. Through this experience, the Bodhisatta recognized he was also subject to birth, old age, sickness and death.

Leaving his family

Just then, Princess Yasodharā gave a birth to a baby boy. On hearing this news, Prince Siddhattha said, 'Rāhula has been born. A bond has been born.' When he was informed of this, King Suddhodana named his grandson Rāhula. His name, derived from the eclipse Rāhu, meant 'family bond' – this was auspicious to the king but an impediment for the prince. That night, when the Bodhisatta woke up, lamps of scented oil illuminated his sleeping

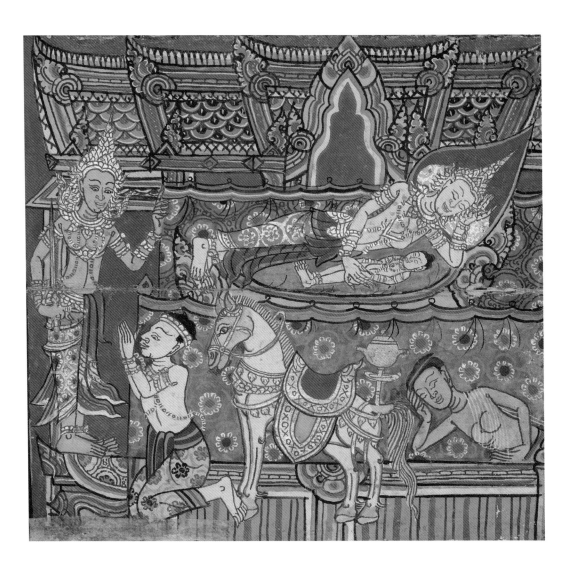

3.8 Leaving his family. The Bodhisatta stands at the entrance to the bedroom partitioned by curtains. His wife Yasodharā (Bimbā) and his baby son Rāhula are sleeping on a bed. A female servant is sleeping in front of the curtain, next to a lamp of scented oil. The Bodhisatta carries his drawn sword, the same sword with which he will cut off his hair in a later scene. His white horse Kaṇṭhaka is harnessed and his horseman Channa is kneeling and saluting. The roof of the palace is depicted behind. Oxford, Bodleian Library, MS. Pali a. 27 (R), A19 right (fol. 19)

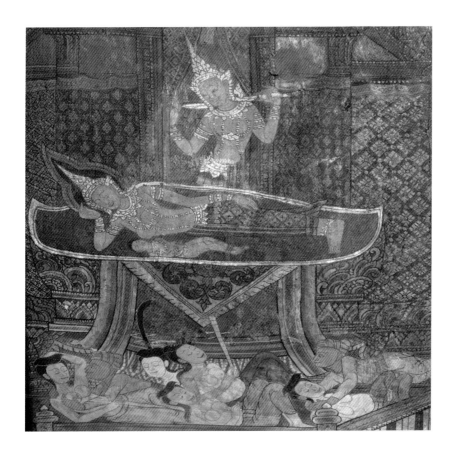

3.9 Leaving his family, Wat Ratchasittharam, Thonburi.
As in this example at Wat Ratchasittharam, temple murals often depict many women (and occasionally men as well) sleeping half-naked near to Yasodharā. With his sword in one hand, the Bodhisatta raises his other hand to shoulder height with the palm facing towards his wife and son in a farewell gesture that is reminiscent of the *abhaya* (non-fear) *mudrā*. Photograph by Toshiya Unebe

female attendants, who were sprawled in slovenly attitudes. Considering the palace to be like a cemetery filled with corpses, he resolved to renounce life in the palace. He ordered his horseman Channa to ready his favourite horse Kaṇṭhaka for his departure, and then went into his wife's chamber to gaze at his son for the last time before setting out on his quest. Although he was tempted to hold and embrace his wife and baby, he resisted for fear of waking them up. Hoping to see them again when he became a Buddha, he quietly left the chamber for the stable.

The great departure

The prince approached Kaṇṭhaka and instructed him to take him away at night so that he could become the Buddha in future to save all beings. As he vaulted up on Kaṇṭhaka's back, deities exerted their power to muffle the sounds of his neighing and hooves so that no one in the palace would become aware of his departure. Although the heavy doors of the city gate were closed tight on the king's order, a deity that lived at the gate opened them. When the prince was about to leave the city, Māra, the 'evil one' (Pāpimant) appeared and attempted to make the prince turn back, tempting him with the glory of

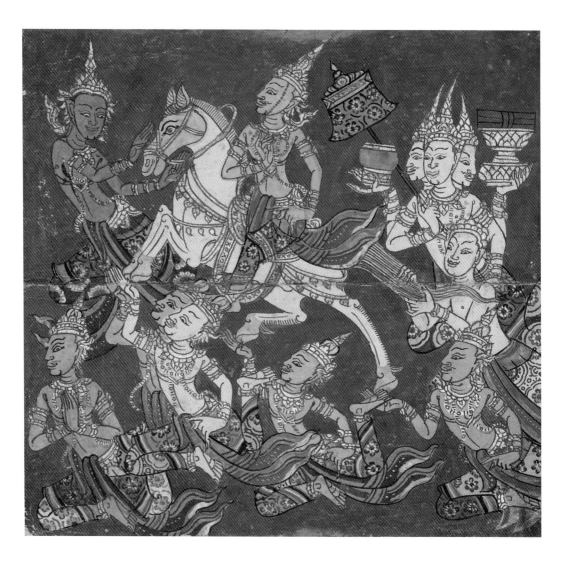

3.10 The great departure. The Bodhisatta is leaving the palace on his horse Kaṇṭhaka. He is flying since four deities support the horse's hooves. In the Thai artistic tradition the Bodhisatta usually carries a sword with one hand in this scene, while the other hand forms the same gesture as in the four signs scene (See Fig. 3.6). However, here his sword is missing. Sakka on the left side is gently keeping the horse's mouth closed to stop him from neighing. On the right, Brahmā holds a parasol and carries a bowl and a set of monastic robes. Channa holds onto the horse's tail. Another saluting figure in front of them is probably the guardian deity of the main gate of the palace who opens the gate for the Bodhisatta. Oxford, Bodleian Library, MS. Pali a. 27 (R), A19 left (fol. 19)

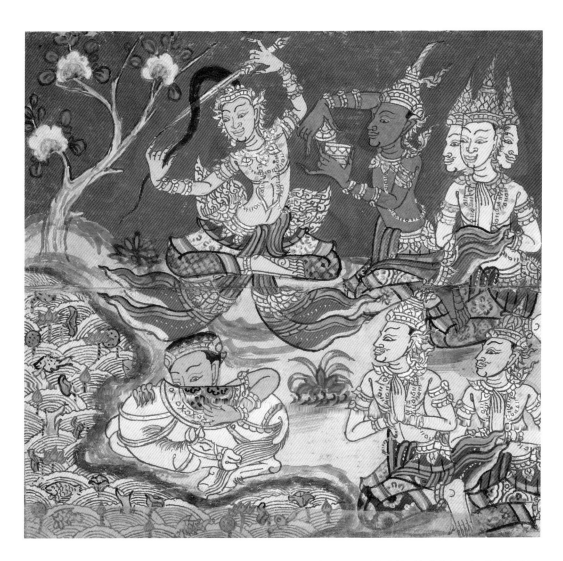

3.11 Cutting off the hair. The Bodhisatta cuts off his hair with a sword held in his left hand, while Sakka opens the casket to receive the hair. In this scene Brahmā is usually holding a bowl and a set of robes to give to the Bodhisatta (as in Fig. 3.13). However, since he was holding them already in the previous picture, here he is just kneeling and saluting the Bodhisatta. Two other male figures are kneeling and saluting in the foreground. Since murals occasionally depict many deities behind Brahmā (as in Fig. 3.13), they are likely to be his attendants. On the left-hand side, the horse Kaṇṭhaka lies dead on the bank of the Anomā River, which is full of lotus flowers. The horse is embraced by the grieving horseman Channa, half-hidden behind him. Oxford, Bodleian Library, MS. Pali a. 27 (R), A24 left (fol. 24)

3.12 The great departure, Wat Thong Thammachat, Thonburi. In temple murals such as this one, Māra is often depicted trying to stop the Bodhisatta's departure. Māra, sometimes known as Death, has dominion over the realm of rebirth and so does not wish the Bodhisatta to become a Buddha and help beings escape his influence. Photograph by Toshiya Unebe

becoming a universal monarch of four continents. But the Bodhisatta rejected these enticements and left the city. Māra, failing to change the Bodhisatta's mind, followed him like a shadow, and from then onwards Māra consistently tried to catch him off his guard to thwart his career. It was at the age of twenty-nine that the Bodhisatta left his palace for the quest for good.

Cutting off the hair

In a single night the Bodhisatta passed through three kingdoms and came to the great river Anomā. He crossed the river and stopped at the bank. Thinking that his hair was not suitable for a recluse (*samaṇa*), he cut off the lock of hair (*cūḷā*) with his sword. He threw it into the air, saying that if he was to become a Buddha, it should remain in the air. As the lock of hair stopped high in the air, Sakka received it and placed it in a shrine called the Cūḷāmaṇi-cetiya in the Tāvatiṃsa Heaven. Brahmā (named Ghaṭīkāra, the Great Brahmā) received the prince's luxurious garment, which the Bodhisatta also considered not suited to a recluse, and he gave to the Bodhisatta monks' requisites such as the threefold robes. Then, the Bodhisatta ordered his horseman Channa and the horse to return to the palace. Kaṇṭhaka the horse was so distressed at parting from the Bodhisatta that he died of grief on the spot.

The lesson of the three strings

In a short period the Bodhisatta mastered meditational practices that were taught by the then-renowned religious masters, Āḷāra Kālāma and

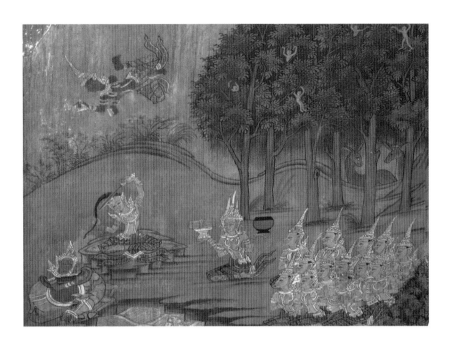

3.13 Cutting off the hair, Wat Ratchasittharam, Thonburi. In temple murals in Thonburi, in accordance with the description of this incident in the *Paṭhamasambodhi*, the Bodhisatta is usually holding his hair in his right hand and cutting it with his left, although depictions found in other areas show the reverse, in accordance with other Pāli texts. As is standard in temple murals in this area, here Sakka is shown descending from the sky to collect the hair relic, while Brahmā offers monastic robes and a bowl to the Bodhisatta. Photograph by Toshiya Unebe

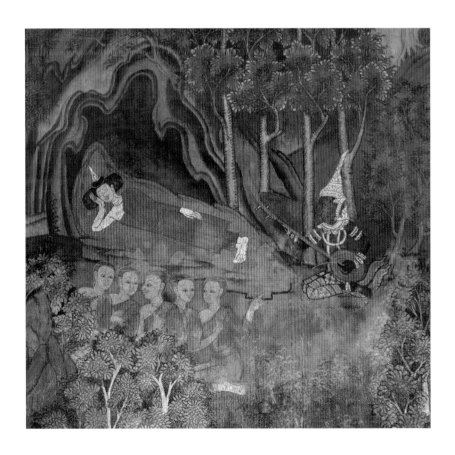

3.14 The lesson of the three strings, Wat Ratchasittharam, Thonburi. Instead of the luxurious bed depicted in the Bodleian manuscript, temple murals usually show a bed made of a rock in front of a rocky cave, as shown here. The Bodhisatta's five companion ascetics are depicted in the foreground. Photograph by Toshiya Unebe

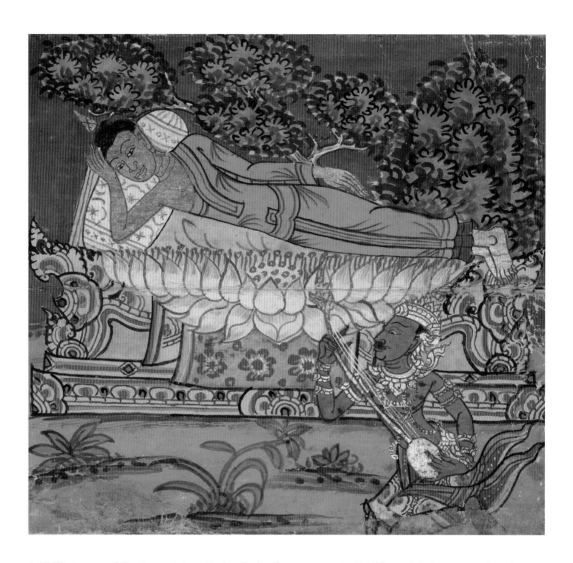

3.15 The lesson of the three strings. In the shade of some trees, the Bodhisatta is lying over a gigantic white lotus flower, laid on a luxurious bed with a bolster. He is lying on his right side – the same posture as that which symbolizes the *parinibbāna*. Hereafter he is depicted as having a gilded flame finial, a golden body and a lotus flower underneath him, even though he has not yet really become an 'Awakened One'. Sakka, kneeling at his feet, is playing the three-stringed instrument. As in this picture, Sakka is usually depicted as playing the instrument with his left hand. Although this scene is very popular in Southeast Asian countries, neither Pāli canonical literature nor other extant Buddhist texts describe this episode, apart from the *Paṭhamasambodhi*. Oxford, Bodleian Library, MS. Pali a. 27 (R), A24 right (fol. 24)

Uddaka Rāmaputta. However, he was not satisfied with their teachings
and practices, and he proceeded to Uruvelā on the banks of the Nerañjarā
River. Five ascetics (*pañcavaggiya*), Koṇḍañña and others, followed
him. There the Bodhisatta practised many religious austerities, including
extreme fasting for six years. When he was going to starve to death, Sakka
intervened and played his three-stringed instrument. A slack string gave an
unpleasant sound and a taut string just snapped. When the middle string
gave beautiful sounds the Bodhisatta understood the Middle Way between
the extremes of pleasure and self-mortification.[17] He gave up the austerities
and started to seek alms for food. Considering the Bodhisatta to have given
up his austerities, the five ascetics left him and went to Isipatana, Bārāṇasī.

The offering of milk-rice

In a village near Uruvelā there was a woman named Sujātā. She made a
vow to a nearby nigrodha (banyan) tree that she would offer a meal to the
tree spirit if she gave birth to a son. On a full-moon day of the Visākhā
month after her wish was fulfilled, she planned to give an offering to the
tree god as she had promised. While she was making milk-rice, deities
covertly helped her. As many wonders occurred, she sent her maid,

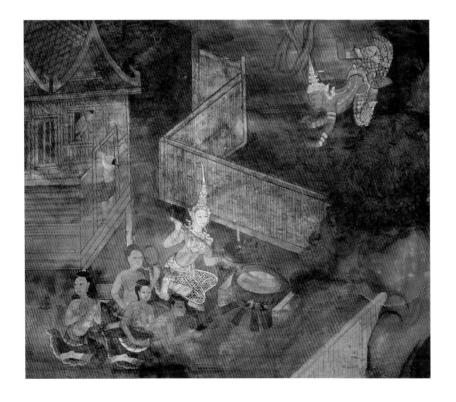

**3.16 Making milk-rice, Wat
Thong Thammachat, Thonburi.**
As at Wat Thong Thammachat,
temple murals occasionally depict
Sujātā making the milk-rice
with her servants too. Sakka
approaches from the sky to assist
her. In addition to this, the scene
of the miracle of the golden plate
(Fig. 3.2), which follows the
offering scene (Fig. 3.17), is also
often depicted. Photograph by
Toshiya Unebe

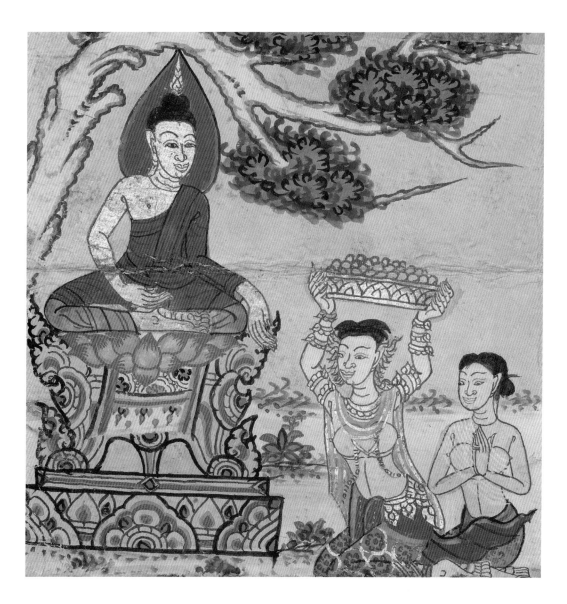

3.17 The offering of milk-rice. The Bodhisatta is seated cross-legged on a throne under a tree. He extends his left hand gracefully to receive the offering of milk-rice. (This gesture is similar to the shape of the *varada* (boon-giving) *mudrā*.) A beautifully adorned village woman, Sujātā, is kneeling and holding over her head a large golden tray covered with balls of milk-rice. In the succeeding scene in murals (e.g. Fig. 3.2), the food vessel floated on the river is usually a shallow golden plate or dish (*pāti*) but not a large tray. Sometimes another kind of offering vessel with a pointed lid or cover is depicted. Sujātā's attendant, Puṇṇā, in a plain costume, also kneels and pays homage. Oxford, Bodleian Library, MS. Pali a. 27 (R), A25 left (fol. 25)

Puṇṇā, to go to inspect the nigrodha tree. Finding the Bodhisatta sitting facing east under the nigrodha tree, Puṇṇā thought that he was the tree spirit. Hearing this, Sujātā carried the milk-rice in a golden vessel with a golden plate as its lid, and offered it to the Bodhisatta. He took the vessel and went to the Nerañjarā River. After bathing in the river, he divided the milk-rice into forty-nine balls and ate them. Those balls would sustain the Bodhisatta for seven weeks after his enlightenment. After eating the milk-rice balls, the Bodhisatta floated the golden plate in the stream, and it went upstream before sinking down to the underwater palace of the serpent king named Kāla.

The victory over Māra

Later on the same day, the Bodhisatta walked to the bodhi tree, carrying eight bundles of *kusa* grass which had been offered by a grass cutter named Sotthiya. When the Bodhisatta scattered the bundles on the east side of the bodhi tree, they became the *vajirāsana* (diamond throne). Facing east and sitting cross-legged with his back against the bodhi tree, the Bodhisatta vowed to himself that he would never stir from the seat until he attained perfect awakening. At that time, Māra, grasping various weapons with his thousand arms and mounted on a fearful elephant called Girimekhala, appeared along with his army to hinder the Bodhisatta. Although they poured down a rain of blades and other weapons, it was turned into a shower of celestial flowers upon reaching the Bodhisatta. Since all of their weapons were useless, Māra verbally attacked the Bodhisatta, claiming that nobody could prove his fulfilment of the ten perfections in his previous lives. Against this, the Bodhisatta touched the ground to call the earth goddess Vasundharā as a witness to his perfection of generosity executed in his previous life as the Prince Vessantara. As she testified, she wrung out her hair and created a massive flood of water that washed away the forces of Māra. It was the accumulation of water poured on the earth each time the Bodhisatta gave a gift, the vast extent of which only the goddess of the earth had been able to witness. Thus, the Bodhisatta won a victory over Māra early in the evening. And in his meditation over that night, he successively obtained the remembrance of his past lives, clairvoyance regarding the past and future, and true knowledge of dependent origination (*paṭiccasamuppāda*). It was at the age of thirty-five, in the sixth year after his departure from Kapilavatthu, that he finally acquired omniscience (*sabbaññutāñāṇa*) and became the Buddha, the Awakened One.

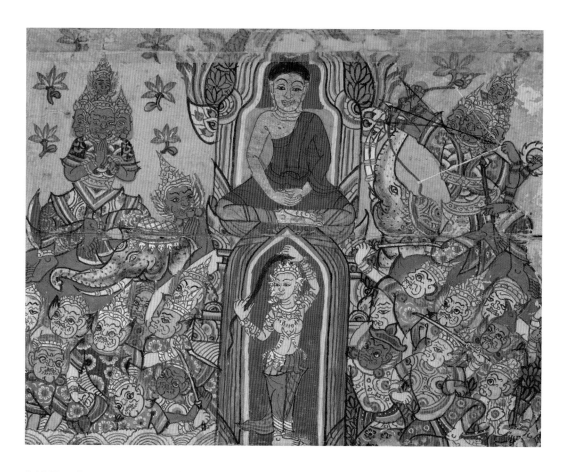

3.18 The victory over Māra. The Bodhisatta is sitting on a throne which here looks as if it has amalgamated with the bodhi tree above. His hands are laid in his lap, palms upward, in the gesture of meditation (known in India as the *dhyāna-mudrā*). The victory over Māra is traditionally symbolized with the gesture of touching the earth to summon the earth goddess to witness (known in India as the *bhūmisparśa-mudrā*). However, in murals in Thonburi temples, as in this manuscript, the Buddha(-to-be) in this scene is usually depicted with hands folded in meditation. The gesture of touching the earth appears in a later scene (Fig. 3.32). On the right, Māra, represented with multiple green faces and riding his elephant Girimekhala, is attacking the Bodhisatta with a bow and a three-pronged arrow, a wheel with teeth, and an army of demons with swords. In this picture, the successive events are shown against a single background. Against Māra's attack, the earth goddess Vasundharā (Phra Mae Thorani (Dharaṇī) in Thai), standing in front of the Bodhisatta, wrings out streams of water from her hair. Then, on the left, the army of demons is swept away by the water; the arrows shot against the Bodhisatta become a shower of flowers; Māra is subdued and turns to pay homage. This key image is wider than the other pictures in the manuscript. Oxford, Bodleian Library, MS. Pali a. 27 (R), A25 right (fol. 25)

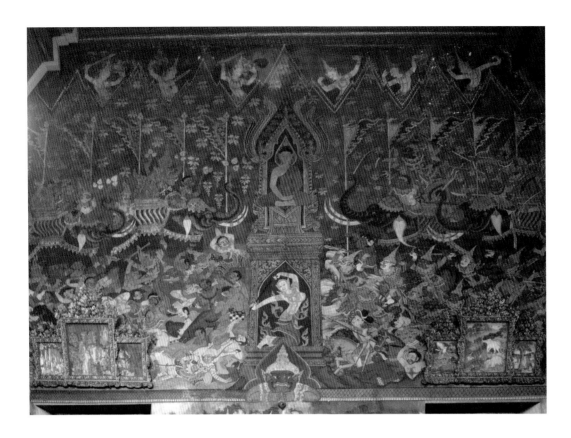

3.19 The victory over Māra, Wat Dusidaram, Thonburi. In temple *uposatha* halls, a huge picture of this scene is depicted over the whole wall above the entrance, thereby facing the main Buddha statue in the hall. In the picture, the central figure of this episode is Vasundharā rather than the Buddha. She is one of the most popular deities in Southeast Asian Buddhism. Māra's army often includes troops of foreign (Western, Chinese, Mon and so on) countries in murals. Photograph by Toshiya Unebe

3.20 The first sermon, Wat Thong Thammachat, Thonburi. Unlike the manuscript's depiction of animals, Thai temple murals usually depict only the five ascetics and deities as the audience, as in this image. As in the manuscript, and as is standard for temple murals of this region, the Buddha is seated in the posture of meditation. Photograph by Toshiya Unebe

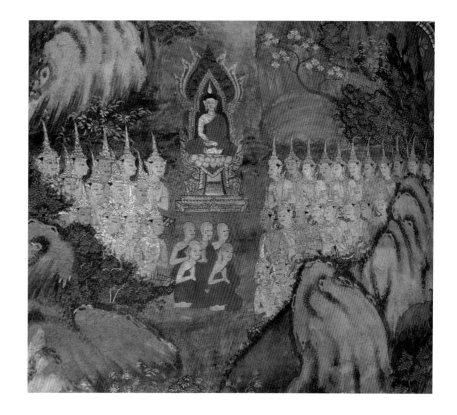

The first sermon

After his enlightenment, the Buddha spent seven weeks in the joy of liberation, moving to a different place each week. Although he had hesitated to teach the profound *dhamma* to others for fear that they would not be able to understand it, he resolved to do so at Brahmā's entreaty. He initially reflected that he should teach the *dhamma* to his previous teachers, Āḷāra Kālāma and Uddaka Rāmaputta. However, he realized that they had already passed away. He then went to the deer park (Migadāya) at Isipatana to see the five ascetics – Kondañña and the others – who had once followed him in the practice of religious austerities. Seeing the Buddha approaching, the five ascetics agreed amongst themselves that they should ignore him, since they considered him to have lapsed. However, as the Blessed One came near, they could not keep their agreement, and they rose to greet him. At the deer park, in front of the five ascetics who became the first monks and many deities from the Brahmā realm, the Buddha turned the wheel of the *dhamma* for the first time. With this first sermon Kondañña attained the Fruit of Sotāpatti (entering upon the stream to the goal of Arahatship). At the same place the Buddha stayed for the first rainy season retreat.

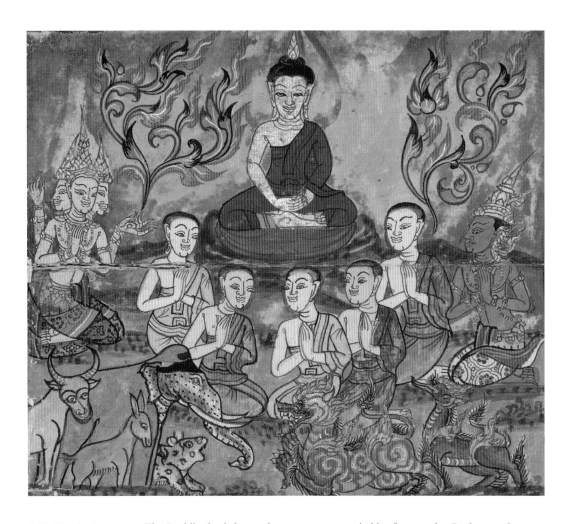

3.21 The first sermon. The Buddha is sitting at the centre, surrounded by five monks, Brahmā and Sakka. The nimbus behind him and the lotus underneath him are missing, probably due to careless repainting, although traces remain. In Thailand, the seated Buddha image with the posture of *paṭhamadesanā* (the first sermon) often raises a single hand in a gesture of exposition (known as *vitarka-mudrā* in India) formed by connecting the thumb and forefinger in a circle. However, in the manuscript the Buddha folds his hands on his lap in contemplation, which is known as *dhyāna-mudrā*. In the foreground stand a buffalo, donkey (deer?), elephant and leopard, along with mythical lions (*rājasīha* and probably *nāgasīha*). Since the first sermon takes place in Migadāya, meaning deer/animal park, deer are often depicted (as symbolic of the location) in other artistic traditions, although Pāli texts do not describe deer or other animals amongst the audience of the first sermon. Oxford, Bodleian Library, MS. Pali a. 27 (R), B09 left (fol. 48)

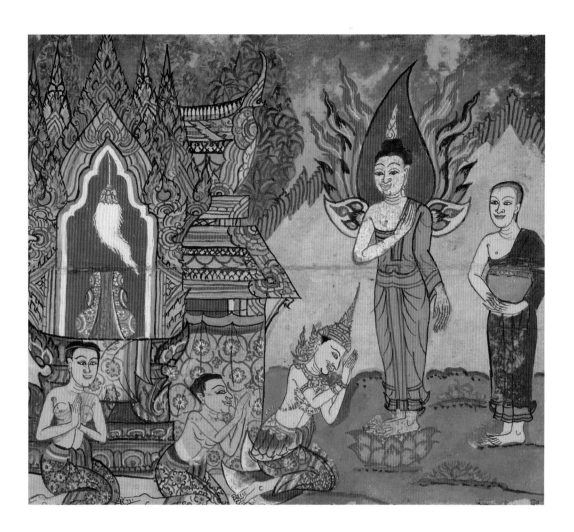

3.22 The return to Kapilavatthu. The Buddha stands with Udāyin, who carries a big bowl of food brought from Kapilavatthu. The Buddha is showing the back of his right hand in front of his chest. In Thai art, this standing posture is understood as that of perfoming miracles (*iddhi-pāṭihāriya*). The red and blue flames symbolize the twin miracle of fire and water (Fig. 3.30). It is difficult to identify the male and female figures behind the king. They may be the Buddha's wife Yasodharā and his son Rāhula, but they would usually be depicted as well-adorned figures. Judging from their plain look, here they could be just two servants. Alternatively the female with short hair could be the Buddha's step-mother Mahāpajāpatī, who would become the first nun, and the male Rāhula, who would soon be ordained. Oxford, Bodleian Library, MS. Pali a. 27 (R), B09 right (fol. 48)

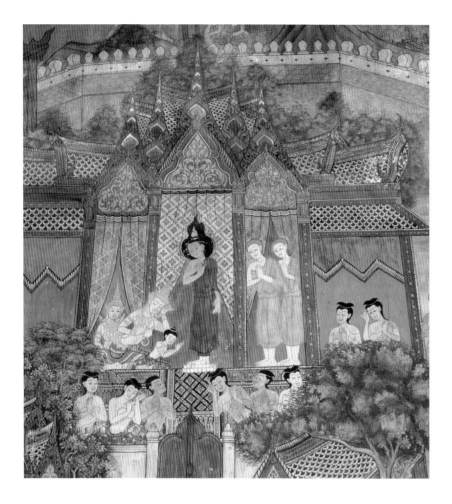

3.23 The return to Kapilavatthu, Wat Ratchasittharam, Thonburi. In this image the well-adorned figures of Yasodharā and Rāhula greet the Buddha, while two monks stand behind him. Photograph by Toshiya Unebe

The return to Kapilavatthu

After the first rainy season retreat at Isipatana, the Blessed One went back and stayed at Uruvelā for a while, and then went to Rājagaha, the capital of the kingdom of Magadha, accompanied by an increasing number of disciples, by this time a thousand in number. King Bimbisāra took refuge in the Buddha's teaching and donated the 'Bamboo Grove', Veḷuvana, to him as the first monastery. While the Blessed One was staying there, his father, King Suddhodana, sent many messengers to invite him to Kapilavatthu, but in vain. Finally, a childhood friend of the Buddha, Udāyin (Kāḷudāyin), was sent to bring him. Although he himself joined the *saṅgha* (community) as a monk (*bhikkhu*), he praised the natural beauty of their homeland, and convinced the Blessed One to travel to Kapilavatthu. During the Buddha's journey homewards, Kāḷudāyin flew daily to the king to report on the progress of their journey, and flew back to the Lord with a bowl full of food from the palace. On the Blessed One's arrival at Kapilavatthu, the Sakyas looked down on him as a mere younger member of their proud family.

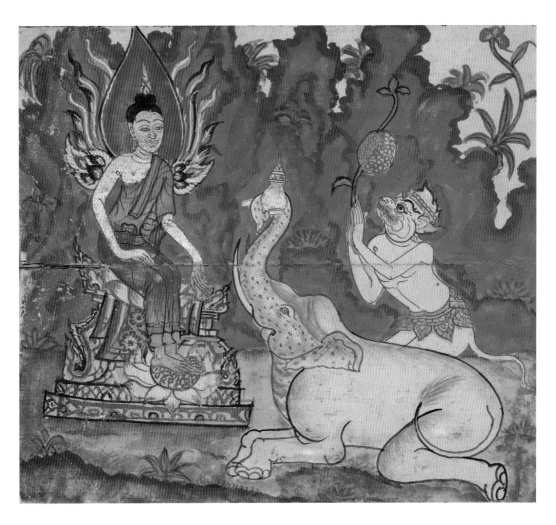

3.24 The offering from elephant and monkey. The Buddha is sitting on a throne in the manner in which one sits on a chair; in murals he usually sits on a rock. He stretches his left arm with the palm upward to receive offerings from the two animals, while his right hand is placed on his lap. This posture, called *pang palelai* in Thai, symbolizes the acceptance of the offerings from animals in the Pālileyya forest. In present-day Thailand, statues depicting this event are very popular and are worshipped by those born on Wednesday evenings (Fig. 1.4). Here the Buddha has a red nimbus and flames, symbolizing miracles. In front of the Buddha, an elephant is kneeling and holding a water-pot with his trunk. To the right of the elephant, a monkey adorned with a crown and a belt is kneeling, offering a honeycomb still attached to the branch. Oxford, Bodleian Library, MS. Pali a. 27 (R), B10 left (fol. 49)

Therefore the Buddha displayed miracles to them. After the miracles, the Blessed One's father, King Suddhodana, was the first to pay homage to him, and the rest of the Sakyas followed suit. When the Buddha's son Prince Rāhula also became a monk, the king deplored the loss of the heir to the throne, and asked the Blessed One not to ordain anybody without their parents' consent. The Buddha agreed to his request.

The offering from elephant and monkey

A trifling quarrel arose between elders of the monastery of Kosambī. Soon the quarrel extended from them to their disciples, to other monks and nuns, and even to the laymen who were supporting the *saṅgha*. It became a big quarrel so that the Buddha himself had to come to Kosambī to calm the situation. The Buddha told them to stop the fighting. In spite of the Blessed One's instructions, repeated three times, they did not listen to him, and the Buddha finally exclaimed that the *saṅgha* was rent asunder. He despaired and left Kosambī for a desolate forest named Pālileyyaka[18] and stayed there during one rainy season. In the forest, an elephant, also named Pālileyyaka, served and protected him. He took a water-pot in his trunk and procured drinking water for the Buddha. A monkey saw the elephant serving the

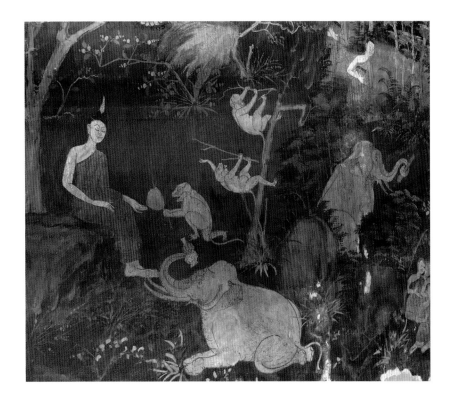

3.25 The offering from elephant and monkey, Wat Pratusan, Suphanburi. The *Paṭhamasambodhi* (fourteen-chapter version) does not narrate this episode in full, but only refers to the name Pālileyya as the place where the Buddha stayed in the rainy season of the tenth year of his teaching career. In accordance with this, Thonburi temple murals usually do not include this scene. This mural at Wat Pratusan in Suphanburi Province does depict the episode, even portraying the overjoyed monkey's accidental death. Photograph by Toshiya Unebe

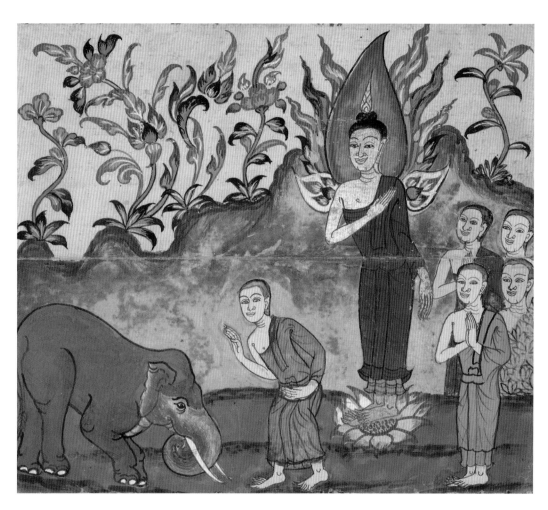

3.26 Taming the elephant. Here the Buddha makes the gesture of performing a miracle as he tames the maddened elephant through his supernormal powers. On the Buddha's right, Ānanda is trying to stop the elephant. In front of him the elephant Nāḷāgiri is about to kneel. On the Buddha's left, four monks are depicted; the front one making an *añjali* could be the chief disciple, Sāriputta, who first tries to stop the elephant. Rocky mountainside is depicted at the back, probably representing Vulture Peak (Gijjhakūṭa), located near Rājagaha, which is the place associated with this miracle. Oxford, Bodleian Library, MS. Pali a. 27 (R), B10 right (fol. 49)

Blessed One and he too wanted to do something for him. So he collected wild honey and offered it to the Buddha. It was in the tenth rainy season retreat that the Buddha thus enjoyed a solitary life in the forest.

Taming the elephant

The Buddha's ambitious cousin Devadatta wanted to take over the *saṅgha* himself, and harboured evil thoughts against the Blessed One. At that time there was a fierce elephant named Nāḷāgiri at Rājagaha. Devadatta made a mahout incite the elephant to attack the Lord as he was coming down the road to Rājagaha. Although the Buddha forbade his disciples from trying to protect him by stopping the elephant's charge, Ānanda stepped forward. While the Buddha pulled Ānanda back with his supernatural power, Nāḷāgiri rushed towards a child left behind at the scene. However, when the Blessed One with a kind voice called the elephant to come to him, the raging elephant was pacified and lowered his trunk. The onlookers admired

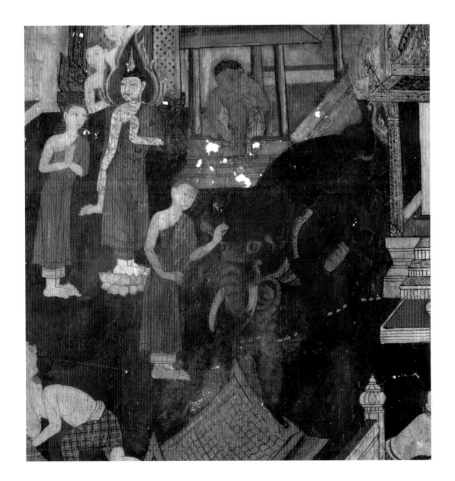

3.27 Taming the elephant, Buddhaisawan Chapel, Bangkok. Like the Pālileyya scene, Thonburi temple murals do not depict this scene, in accordance with the *Paṭhamasambodhi*. However, the mural of the Buddhaisawan Chapel, located in the National Museum, Bangkok, includes the Nāḷāgiri episode. Although the main characters and their gestures in both pictures are the same, the locations are different. In the case of the Buddhaisawan mural, the location is in the city of Rājagaha and many onlookers are depicted. Photograph by Toshiya Unebe, by permission of the Fine Arts Department, National Museum, Bangkok, Thailand

this and Nāḷāgiri, who was given precious ornaments by them, came to be called Dhanapālaka (Guardian of Fortune) after that. It is said that Ajātasattu usurped his father Bimbisāra's throne on account of Devadatta's plotting in the thirty-seventh year after the Buddha's enlightenment, and it is considered that this attack took place shortly after Bimbisāra's death.

The offering of a mango

Although the Buddha prohibited his disciples from displaying supernatural powers, one day he declared that he would display miracles under Gaṇḍa's mango tree in Sāvatthī, the capital of the kingdom of Kosala, in order to defeat the other religious leaders, who bragged that they had great supernatural powers. On hearing this, they had all the mango trees in and around Sāvatthī cut down. On the morning that the miracle was due to be performed, the Blessed One went to Sāvatthī to collect alms. One of King Pasenadi of Kosala's gardeners, Gaṇḍa, offered him a big mango fruit that had miraculously ripened out of season. The Buddha squeezed the juice of the mango fruit and drank it. He then had Gaṇḍa plant the mango stone. It instantly grew into a big tree with flowers blooming and fruits ripening. The tree came to be known as Gaṇḍa's mango tree.

3.28 Statue of accepting a mango, Wat Phra Pathom Chedi, Nakhon Pathom.
Although this episode is known to Thai people, this particular scene does not seem to be represented in murals. However, the Buddha in the posture of accepting the mango fruit is relatively popular as a statue, as in this example. This is one of the statues in various postures (*pang*) located on the main circumambulatory of Phra Pathom Chedi, the famous 'first' *cetiya* (shrine) in Thailand (see n. 6).

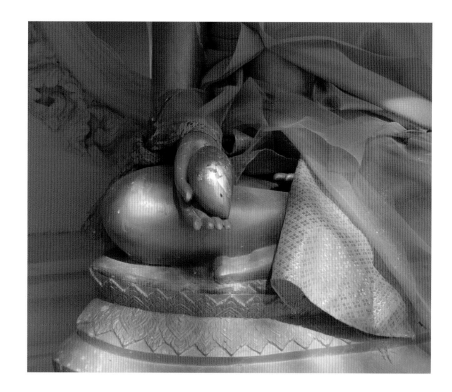

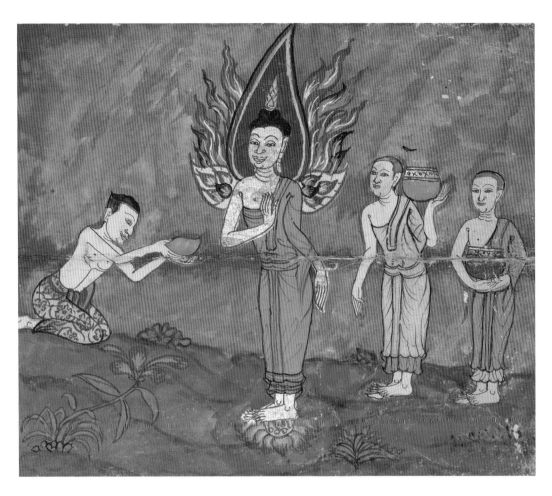

3.29 The offering of a mango. On the left, Gaṇḍa is offering a ripe mango, and the Buddha once again shows the gesture of performing a miracle, signifying that the miracle of Gaṇḍa's mango tree follows. Since this event takes place on the almsround in Sāvatthī, two monks are carrying begging bowls, one on his shoulder and the other in his hands. Oxford, Bodleian Library, MS. Pali a. 27 (R), B26 right (fol. 65)

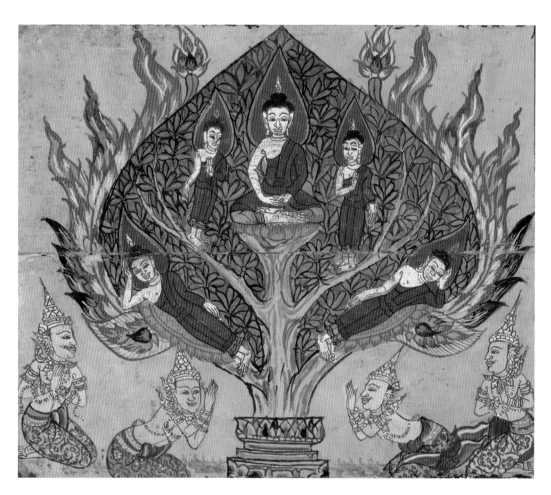

3.30 The miracles at Sāvatthī. Here the three miracles manifested by the Buddha are depicted as one. In the centre stands the great mango tree that instantly sprang up from Gaṇḍa's mango seed. The base of its trunk is decorated. The Buddha, seated in meditation, is performing the miracle of multiple figures: two standing Buddhas showing the gesture of performing miracles are on the sides of the middle branches, and two reclining Buddhas are on the edge of the foliage. The 'twin miracle', the miracle of fire and water, is expressed by the multi-coloured flames that surround the foliage. Four noble figures (possibly deities) kneel at the bottom of the tree. Oxford, Bodleian Library, MS. Pali a. 27 (R), B26 left (fol. 65)

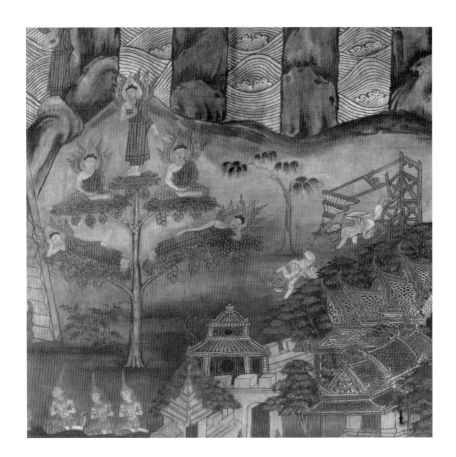

3.31 The miracles at Sāvatthī, Wat Suwannaram, Thonburi. Temple murals of this scene usually include the defeated heretics in place of the noble figures shown in the manuscript, as in this Wat Suwannaram mural. Lots of ripe mango fruit is shown on the tree. Photograph by Toshiya Unebe

The miracles at Sāvatthī

In the evening, the Blessed One went to the foot of Gaṇḍa's mango tree. Although Mahāmoggallāna and other disciples, who could perform miracles, offered to defeat the other sectarian teachers through their powers, the Buddha held them back. He himself performed the 'twin miracle' (*yamaka-pāṭihāriya*) in front of many spectators. He produced flames from the upper part of his body, and a stream of water from the lower part, and then vice versa. Fire and water also blazed or streamed alternately from the right and left sides of his body. In the same way, he released fire and water from his limbs and other paired physical features. Further, he created doubles in his own image in the four positions: standing, walking, sitting and lying down. As soon as the other religious leaders, including the six renowned teachers, saw these miracles, they fell into disarray and fled.

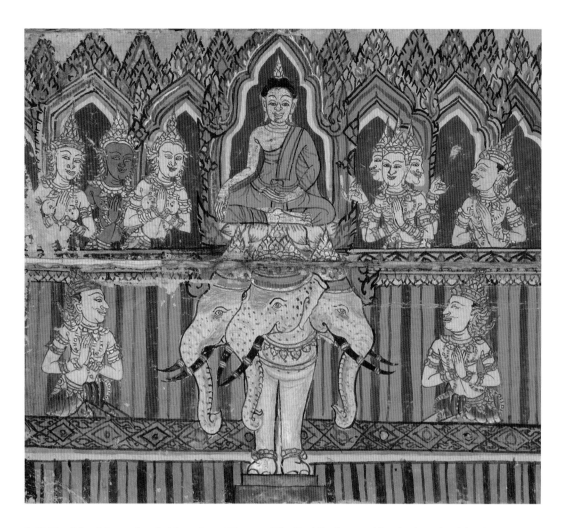

3.32 Teaching his mother in Tāvatiṃsa Heaven. The Buddha is preaching in the celestial palace
in the Tāvatiṃsa Heaven. He is seated on a throne set upon Sakka's three-headed elephant, Erāvaṇa,
and reaching down with his right hand to touch the earth. As related in the *Paṭhamasambodhi*, on the
Buddha's right-hand side (the observer's left side), the Buddha's mother Mahāmāyā is saluting him.
Behind her stand Sakka and a female deity, while Brahmā and a male deity on the other side are also
paying homage. There are two more worshipping deities in the lower area. Oxford, Bodleian Library,
MS. Pali a. 27 (R), B27 left (fol. 66)

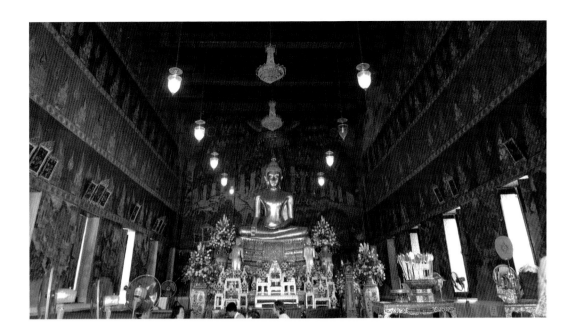

Teaching his mother in Tāvatiṃsa Heaven

The miracles at Sāvatthī were also performed by the *buddha*s of the past. The present Buddha realized that after performing the miracles, the *buddha*s of the past had gone to the Tāvatiṃsa Heaven to teach *Abhidhamma* to their mothers. He therefore rose from his throne, placed his right foot on the top of Mount Yugandhara and placed his left foot on Mount Sineru. In three strides he climbed up to the Tāvatiṃsa Heaven, where he resided at the Paṇḍukambala (yellow blanket) stone throne of Sakka under a *pāricchattaka* tree. Teaching the seven books of the *Abhidhamma* to the deities in heaven, including his mother Mahāmāyā, who had come from the Tusita Heaven, the Buddha stayed there for the three months of the rainy season. This is counted as the Blessed One's seventh rainy season retreat after the enlightenment.

The descent from Tāvatiṃsa Heaven

During the three months of the rainy season, the immense crowd of spectators that had gathered in Sāvatthī was at a loss as to where the Buddha had gone, but they remained there. Mahāmoggallāna went to Tāvatiṃsa Heaven with his supernatural power and asked the master when and where he would descend from heaven. The latter answered that after seven days, at the end of the rainy season retreat, he would descend to the town of Sankassa where Sāriputta was staying with five hundred monks. On that

3.33 *Uposatha* hall, Wat Suvannaram, Thonburi. In the *uposatha* hall of temples in Thonburi, such as this one, the main Buddha statue is usually seated in the earth-touching posture. Behind the statue the celestial palace in the Tāvatiṃsa Heaven is magnificently depicted. Further, the upper parts of the side walls are covered with rows of worshipping deities. This arrangement therefore parallels the manuscript's illustration of the Buddha's visit to the Tāvatiṃsa Heaven. Photograph by Toshiya Unebe

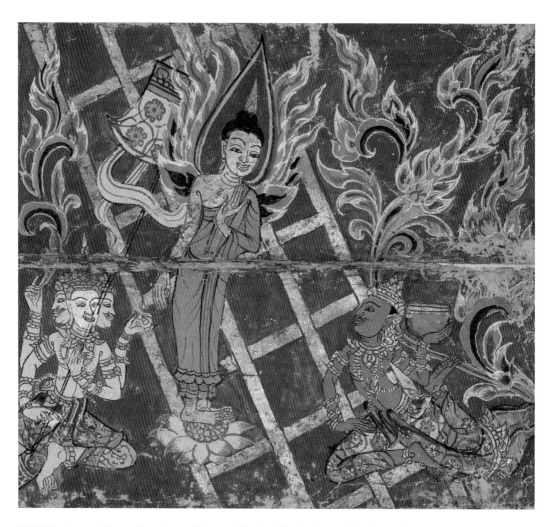

3.34 The descent from Tāvatiṃsa Heaven. The Buddha is descending from the Tāvatiṃsa Heaven.
The position of his hand is not clear, but it appears to be the gesture of performing miracles. The ladder
is in gold with three rails represented by a simple grid, although Pāli texts describe it as a triple ladder
made of gold (right), jewels (centre) and silver (left). On the left, Brahmā holds a parasol; on the right,
Sakka holds a blue bowl, in accordance with the description in the *Paṭhamasambodhi*. Oxford, Bodleian
Library, MS. Pali a. 27 (R), B27 right (fol. 66)

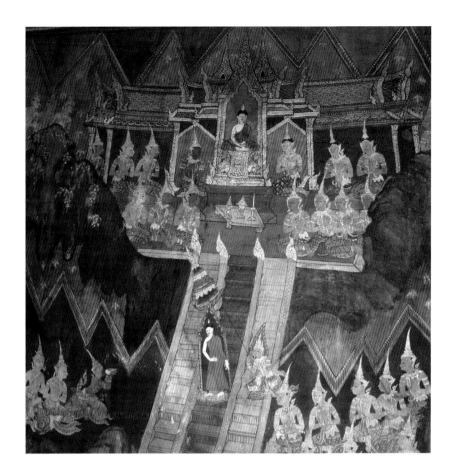

3.35 The descent from Tāvatiṃsa Heaven, Wat Thong Thammachat, Thonburi. Occasionally, the scene of the descent is incorporated into the magnificent composition of the visit to the Tāvatiṃsa Heaven drawn on the back wall behind the main Buddha statue, as in the Wat Suwannaram mural (Fig. 3.33). Alternatively, as in the Wat Thong Thammachat mural depicted here, the descent scene is often shown on a side wall panel. In this mural, the three stairways of gold, jewels and silver are clearly distinguished. Photograph by Toshiya Unebe

day, Sakka ordered the divine architect Vissakamma to prepare three flights of stairs. The Blessed One came down the middle stairway, which was made of precious gems. Sakka and other deities descended by the golden stairs on the right, and Brahmā and his train used the silver stairs on the left. Brahmā held a white parasol over the Buddha and Sakka held a bowl in his hand. On descending, the Blessed One performed the twin miracle and the miracle of unveiling of the world (*loka-vivaraṇa*) from the highest Brahma heaven to the lowest Avīci hell. In this miracle, deities could see humans and humans could see the deities.

The cremation

For forty-five years after his enlightenment, the Buddha devoted himself to a career of teaching. At the age of eighty, when he was resting in Vesālī, Māra appeared and encouraged him to enter *parinibbāna*. Although the Blessed One finally agreed, deciding to do so three months later, he

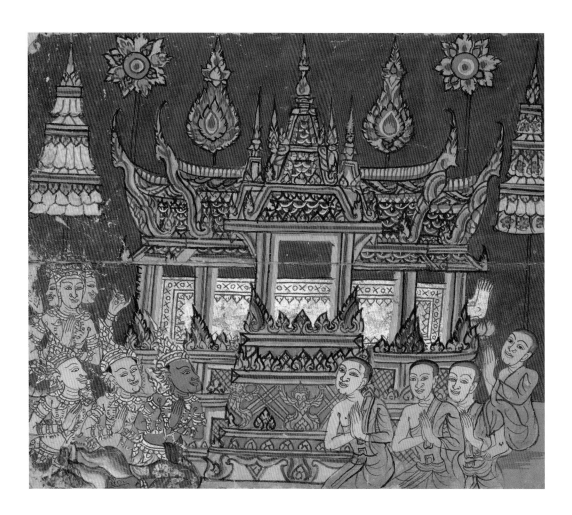

3.36 The cremation: saluting the Buddha's feet. In the centre is a big multi-roofed cremation pavilion; under the decorated roof lies a golden coffin. On the right, Mahākassapa pays homage to the Buddha's feet, which emerged miraculously from the coffin when Mahākassapa arrived. Beneath the feet is a lotus flower. In front of the coffin three monks are depicted on the right, and Brahmā, Sakka and two other deities on the left. They are all saluting the coffin. Oxford, Bodleian Library, MS. Pali a. 27 (R), B35 left (fol. 74)

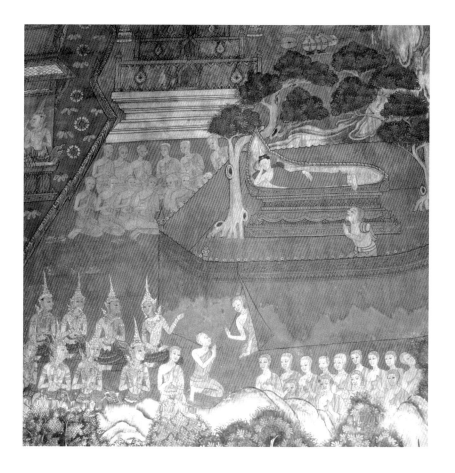

3.37 Entering *parinibbāna*, Wat Ratchasittharam, Thonburi.
In addition to the scene of Mahākassapa's salutation to the Buddha's feet, the Buddha lying on his right side is frequently depicted in murals. In such cases, unlike the northern Buddhist tradition, which usually depicts the Buddha after he has already entered into *parinibbāna*, while people and animals lament in grief, the scene represents the Buddha about to enter into *parinibbāna*. The two monks debating in the centre are Anuruddha and Ānanda: the former, saying that the Buddha has just entered a stage of meditation, corrects the latter who thought he had already entered, into *parinibbāna*. The visit of Subhadda, who became the last disciple of the Buddha, is also depicted in this mural. Photograph by Toshiya Unebe

continued his walking tour. At a grove of *sāla* trees in Kusinārā, the Blessed One lay down on his right side with his head to the north between two flowering *sāla* trees. He continued to meet those who came to see him, and then, going in and out of various meditational stages repeatedly, he entered into *parinibbāna*. According to the instructions of the Buddha's attendant, Ānanda, the Malla people of Kusinārā tried to hold the funeral ceremony based on the model of the ceremony for a universal monarch. However, they could not light the funeral pyre under the coffin. When the senior monk, Mahākassapa, belatedly arrived from a distant place, the feet of the Buddha miraculously came out. After Mahākassapa saluted the feet, the pyre ignited by itself.

The division of the relics

The Malla people of Kusinārā who held the cremation ceremony claimed ownership of the relics of the Buddha. This led to a dispute over the relics among representatives of neighbouring tribes and countries, including

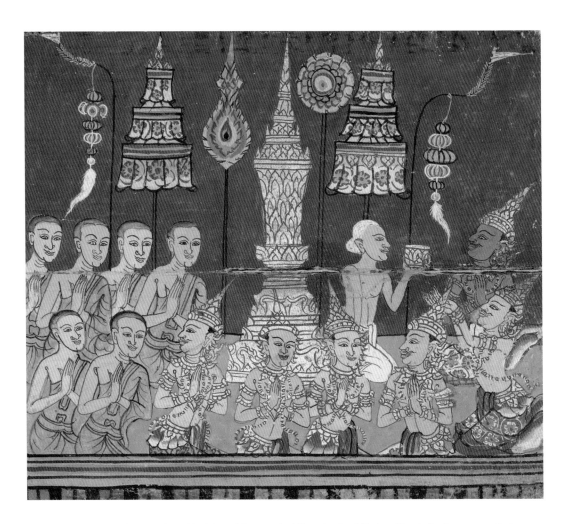

3.38 The division of the relics. The big golden urn holding the Buddha's relics is in the centre. Quite similar to present-day Thai royal funeral urns, it is placed in-between various decorations such as parasols. Surrounding the urn are six monks on the left and four kings in the centre, all kneeling and saluting. They are all demanding relics; some look as if they are talking about their distribution. Another king extends his arms towards the distributor, a brahmin named Doṇa, who has white hair twisted into a bun and wears a white dhoti. He is handing a golden casket to the king, or perhaps to Sakka, who is kneeling by his side. Oxford, Bodleian Library, MS. Pali a. 27 (R), B35 right (fol. 74)

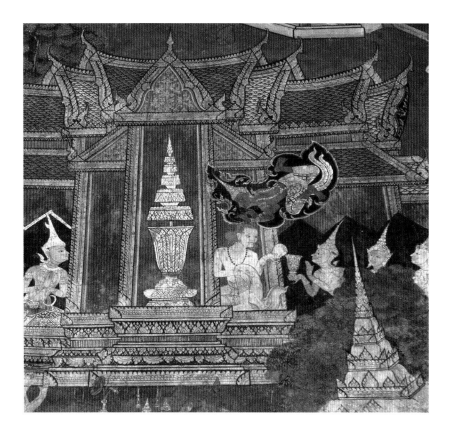

3.39 The division of the relics, Wat Dusidaram, Thonburi. In murals, Sakka is usually depicted as floating and snatching back the Buddha's tooth relics that Doṇa had hidden in his bun. In such cases, Doṇa's face looks not noble but somehow cunning. This version of the episode is found in the commentary to the *Mahāparinibbānasuttanta*, while the *Paṭhamasambodhi* does not mention Sakka's removal of relics from Doṇa. Photograph by Toshiya Unebe

King Ajātasattu of Magadha. To mediate the situation, a brahmin named Doṇa proposed dividing the relics into eight portions, and the contending parties agreed to the proposal. In addition to the eight portions of relics, Doṇa himself obtained the urn for the relics, and another belated representative of a tribe took the remaining ashes home. In this way, the Blessed One's relics and other remains were deposited in ten relic *stūpa*s (*dhātu-thūpa*) built in various countries.

～ 4 ～

The lifestory of a manuscript

SARAH SHAW

A manuscript such as this *samut khoi* brings together the art, learning and skills of a sophisticated cultural heritage. So understanding its history and background involves a great deal of 'unpacking' and detective work. Where is it from? Why was it made? What is it made of? Can it be dated? What is its provenance? Each area – paper, materials, artistic discussion, historical background, script, philology and provenance – offers a different perspective. This folding book has its own lifestory, through which we can see some of the history of Southern Buddhism and its contact with the West: made in Siam, it went then to Kandy, to Galle, to Edinburgh, from where it came to the Bodleian Library in the 1880s. A letter and a label have become attached at some time, which, as we shall see, raise as many questions as they answer. So in this chapter a few different approaches, connected with this particular folding book, are explored: its background, history, contents, art and provenance.

Buddhist illustrated manuscripts

The earliest way of communicating Buddhist teachings was oral, but the matching of writing with a visual image is ancient: from around the second century BCE onwards it occurs at sites such as Bharhut in India, where captions accompany stone depictions of *jātaka*s, and on, for instance, Bactrian coins that use the word 'Buddha' with his visual image.

The prime intent of those committing the teaching to manuscripts at the outset of the tradition seems to have been its perpetuation, but writing also was regarded from the earliest times as an activity of considerable craft and learning, producing in such cases merit for all involved. The earliest extant Buddhist texts, Gandhāran birch-bark scrolls dating from the beginning of the first millennium, demonstrate that great skill – in part simply to avoid splitting the reed pen on the fibrous line – was necessary for those first inscribing Buddhist texts.[1] They seem to have been treated

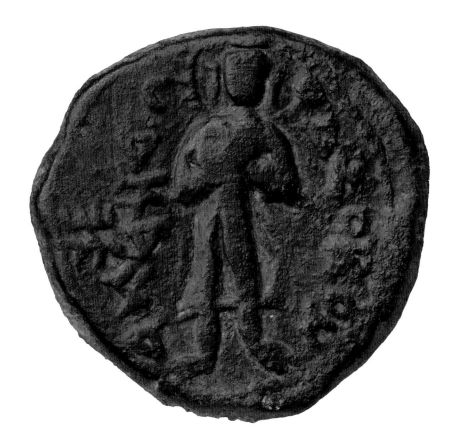

4.1 Kanişkan coin (127–155 CE). This coin is an early example of the coupling of word and image in a Buddhist context. © Ashmolean Museum, University of Oxford, HCR 6557

as important material objects: texts were ritually interred, like Western counterparts, when damaged, or buried perhaps as repositories for the future. An early assumption developed that reserves of merit, good fortune for future rebirths, accrue to those involved in copying, commissioning or donating a manuscript. So we find colophons, additions to the text, with scribal aspirations that the merit accrued might allow them to attain some favourable rebirth, such as at the time of the future *buddha*, Metteyya, or nirvana, or that other beings may benefit too.[2]

Southeast Asian manuscript culture evolved in a comparable way to that of India and Sri Lanka, with many manuscripts inscribed on palm leaf, the usual custom in these regions. The first illustrated Buddhist manuscripts are not found until the second half of the first millennium, in central Asia and northeast India.[3] Some time from the thirteenth century Siamese Buddhists also developed a tradition of making paper manuscripts with pictures and adornment: the oldest dates from 1504.[4] The Bodleian *samut khoi* would then have started life in papermaking processes, which involved soaking *khoi* leaves and then spreading the pulp onto frames, where it would have dried. The long sheets of strong *khoi* paper would be folded backwards and forwards into an accordion or concertina shape and joined to others for the

required length, often of several yards. These would then be sandwiched between lacquered and sometimes gilded covers. Such books allowed for the introduction of decorative possibilities, not just on the covers but also inside, with watercolour pictures and more ornate ink calligraphy – something that was less possible on fibrous leaf or bark. Brushes were made from bark from the lumjiak tree, soaked and then split into fibres; sometimes animal hair was used for fine work.[5]

In some ways the *samut khoi* fuses a number of forms. Its concertina effect harks back to the ancient scroll, although this was not used in Siam, and aligns it also with banner depictions of the life of the Buddha, popular since the sixteenth century in Siamese festivals.[6] The way the

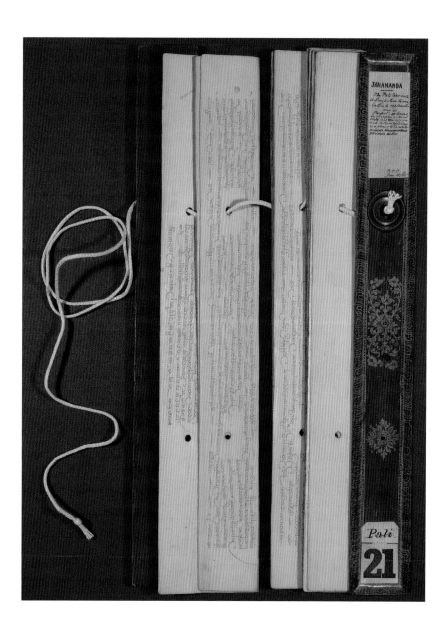

4.2 Palm-leaf manuscript, 1868.
This is an example of a traditional palm-leaf Buddhist manuscript from Sri Lanka. Oxford, Bodleian Library, MS. Pali b 2 (R)

samut khoi opens, however, is like a codex book, with which Siam would have been increasingly familiar through its burgeoning trade. Its closest relatives, though, in shape and design, are palm-leaf manuscripts, with long, narrow leaves. In the course of time, the dimensions of *samut khoi* became wider and higher, allowing more space for illustrations.[7] The shift occurred by the late eighteenth century, although it is not seen in this Bodleian manuscript.

The eighteenth century saw Siam's increasing contact with other cultures, both from nearby and with the West. Siam had long been a cosmopolitan hub, with its location and riverine, maritime and land communications ensuring interchange with highly varied groups, including traders, visitors and diplomats from Persia, China, South and Southeast Asia, Europe and India, with monks from many regions. By the early eighteenth century, however, the inland capital of Ayutthaya, accessible largely by river, had become, despite trade threats from China, a centre not only for trade and diplomacy, but also for Siamese Buddhism. A groundswell of Buddhist enthusiasm, largely on the part of a newly independent aristocracy in whom a mercantile rather than military ethos was emerging, helped to make it a showcase of arts connected with Buddhist practice.[8] The soft reddish brickwork of the many temples, *stūpa*s (shrines) and large assembly halls from this period that fringe the network of canals and rivers created a skyline that still beguiles a visitor today.

Temples were richly decorated, and art became complex, with more scenes, details and the use of new colours, such as ochre, clay, white, from kaolin, and black, from ashes, while more dramatic scenery and contrast were introduced.[9] The artists of eighteenth- and nineteenth-century *samut khoi*s also started to make use of imported as well as local materials: *khoi* came from the leaves of north Siamese trees, pulped in workshops in Bangkok; gum, ink and some paints came from China and India, and, later, Britain.[10] It is in this atmosphere of wealth, devotion and a wish for artistic expression that the *samut khoi* form came into its own.

In the eighteenth century manuscripts were usually written in Pāli, the traditional language of Buddhist texts and monastic interchange in Southeast Asia, with extracts from the Pāli scriptures and non-canonical chanting texts. At this stage, contents and artwork were simple, with pairs of worshipping figures, scenes from the ten *jātaka* stories, or freely drawn flowers and animals as illustrations. Within these parameters, however, decorative, calligraphic and devotional art flourished, using less-varied subjects and content than murals but, with its fine brushwork, showing an extension of the delicacy and highly skilled techniques of the architecture, sculpture and wall painting of this period. Those working on the manuscripts were monks, miniaturists or lay practitioners trained within temples and local communities.[11]

When was the manuscript made?

Although it is clear from comparison with the texts and pictures in other manuscripts and temple murals that our manuscript is eighteenth-century and Siamese, assigning an accurate date is difficult. Comparison with the few dated manuscripts that have been preserved from this region and period is of limited help. In terms of both text and illustration the contents of *samut khoi* became quite different during the transition from the eighteenth century to the nineteenth century. By the nineteenth century a pattern emerged whereby the first several illustrations still depict pairs of worshipping figures or scenes from the ten *jātaka* stories. The principal pictorial theme, however, is the increasingly popular story of an enlightened monk, named Phra Malai, who, in the many forms of the legend, traverses the heavens to question the future Buddha, and visits and consoles those in the hells. In these, text, usually consisting of extracts from the Pāli scriptures and vernacular renderings of the Phra Malai story, matches image. By the nineteenth century frequent pictorial presentation of monks, sometimes in exemplary mode, and sometimes comically badly behaved, would also – to the monks using the *samut khoi* – offer messages from the *samut khoi* themselves, reminding monks of their role in using folding books.

One feature that should be noted is that this Bodleian manuscript is quite different from its contemporaries in that it depicts the final life of the Buddha. Images of this are not generally found in Siamese manuscripts, though they are common in folding books in neighbouring Burma. Patricia Herbert has suggested that a life of the Buddha in Burmese prose that was composed in 1798, which was then reproduced with accompanying illustrations, may have had some influence there.[12] However, the lack of lifestory images in Siamese manuscripts does not indicate that it lacked popularity: pictures of the Buddha's final life were frequent in central Siamese temples, often accompanying images of the ten birth stories. It is puzzling, therefore, why the ten birth stories were commonly depicted in Siamese *samut khoi* while the final life was not.[13] Perhaps the omnipresent images, statues and pictures of the Buddha and scenes from the lifestory, in consecrated shrines, were felt to require a particular kind of devotional attention. Or perhaps the ten *jātaka*s were felt to have some independent power on their own, as denoters of the ten perfections and hence an easily remembered series suggestive of the path to Buddhahood.

Historical considerations offer some clues as to why the life of the Buddha might have been included. The second half of the eighteenth century was a turbulent time for the kingdom of Siam. After Ayutthaya was sacked by the Burmese in 1767, the capital moved to Thonburi, and then Bangkok in 1782. Although the Thonburi years were politically difficult, there is evidence that important manuscripts were commissioned during this period, with three dated to 1776 and another to 1780.[14] The fact that

these manuscripts bear a date implies that their patron was keen to ensure that the Thonburi kingdom was credited for preserving its Ayutthaya artistic heritage. Perhaps the lifestory pictures were included in the Bodleian manuscript as a part of this venture. The Ayutthayan style often persisted in mural and manuscript art, compounding difficulties with dating. Conversely, some early nineteenth-century temple murals, such those at Wat Khongkharam, were completely restored, with brighter colours and new details added to pre-existing paintings.[15]

Another crucial factor, from an external source, may also have been involved. From the twelfth century, a type of Buddhism that had developed in Ceylon (Sri Lanka) became widespread throughout Southeast Asia too, in Thailand, Laos, Cambodia and Burma. These areas had frequent interchange with one another, involving ideas, practices, arts, narratives and material cultures. Regional Buddhism was and is highly distinct, with great local variation in emphases, favoured texts, stories, chanting styles and customs. All, however, share a common religious language, Pāli, and ordination system, thus allowing some flexibility, with one region being able to draw on another in times of need. The monastic ordination whereby monks were ordained by ten others, in a special space, was common, and ensured a continuity of teachings, personal contact and lineages dating from the earliest times.[16]

In the middle of the eighteenth century, the ordination line of monks was lost in Ceylon, as it had been in the seventeenth century, and the higher ordination – with enough monks to ensure its efficacy – needed to be reintroduced. In 1753 and 1756, in response to requests from the king of Kandy, delegations of monks, taking ordination texts (*kammavācā*), manuscripts and other artefacts, went from Siam to Ceylon. A letter from 1756 lists seventy-five texts that were sent to Ceylon by the king of Siam. Although the Bodleian manuscript does not appear in the 1756 list, others from the delegations, also not mentioned, have been attested.[17] So it is possible that it was intended to support this movement, known as the Siyam Nikaya. Monks, texts and sacred objects travelled frequently between Siam and the island, in an apparently successful interchange: the Siyam Nikaya remains to this day one of the major Buddhist lineages in Sri Lanka. At the time it prompted a Buddhist revival, with large numbers of monks becoming ordained, and many manuscripts copied. Many Sri Lankan manuscripts that we have today date to this period, a testament to their durability in a humid climate, noted by the early traveller John Davy.[18] The presence of new images, of the *Siricudāmaṇi-Jātaka* and the Buddha's lifestory, may have been felt helpful to communicate temple iconography and guidance for a renewal of Buddhist understanding in Sri Lanka. For Buddhists, the idea of the Buddha and his life as an embodiment of the teaching was deeply embedded. For monks teaching in a temple in Siam, the lifestory would

be all over the walls and used extensively for teaching the recollection of the Buddha's qualities, which, as we shall see, are included in the written text. By including paintings of an entire lifestory series of the Buddha, the pictures may have represented an attempt to communicate a sense also of the completeness of the teaching, through the final as well as the previous lives of its teacher.

So our manuscript is undated, yet certainly comes from before the very last years of the eighteenth century, when the style and content of *samut khoi*s underwent radical changes: the latter years of the Ayutthaya period seem possible – perhaps, given its unusual and innovative use of material and images, in part as a response to a request from Kandy.

The written content

4.3 Map of South and Southeast Asia, 1869. Oxford, Bodleian Library, DIO (128)

The Bodleian manuscript is exceptional for its depictions of past lives and the last life of the Buddha. However, these stories, related in Chapters 2 and 3, are not recounted verbally in the manuscript: these chapters allude

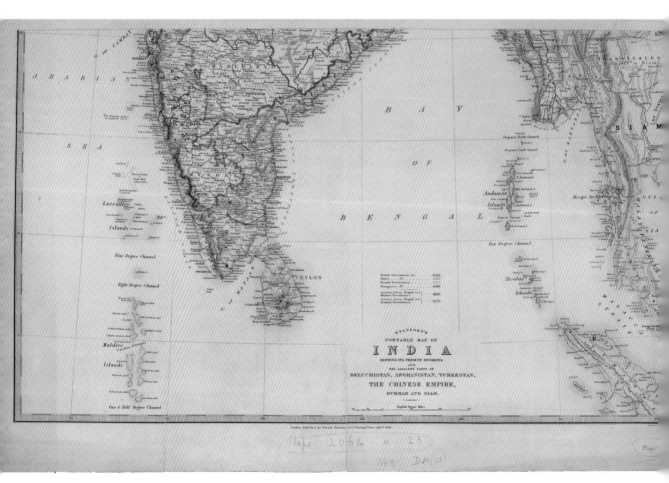

to texts associated with a common pool of stories, known to all, that would have formed the background to each of the painted pictures. So, what is the written text in this manuscript about? A range of texts feature in *samut khoi*s, which are sometimes unillustrated. This manuscript, in common with many others, offers short distillations or extracts from all of what are known as the three 'baskets' of the Buddhist teaching: the *Vinaya*, the rules for monks (text 1), the *Sutta*s, the teachings given in specific situations (text 2), and the *Abhidhamma*, the 'higher teaching' (text 3). These opening texts are *sankhepa* ('abridgements') and in each case the initial words of each basket are seen as evoking the power and meaning of the whole.

The latter basket, the *Abhidhamma*, gives an account of the various momentary states of mind (*nāma*) that arise in meditation, daily life and the stages of attaining the path, along with their relationship to form (*rūpa*). Texts frequently used in modern chanting practice evoke the seven books of the *Abhidhamma*, such as the ancient and short *mātikā*, or root chant of categories, and a summary of each book. According to legends commonly depicted behind the shrine in temples, the Buddha taught the *Abhidhamma* in the Tāvatiṃsa Heaven, the realm of the thirty-three gods and home to Sakka, to pay his debt to his mother, who had died seven days after his birth. Perhaps because of this association, the *Abhidhamma* chants are often intoned to this day at funerals, with mourners transferring blessings and merit to wish the dead person well in the next rebirth. Slow, flowing and melismatic, they are considered by Southeast Asian Buddhists to be amongst the most moving chants in the monks' repertoire.

Another text (*Sahassanaya*, text 4) describes the 'thousand' states of mind associated with meditation and awakening, from an *Abhidhamma* point of view; a version of this text, included presumably to arouse faith and a sense of the culmination of the Buddhist path, is frequently chanted today in Thailand. Although also often chanted at funerals, its rapidity and upbeat lightness of tone contrasts strongly with funerary *Abhidhamma* chanting.[19]

Another popular text – indeed arguably the defining text of modern Thai Buddhism – is the elaboration of the qualities of the Triple Gem, *Iti pi so bhagavā arahaṃ sammāsambuddho vijjācaraṇasampanno sugato lokavidū anuttaro purisadammasārathī satthā devamanussānaṃ buddho bhagavā ti* (The Blessed One is indeed called thus: a worthy one, completely and fully awakened, perfect in wisdom and conduct, one who has gone rightly, the knower of all worlds, the incomparable trainer of those ready for training, teacher of gods and men, awakened, the Blessed One). The basic chant is in constant use in these countries for daily devotion, blessings and as protection. In this manuscript, the *Iti pi so* is represented by 'The Great Qualities of the Buddha' (*Mahābuddhaguṇa*, text 5) and 'The Explication of the Great Qualities of the Buddha' (*Mahābuddhaguṇavaṇṇanā*, text 6), explaining with great elaboration various epithets of the Buddha – that

4.4 Folio of text showing a portion of the *Mahābuddhaguṇa*, in which, along with its continuation the *Mahābuddhaguṇavaṇṇanā*, the various qualities of the Buddha are enumerated. Oxford, Bodleian Library, MS. Pali a. 27 (R), A26 (fol. 26)

he is, for instance, 'fully awakened' and 'the teacher of gods and men'. It seems significant that this key chant starts with the last illustration of face A (Fig. 3.18), which depicts the attainment of awakening and the beginning of the Buddha's career.

For Southern Buddhists, each aspect of the Triple Gem is also a meditative practice. As noted in Chapter 1, the Buddha's lifestory and the stories of his past lives support the reflective practice known as the recollection of the Buddha.[20] Although not included in this manuscript, recollection of the teaching, so closely associated with the Buddha's past and last lives, is another form of meditation, with the practitioner encouraged to consider that it is 'inviting inspection, leading onwards, to be known each for oneself'. Recollection of the qualities of the community, represented by monks, completes the set. The formula for each of the meditations is explained by early meditation manuals.[21] They are often conducted as walking meditations, with the circumambulation of a *stūpa* or shrine, collectively, with individual use of this chant, remembering each of the three qualities in turn. A teaching and possibly a meditative element is present in texts relating to this chant, particularly where there is considerable repetition and eulogy, as in texts 5 and 6 in this work.

The last text, the 'Victory of the Turban Crown' (*Uṇhissavijaya*, text 7), represents the culmination of the chants.[22] The 'turban crown' in traditional iconography is the last and most auspicious of the thirty-two marks of the Buddha. Texts of the same name as this, in Sanskrit, Chinese and Tibetan, are found throughout Buddhist regions, describing the Buddha emitting rays from his turbaned head, and, through teaching, helping a practitioner to save himself from frightening rebirths and extend his life by means of chant and devotion. According to the text, the Buddha gave the teaching whilst in the Tāvatiṃsa Heaven, relating the *Abhidhamma* to his mother and other assembled deities.[23] As indicated in Chapter 3, the part of the

text referring to the Buddha's teaching of *Abhidhamma* to his mother is given emphasis by coinciding exactly in our manuscript with the depiction of this incident (folio B27). This sole dovetailing of written and visual text supports the last text's role in giving guidance for the monks as they teach and chant; indeed, in many areas in Siam and Ceylon, many monks would be likely to have female relatives, including mothers, present there too. Other images bear no obvious alignment with text, though the juxtaposition of the birth of the Buddha with what is considered the most auspicious book of the *Abhidhamma*, the *Paṭṭhāna*, and the fact that the elaborated *Iti pi so* chant enumerating the Buddha's attributes starts at the picture of the newly enlightened Buddha, suggest great care in arranging text with image. (For a map of the manuscript, showing the alignment of texts with images, see pages xii–xiii.)

Manuscript art

As the last two chapters have shown, the Bodleian manuscript is distinguished by its artwork. We can see the adaptive skill of the artist/s involved in working within the form and developing conventions of the *samut khoi*, with twenty-two paired past-life pictures and eighteen lifestory pictures, framed around the 'turning point' of the awakening. Both themes, as we have seen in Chapters 2 and 3, are commonly found in Thai temples, although in temple art *jātaka* depictions can be far more varied and full of incident than those in manuscripts. There is simply more room on a wall for extensive depiction of a number of scenes from a single, often intricate story, sometimes arranged chronologically, but often in a non-linear succession, with incidents separated by sawtooth lines. Their presence, however, is like bringing a sense of the temple to the space of a manuscript: the artists were perhaps asked to evoke the Buddha, through a series of pictures that the monks could contemplate and show to the laity.[24] If this manuscript was indeed commissioned to revitalize Buddhism in Ceylon, it was designed perhaps to show the Kandyans something of the richness of the Buddha's lives, as depicted and taught in Siamese temples. Iconographic imagery and symbols tend to be comparable in manuscript and temple mural art throughout these periods.

Where manuscript art differs is, of course, in features demanded by the exigencies of the form and the materials used: manuscript pictures are tiny in comparison, and cannot take too much complexity or too many human depictions, though some pictures do fill the space with human figures. Most, however, show few figures, within very simple basic tableaux, whatever the complexity of individual characterization or interaction between the elements of the picture. In the Ayutthaya period pictures are about 9–11 cm high and by the nineteenth century, when the folding books were wider,

about 14 cm; our manuscript is of the earlier type.[25] While pictures of the Buddha's life in this manuscript do sometimes involve many characters and incidents, artists working in this small space tend to leave more background open, or fill it with floral motifs or outlines of natural features. Indeed one scholar has argued that the frequency with which flowers are used as decoration, 'space-fillers' and adornment to wooden covers suggest that they perform an offering function, just as flowers may be offered in a Buddhist ritual.[26] In manuscript art they tend to offer contrasting or complementary colours to the subject matter.

Some characteristics distinguishing manuscripts of the mid-eighteenth century from later ones are: a light or translucent colour-wash background, with the occasional use of deeper tones of red or orange; a lack of perspective, giving subject matter and theme rather than a literal 'view' prominence on the page, and a flowing compositional balance whereby the scene seems rounded and interconnected, as are the movements of lines suggesting physical relationships between characters, animals and objects. The chariot, horse and Temiya, for instance (Fig. 2.8), make one circular sweep, with an exuberant continuity of line and movement, for which the right foot's alignment with the horses in the bottom left of the picture is crucial. Figures of this time are delineated with an easy grace and sometimes curvy stroke. With the influence of nineteenth-century Western figurative realism, the lines of figures become less undulating: characters in later manuscripts are more clearly separated from one another, isolated in the European manner; perspective is more evident, and a sense of spatial rather than emotional differentiation makes the pictures seem more literal, though perhaps sometimes less exquisitely buoyant.

In common with temple art, the colour palette in mid-eighteenth-century manuscripts is limited, with delicately luminous and subtle shades and washes, as opposed to the highly dramatic contrasts of the nineteenth century. As Ginsberg notes, deeper background colours are used in our manuscript, though it does not yet use the new pigments and dyes that produce the heavy rich colours, used in matt blocks as background, of nineteenth-century manuscripts. Later manuscripts also often have heavy layers of stylized flowers, almost brocade-like in their density, for borders that box in and frame the whole picture. Free-form flowers or lozenge shapes within narrow vertical friezes, or loose vertical lines, in two or three colours, make simple markers – from text to picture, and to end of page – in eighteenth-century depictions. Manuscripts of the eighteenth century tend to have freely but precisely drawn, flowing and non-repetitive flowers, foliage, trees, rocks, mountains and other natural features within their pictures too.[27]

This work, with its smaller size, loose-line borders, thick script and overall visual style, shares many features with Ayutthayan art, but, in

addition to the red and orange backgrounds of Ayutthayan manuscripts, it makes use of strong backgrounds in other colours – suggestive of a later date, perhaps towards the end of the eighteenth century.[28] The script is thick Khom, rather than the thin line form that developed by the end of the eighteenth century. So from the artistic point of view, the manuscript seems eighteenth century, but starting to experiment with the deeper colours that characterized the painting of the following century.

The fold in the book

The artists and the people who commissioned the pictures made adventurous decisions, either to reinforce at home or to communicate abroad a full sense of Siamese Buddhism. One manifestation of this manuscript's deftly practical approach can be seen in its occasional use of one simple feature: the fold between pages, across the horizontal axis of each opening and thus the centre of each picture. In other Siamese manuscripts figures such as the Bodhisatta, the Buddha or gods sometimes occupy a central position just above the fold, often in a cross-legged posture; depictions of monks, living the 'higher life', also often take the higher space, as they do in Buddhist ritual and ideology. In such depictions, they frequently face the reader, or sometimes themselves, while a horizontal line, denoting the dais they sit upon, lies just above or below the fold, separating them from the lower section, where the laity is depicted, facing the monks or each other.[29] In our work, some pictures do not make great use of the fold. In many, however, the crease is deployed to offer an almost physical divide, creating a strong 'higher' and 'lower' compositional dynamic. In one Temiya picture the Bodhisatta sits exactly on the fold, above the throne he is rejecting, which occupies the lower space; in the partner picture, his foot seems to use the join as an almost physical support for whirling the chariot (Figs 2.6 and 2.8). In several he sits centrally, the base of his seated body around the fold point. In one Sāma picture the depth of the Bodhisatta's plight after being shot is represented by his placing below the fold, while the forest goddess and Sakka support him from above (Fig. 2.13). His final acts of generosity in giving away the children and his wife in the Vessantara pictures are also both shown, significantly, in the lower space. In the first, Maddī, the virtuous wife, literally rises above him, making her beseeching *añjali* above the fold, while she too is drawn down to the lower area when she is being given away herself, with only the god Sakka in the space above, linked by the same vertical axis to his own emanation in the space below (Figs 2.33 and 2.34). In the Nārada story, the virtuous Rucā also makes her *añjali* above the fold, like Maddī, separating herself emotionally and spatially from the turbulent events depicted below (Fig. 2.28).[30] It is perhaps significant in such a context that the depiction of the

twin miracle, where the Buddha triumphantly crosses the barrier between heavenly and human, ignores the fold completely (Fig. 3.30).

A vertical axis sometimes complements the fold. In one Nemi picture the helplessness of the hells is communicated by the appallingly pinioned man that overshadows the central 'higher' space, on a central vertical axis (Fig. 2.15). In two pictures, arguably the most important in the manuscript, an arresting cross-axis is created. The first is in the Buddha life, the incident of the visit to teach his mother, that, as we have seen, is placed alongside a reference to this in the contents of the book. It is the usual scene to be shown behind the shrine in Siam. This picture places Sakka's three-headed elephant below the fold and the Buddha above, resting above it, dramatically employing both a vertical and horizontal visual axis, which still retains a unifying sense of flow and movement between the parts (Fig. 3.32). This axis is also deployed in another picture, for the rout of Māra, a personification of the forces of delusion and doubt, and his armies. Here the Buddha-to-be fights his last opponent, having called the goddess of the earth to witness for his great acts of generosity in earlier lives. The artist places the Bodhisatta above the fold; the goddess of the earth, releasing her hair, lets forth the rivers of water, which have accompanied his generosity in the past, below.[31] Protector of the lower space, she is directly beneath him, as she often is in mural art, and by her actions allows the Bodhisatta to defeat Māra's army, which flank him on both sides (Fig. 3.18). These two are perhaps the most popular images in Siamese temple murals, often filling the whole of the back and entrance walls respectively. Their presence in this manuscript, and emphasis through a powerful cross-axis, seems to bring the majesty of the whole temple setting within the tiny space of the folding book.

The travels of the manuscript

The manuscript would have undergone a long but probably protected journey to its destination. It could have been sent from Ayutthaya, Thonburi or Bangkok, and then perhaps included in a monastic delegation and escorted by barge, or perhaps on an elephant if in a royal commission, to the harbour, then by European boat. Arriving probably in Galle, it would have undergone the arduous journey to the highlands, taken on carts on a journey of many days, until it reached the centre of the island. Kandy, high in heavily forested and mist-covered mountains, was designed to be difficult to reach and to enter, as foreign emissaries, kept for lengthy periods on its outskirts, found. Modelled, it has been argued, in part as a sacred city – with kingship reflecting ancient Buddhist ideals derived from the Aśokan period in India and earlier mythology of the benign universal monarch – it was isolated, and any entrance into its environs was accompanied by ritual and protocol.[32]

However, the times were not favourable. Ruled by Dravidian kings, whose complex marriage arrangements, whereby whole families moved to join brides from India, with a strong nobility – from which many senior members of the monastic community were drawn – and an impoverished economy compared to that of older Ceylonese capitals, Kandy was always potentially insecure. Kirti Sri Raja Singha (r. 1737–82), king at the time of the revitalization programme, retained the goodwill of the Kandyans, making the annual *perahera* procession a Buddhist festival as well as reintroducing the ordination line. But the capital faced other, external threats. Dutch emissaries, amazed at the treasures they found in the palace, ransacked it completely in 1762, as well as, it seems, the Temple of the Tooth – the home of a supposed tooth of the Buddha and the centre of Kandy religious life. The temple was apparently almost entirely destroyed.[33] Threats from the British soon followed, after the departure of the Dutch in 1795. Kirti Sri Raja Singha was succeeded by his brother, whose throne subsequently passed to a nephew, Raja Sri Vikrama Singha (r. 1798–1815). Popular at first, he defeated British threats roundly in 1803. But shortly afterwards he embarked on exploitative rebuilding programmes, appropriating monastic property, introducing forced labour and inflicting cruel executions that caused local uproar. After a revolt in 1814 was brutally suppressed, some monks suspected of being involved were executed, a terrible crime for Buddhists; some noble families were publicly tortured and killed, and a delegation of British emissaries were all mutilated. The British became involved in response to Kandyan requests for help. They took the city in 1815, sent the king into exile and for a year appropriated the tooth relic from the Temple of the Tooth. A leading figure after the king's dismissal, Ahalepola, denounced Vikrama for executing monks, cutting down bodhi trees and ruthless confiscation of monastic property and artefacts.[34] If the Bodleian manuscript arrived at any time between 1756 and the end of the eighteenth century, it is perhaps surprising, after these onslaughts, not that it was taken, but that it survived at all. More upheaval followed. Kandyan tensions erupted and in 1819–21, in a series of rebellions crushed by the British, thousands died. It is perhaps at this time that the manuscript left Kandy.[35]

While manuscripts are treated as sacred throughout the region, the usual borrowings, appropriations, thefts and misplacings of these texts were unfortunately common then, as occasionally they are now.[36] In addition, from ancient times, decayed manuscripts were sometimes rejected as needing replacement. Evidence for this period is complex, and more work needs to be undertaken to explain how so many manuscripts could and did survive. The Bodleian manuscript would have been at risk from the Dutch and even the Kandyan monarch – presumably, alert local monks and laypeople must have taken pains to protect this and other surviving manuscripts. It should not be assumed, though, that the manuscript was misappropriated or

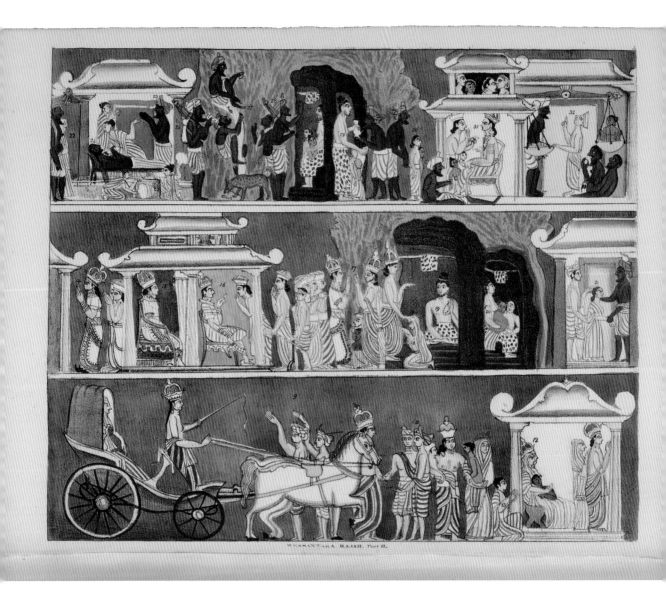

4.5 Hand-painted image of
***Vessantara-Jātaka* by Edward**
Upham, 1829. *The History and*
Doctrine of Budhism, Oxford,
Bodleian Library, (IND) Ceylon
11 c 1

stolen. Some manuscripts were donated during this period by monks who
had converted to Christianity under new missionary impetus. Many other
monks educated missionaries in local customs, languages and Pāli, and also
handed some manuscripts over to civil servants in gestures of goodwill.
Alexander Johnston, chief justice in the second decade of the nineteenth
century, sent numerous manuscripts donated in this way to Britain. Such a
recipient was Edward Upham, who then wrote on Buddhism for the British
public.[37] From whatever source, the later owner of the Bodleian manuscript
acquired it shortly after the upheavals.

A provenance puzzle

We now move on to a different kind of evidence about the history of this folding book, seen from the perspective of an entirely different culture. For anyone looking through manuscripts in the Bodleian, the letters and 'paperwork' accompanying the object's arrival sometimes give an unintended glimpse into the way that such artefacts were really regarded. The history of this period is a sorry one, but, as Elizabeth Harris notes, it is 'dangerously myopic to concentrate on only one side of the encounter'.[38] As we see in the letter linked to this folding book, even amongst those British missionaries who perceived their culture as superior, a real appreciation of the contents of Buddhism, and its manifestations in its books and manuscripts, did sometimes emerge.

The letter was written and sent, presumably in Ceylon, in the early part of the nineteenth century, by the Methodist missionary Reverend Benjamin Clough (1791–1853). It is a response to a manuscript he had been asked to assess by his friend William Carmichael Gibson (1768–1832),[39] who, like other younger sons to the British gentry, had sought his fortunes in the East, marrying a British girl born in India, and then become port attendant at Galle. At that time Galle provided an interchange point in the south for most sea travel to the Far East and, for the British, the usual port of call on the way to eastern India. The year 1814 had seen the arrival of the Wesleyan mission from Britain, when Clough had arrived in Ceylon, with as yet little knowledge of the culture and language. The British had not long taken Ceylon as a Crown colony; the mores and manners of the Sinhalese were still unknown.

A graphic, if obviously biased, account of the arrival of the mission, which had been beset by death and loss, from 1814 onwards, is given by William Martin Harvard, in a self-published account of these early years (1823). After severe setbacks the mission docked safely at Galle, to a warm welcome by Gibson, who brought them to his hospitable 'bungaloe', with views in the far distance of Adam's Peak, the sacred mountain towering over southern Sri Lanka. Gibson's avuncular support must have been sustaining. The group settled, at first around Galle and Colombo, and missionary work soon began on native conversions, despite the constant threat of illness. The missionaries had some Portuguese, but had been unable to find information about the local language. They soon set to learning it, and Benjamin Clough, a gifted linguist, acquired great proficiency, producing the first Sinhalese–English dictionary (1821–30) and a Pāli grammar in 1824. Clough continued to work with young Sinhalese, helping to establish various schools and educational projects in Ceylon. His dedication, genuine commitment to the Sinhalese people and love of their language are not to be doubted.

Perhaps with Buddhism still fragile, despite its revival, Christian conversions around this area and Colombo soon followed, as they did in other

coastal regions.[40] But, if we take Harvard's account as truthful, if partial, we can see this from the perspective of the need for the 1756 mission to Kandy. If Buddhism had been in a period of some decline, it had clearly revived. Harvard expostulates that so many new temples, mostly Buddhist but some of other traditions, had been built after the departure of the Dutch in 1796 that there were now twelve hundred on the island: some testament, at any rate, to the continued success of the Siyam Nikaya project.[41]

The letter

Clough's letter is apparently written around this tumultous period, in 1819, in response to a query about a manuscript by Gibson, perhaps made in person. When it was written, both men were probably around Galle and Colombo. Written on paper that folds in two, it is folded again – in the usual manner, before the invention of stamps or envelopes – in three, with the addressee's name on the outside. It has a slight tear in one corner where a coloured seal or wafer has been used, staining the paper at three places. It was not posted or franked, and is undated: this latter unusual point is perhaps suggestive of such recent contact between the two men that Clough did not trouble to do this.[42]

The letter reads as follows:

Very dear Sir,

I have the pleasure to return you the curious book – with many thanks for a sight of it. I was anxious if possible to make it out – I went through a considerable part of the beginning but find the language rather too high for me – it is pure Pāli – the style is [placed afterwards above] beautiful – In fact the style is so soft and musical that I thought it was Eloo which is the language of celebrated Cingalise [Sinhalese] Poets.[43] But on turning over to the latter part: about three or four of the last pages I find an account of it in Cingalese – the book is called Tallabanna[44] taken from the Appannakka Sootra and contains some of 'the inexplicably rich' orations of the Buddha.[45] The book is concluded by an account of the amazing effects which were produced on a certain occasion to a public assembly – The story is this –

A celebrated Priest called Dharma..dissana Trōōnadāns [illegible] – presided in the Temple called Tallagoroo Wehāra [*vihāra*, Buddhist temple] went to another temple or rather place called Matōah (actually a hall or court) capable of containing 30 congregations[46] – At this place was [de]livered[47] the contents of this book – which when he had finished he had pointed his fan to the ground – upon which – the lower Regions of the World had opened – from the surface of the Sea down as far as the 136th Hell [inserted comment here: 'Going as far as the avicchamahanarakādia,

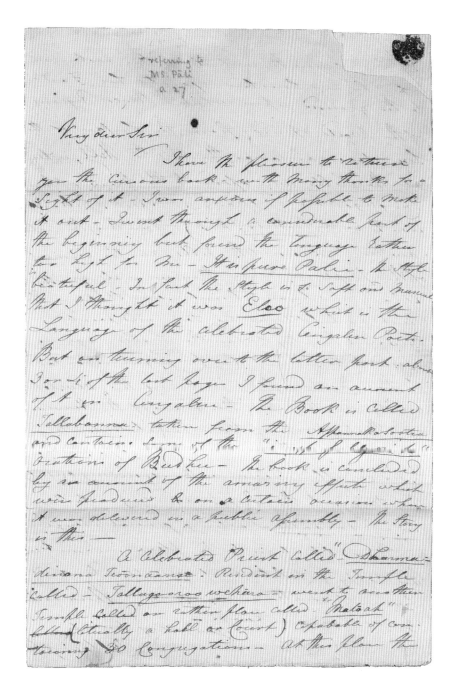

4.6 (*left and overleaf*) Letter written by the Rev. Clough in response to W.C. Gibson's query. Oxford, Bodleian Library, MS. Pali a. 27 (R), A01

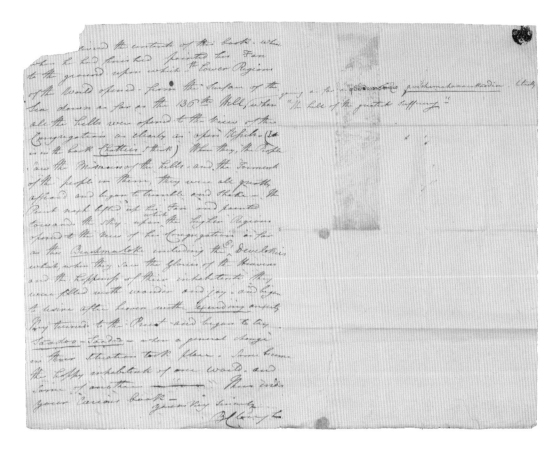

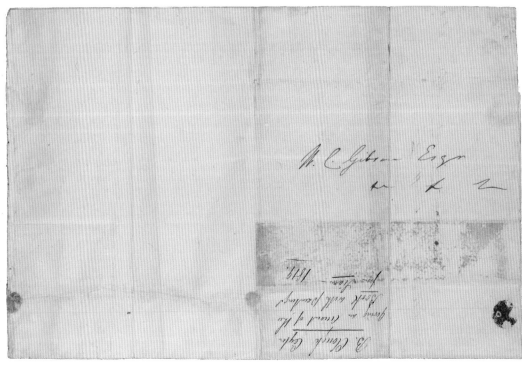

literally, "the hell of the greatest suffering"'] When all the hells were opened to the view of the Congregation as clearly as 'open' vessels (it is the book Chatties I think)[48] when they, the People saw the Miseries of the Hells – and the torments of the people in these, they were all greatly afraid and began to tremble and shake – the priest next lifted up his Fan and pointed to the Sky – upon which the higher Regions opened to the view of his Congregations as far as the <u>Brachmaloke</u>[49] including the (6) devalokies which, when they saw the Glories of the Heavens and the happiness of their inhabitants they were filled with wonder and joy – and began to desire after heaven with <u>exceeding</u> anxiety. They turned to the Priest and began to cry Sāādoo – sāādoo[50] – When a general change to their situation took place – Some became the happy inhabitants of one world and some of another – There ends your curious book –

<div align="right">

Yours very sincerely,

Rev. B. Clough

</div>

Whether the letter refers to the Bodleian manuscript, or to another, perhaps collected by Gibson, it is revealing as a missive from someone now recognized as a pioneer in Asian studies. Clough demonstrates a surprising appreciation for the object he has been asked to assess. This is transmitted both through his sensitive references to the nuances of the languages of Ceylon, despite his own admitted shortcomings in understanding, and through his intuition of the worth of the Buddhist tradition, with his reference to the 'inexplicably rich' orations of the Buddha.[51] Buddhist texts were at that time largely untranslated into Western languages; the terms 'karma' and 'nirvana' only appeared in English dictionaries in 1827 and 1836 respectively.[52] Oddly enough, Western travellers to Southeast Asia tended to know the details of the arrangement of Buddhist cosmology – presumably a feature of the tradition more easily communicable by those they encountered than subtleties of doctrine – but little else.[53] Harris notes that Buddhist notions of rebirth were not really understood, nor the concept of nirvana, thought at the time to be nihilistic and passive.[54]

In 1819, if the letter was written then, Europeans were beginning to understand the grammar and formation of Pāli. Clough would have started work on Pāli, though it would not yet be strong;[55] he clearly regards it as more difficult than the vernacular. The letter is also, of course, noteworthy for his vivid account of some sensational circumstances in a Buddhist congregation. This narrative constitutes the bulk of the letter. It provides a quite literal interpretation of the term 'hellfire sermon', though balanced in this case by a display of 'heavens' too. This story, found in Buddhaghosa's *Visuddhimagga*, after describing the miracle of the Buddha's descent from the Tāvatiṃsa Heaven, describes a Sinhalese monk, Taḷaṅgaravāsī Dhammadinna(na)tthera, miraculously revealing higher and lower worlds.

He also recounts a teaching known as the *Apaṇṇakasutta,* as the letter describes. Indeed, as we have seen, rebirth in hells and heavens is also touched upon in the last text in the contents of the Bodleian manuscript, the *Uṇhissavijaya*, though it is noteworthy that in that text the Buddha offers a clearly accessible path of deliverance from unfortunate rebirths, as does Buddhaghosa's story. It seems possible that a Sinhalese monk, unfamiliar with the Khom script, saw the picture of the miracle of the descent from the Tāvatiṃsa Heaven near the end of the Bodleian manuscript, and decided to describe a comparable miracle in Ceylon, on papers that have now been lost but which were read by Clough.[56]

The letter certainly poses major problems, as no such account of this event in Sinhalese script or language now remains. This manuscript, although in Pāli, employs Khom lettering, and the text does not include these stories. Clough's letter reads as if he had perused the manuscript himself; he does not mention the Khom script or Siam as a place of origin. So it is possible that the letter was written on receipt of a palm-leaf manuscript, also called 'book' by Europeans,[57] which is not this one. There would have been many of these in temples all over Sri Lanka. Clough evidently regarded the work he was viewing as quite distinctive in some regard, however, a feature that again aligns it with our manuscript.

It is a puzzle, although the manuscript's last piece does describe the possibility of rebirth in heavens and hells, with a way to avoid unhappy states. The story would be well known, and could have been suggested by pictures in the manuscript. So it seems possible that an anecdote describing a revelation of higher and lower realms could have been written out in Sinhalese, in papers now misplaced.

The association of this letter with our manuscript poses another riddle. On the obverse side of the letter, where W.C. Gibson is named as the addressee, is a note across the page in a confident scribal copperplate, suggesting a lawyer's or an estate manager's hand; the underlinings indicate words key to a sale or inventory, perhaps after Gibson's death. This note reads:

> B. Clough Ceylon giving an account of the book with paintings from Siam 1819

The date and correct original source for this manuscript suggest that the letter had indeed been stored somewhere with our folding book, by someone who knew its source, and marked by an estate manager or lawyer.

The label
There is one last piece of evidence. A label glued to the inside cover of the folding book reads:

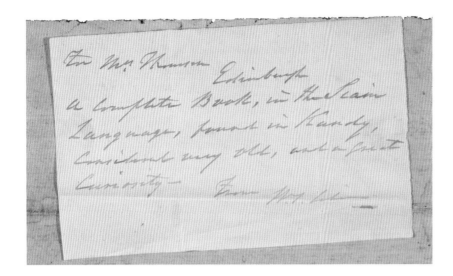

4.7 Label attached to the manuscript. Is the signature Gibson's? Oxford, Bodleian Library, MS. Pali a. 27 (R), A01

To Messrs/Mrs[58] Thomson Edinburgh a complete book, in the Siam language, found in Kandy, considered very old, and a great curiosity from [illegible, but could be W.C. Gibson].

The letter makes no mention of Kandy, apart from the scribal cross-writing. So the label brings us back to what seems to have been the original purpose of our folding book, if it was sent by Siamese donors in an attempt to revitalize Buddhism in Kandy in the eighteenth century. Given the contents, the possible tailoring of the illustrations for a different region, and the known dispatch of manuscripts from Siam at this time, this appears to confirm Kandy as its earlier home. The label is undated.

The label also gives some clues about what happened to the manuscript when it left Ceylon. The family who held the manuscript at the time of the sale in 1888, the Gibson-Craigs, were close relatives of W.C. Gibson in Galle: Gibson's elder brother changed his name to Gibson-Craig in order to accept an old baronetcy, as recorded in *Debrett's* in 1831. His wife was an Anne Thomson, described on her marriage as the daughter of a merchant.[59]

It seems the manuscript went to the Gibson-Craigs, before Gibson's death in 1831, perhaps through 'Messrs Thomson', or to a 'Mrs Thomson', with some connection by marriage. The Gibson Craigs' second son, W.C. Gibson's nephew, was the bibliophile from whose effects our manuscript was bought in 1888, after he died without issue.[60] The date 1819 does not appear within the letter, but seems likely to be correct.[61] The signature on the label could be W.C. Gibson.

So Gibson at any rate, if it is his signature, recognized the book as Siamese. Whether he sent it back to his sister-in-law's family first we

do not know. At any rate, his nephew, James Thomson Gibson-Craig, at some stage became the owner. A friend and benefactor of Sir Walter Scott, he was a renowned collector of books, maps and manuscripts in various languages, who had perhaps derived inspiration from the adventurous uncle who had died in Ceylon. When he died he was given an obituary in the *New York Times* (9 August 1886), which said that he had one of the finest book collections in the United Kingdom, and was 'fond of showing his possessions to congenial visitors'.

The Gibson-Craig sale

The next documentation we can trace is the manuscript listed in a sale of Gibson-Craig's estate, on 17 November 1888 (lot 758), with a number of other books. The bibliography of his library lists it as follows:

> 758 A Pali Manuscript, on thick Siamese Paper, folded in Siamese fashion, and illustrated with Pictures, *beautifully written in the Kambodian character*, and containing several *Sutta*s or Religious Narratives.

This largely correct account of its contents is impressive – many scholars still regard the script as Cambodian in origin, although this is now contested – and bears testimony to the late Victorian scrupulousness with which Gibson-Craig or his estate managers ensured that expert knowledge was brought to bear upon his acquisitions. The manuscript was bought by Bernard Quaritch, the leading bookseller of the time, for £4.00, and then presumably by the Bodleian; there is no associated paperwork amongst Bodleian records. The only other book the Bodleian bought from items in the sale was a Javanese codex book, so the letter could not have been muddled then.[62] So there are two possibilities: first, that our letter, so interesting as an account of European perceptions of Buddhism in the early nineteenth century, was supposed to be attached to another, Sinhalese manuscript, perhaps in Gibson's possession, whose whereabouts we do not now know, and which was misplaced at some point. This possibility does not explain a probably correct date, and the attribution to Siam on the outside of the letter. So, second, if it was the Bodleian manuscript that Clough saw, the fact he does not mention the script is odd, or Siam as a place of origin, and we need to presume that the papers with the anecdote on them have been lost.

Lifestory of a manuscript

At each stage the Bodleian manuscript has had a mysterious history, sometimes at the front line of new developments, state unrest and change.

It started life in Siamese temples and, unusual and innovative in several ways, was perhaps from the outset intended for Kandy. It would have gone by boat to Galle, either sent as part of the revitalization programme or some ventures shortly after that. From there it would have been taken to Kandy, where it would have been lodged in a temple there. But misfortune troubled the city: it was probably taken in 1819, as the label suggests, at the time of the revolt against the British, though it could have been plundered, sold, neglected, given away or even rescued from a ransacked temple before then. It then made the journey back to Galle, to Gibson, who knew it was in some way connected with Siam, though not in 'the Siam language', as is claimed on the label. From here, it was perhaps also sent to be viewed by Clough, who was probably nearby; otherwise it would have been kept at Gibson's spacious 'bungaloe'.

At some point after 1819, and probably before Gibson's death in 1831, it went seven thousand miles to Scotland, addressed to Messrs Thomson, Edinburgh, and from there into the hands of the Gibson-Craig family, also in Edinburgh. The port attendant's nephew, James Thomson Gibson-Craig, acted as custodian of the book and placed it in his renowned library. It was then sold after his death, in 1888, with the letter. This letter has its own history, as an accompaniment to the folding book, and gives added insight into early Western encounters with Buddhism, the 'missionary' mind and the curious and close familial links with Asia that so many British families had at the time.

Finally the folding book and letter came to the Bodleian Library, where they have remained. The manuscript's composition and lifestory speak of the ritual, narrative, usage and patronage of its own heritage, and of the encounter of British colonialism with an ancient religious, philosophical and artistic tradition. It is now recognized as a masterpiece of eighteenth-century Siamese art and craftsmanship.

Conclusion

This book has shown the 'life' of the Buddha and his teaching portrayed in one manuscript, through paintings, text, narrative choices and the singular arrangement whereby illustrations work as a sequence, complementing text within the parameters of the folding-book format. By bringing into one manuscript events based on the *jātaka*s, including a para-canonical *jātaka* and, running through to face B, an illustration of a popular text, the *Paṭhamasambodhi*, as one series, the Bodleian manuscript offers a creative and idiosyncratic distillation of the journey to, and including, Buddhahood, as understood in eighteenth-century Siam. The intention behind these depictions, and the unusual inclusion of the last life of the Buddha, is unknown, but its achievement, as this book demonstrates, is

magnificent: the manuscript presents the lineage of the Bodhisatta and the path to Buddhahood, through pictures which enliven written works that are the product and heritage of that path. Such pictures would have helped monks teach, through examples, the meditation on the qualities of the Buddha, recorded in the *Iti pi so* amongst its written texts. If the manuscript was sent to sustain the teaching and monastic orders in Ceylon, it becomes an important historical document of perceived priorities within diplomatic and monastic cooperation between Southern Buddhist states. But the Bodleian manuscript is primarily noteworthy for its reinforcement of the axiom, also recorded in the *Iti pi so* chant, that the teaching of the Buddha is 'beautiful in the beginning, beautiful in the middle and beautiful in the end'. It takes full advantage of the folding-book form and is filled with script, illustrations, calligraphy, texts that would have been chanted then and now, and the interplay of these elements. In the world history of the book, a manuscript specifically tailored for communal reading must be unusual: this one memorably evokes different types of text and stages on the Buddhist path.

Notes

Chapter 1: Introduction

1 See Sarah Shaw, *The Jatakas: Birth Stories of the Bodhisatta,* Penguin Books India, New Delhi, 2006; Peter Skilling (ed.), *Past Lives of the Buddha: Wat Si Chum – Art, Architecture and Inscriptions*, River Books, Bangkok, 2008; and Naomi Appleton, *Jātaka Stories in Theravāda Buddhism: Narrating the Bodhisatta Path*, Ashgate, Farnham, 2010.

2 The Western term 'Siam' denoted a number of regions within what is now Thailand. In the early twentieth century Siam annexed the northern states, the old 'Lanna', hitherto under Burmese control. In 1939 the whole region took the name 'Thailand'.

3 Henry Ginsberg, *Thai Art and Culture: Historic Manuscripts from Western Collections*, British Library, London, 2000, p. 87.

4 *Dhammapada*, verse 354 states 'the gift of the Dhamma conquers all gifts'. Valerie Roebuck (trans.), *The Dhammapada*, Penguin, London, 2010.

5 Skilling, *Past Lives*, pp. 80ff.

6 Jacqueline Filliozat, *Survey of the Pāli Manuscript Collection in the Bodleian Library*, Ecole Française d'Extrême-Orient/Pali Text Society, Oxford, 1994–96, p. 4.

7 In nineteenth-century Burmese manuscripts artwork sometimes occupies the central position.

8 Rupert Gethin, 'The Mātikās: Memorization, Mindfulness, and the List', in Janet Gyatso (ed.), *In the Mirror of Memory: Reflections on Mindfulness and Remembrance in Indian and Tibetan Buddhism*, State University of New York Press, New York, 1992, pp. 149–72.

9 In Cambodia and Thailand, it is widely used for *yantra*s (sacred diagrams) in texts, amulets, tattoos, banners and horoscopes: writing is arranged to form a shape, say a *stūpa*, on the page of a manuscript. Embellishments such as the *anulom*, a swirling flourish like the 'long tail' in British Elizabethan manuscripts, have also long been popular in manuscripts as decoration and, placed horizontally, simply as denoters to the beginning and end of sections.

10 J.-F. Huang, 'A Technical Examination of 7 Thai Manuscripts in the 18th, 19th, and 20th Centuries', online resource, Harvard University, 2006: http://www.ischool.utexas.edu/~anagpic/2006pdf/2006ANAGPIC_Huang.pdf

11 Ginsberg, *Thai Art*, p. 54.

12 Skilling, *Past Lives*, p. 72.

13 See Gethin, 'Mātikās'. The artwork of the *samut khoi* seems akin to illuminations around musical notation and text found in fourteenth-century choirbooks: see Miklós Boskovits, Richard Offner and Klara

Steinwig, *The Fourteenth Century: The Painters of the Miniaturist Tendency*, Giunti, Florence, 1984. For emblematic imagery, see Edgar Wind, *Pagan Mysteries in the Renaissance*, Penguin, Harmondsworth, Middlesex, 1967, pp. 17ff; and Frances A. Yates, *The Art of Memory*, Penguin, Harmondsworth, Middlesex, 1966, pp. 355ff.

14 A complexity of scene depiction is particularly associated with temples, with a circular arrangement of scenes, sometimes divided by sawtooth screens, sometimes covering a whole wall (see Elizabeth Wray, Clare Rosenfield, Dorothy Bailey and Joe D. Wray, *Ten Lives of the Buddha: Siamese Temple Painting and Jataka Tales*, Weatherhill, New York and Tokyo, revised paperback edn, 1996). Such an ordering of the story material dates back to Bharhut roundel depiction (Skilling, *Past Lives*, p. 60).

15 K.I. Matics, *Gestures of the Buddha*, Mahachulalongkorn Press, Bangkok, 2004.

16 Other common subjects for art, not employed in our work, are the Phra Malai stories, showing the visit of a monk to the heavens and hells. Elephants, considered particularly auspicious, are also a popular theme.

Chapter 2: The past lives of the Buddha

1 This is in contrast to the Sri Lankan tradition. See Naomi Appleton, *Jātaka Stories in Theravāda Buddhism*, Ashgate, Farnham, 2010, pp. 74–5.

2 Peter Skilling (ed.), *Past Lives of the Buddha: Wat Si Chum – Art, Architecture and Inscriptions*, River Books, Bangkok, 2008, p. 70.

3 Information on this mnemonic has been kindly provided by Arthid Sheravanichkul.

4 My thanks to Sarah Shaw for this information.

5 Arthid Sheravanichkul, 'From a Jataka Character to an Amulet: The Cult of Jujaka Worship in Thailand', paper presented at the 6th EuroSEAS Conference, 26–28 August 2010, University of Gothenburg, Sweden.

6 Arthid Sheravanichkul, 'Self-Sacrifice of the Bodhisatta in the Paññāsa Jātaka', *Religion Compass*, vol. 2, no. 5, 2008, pp. 769–87.

7 Examples are discussed in Santi Leksukhum, *Temples of Gold: Seven Centuries of Thai Buddhist Paintings,* River Books, Bangkok, 2000, pp. 160–63.

8 This is the spelling found in the Pali Text Society edition and translation. Manuscript spellings vary. In palm-leaf manuscripts in Thailand we normally find 'Siricuddhāmaṇi'.

9 The inclusion of a *Paññāsa Jātaka* story also provides further evidence (along with the inclusion of the final lifestory of the Buddha) in support of our conjecture that this mansucript was intended to recreate temple iconography for an overseas audience, as discussed elsewhere in this volume.

10 Elizabeth Wray, Clare Rosenfield, Dorothy Bailey and Joe D. Wray, *Ten Lives of the Buddha: Siamese Temple Painting and Jataka Tales*, Weatherhill, New York and Tokyo, revised paperback edn, 1996, p. 114.

11 Wray et al., *Ten Lives of the Buddha*, p. 128; Henry Ginsberg, 'Ayutthaya Painting', in Forrest McGill (ed.), *The Kingdom of Siam: The Art of Central Thailand, 1350–1800*, Asian Art Museum, San Francisco, 2005, pp. 108–9.

12 For an example of a cloth banner depicting all ten, and two images on a lacquered scripture cabinet, see Skilling, *Past Lives*, pp. 72–3.

13 The full text of the stories, in English translation, may be found in I.B. Horner and Padmanabh S. Jaini (trans.), *Apocryphal Birth Stories (Paññāsa-Jātaka)*, vol. 1, Pali Text Society, Oxford, 2001; and E.B. Cowell et al. (trans.), *The Jātaka, or Stories of the Buddha's Former Births*, vol. 6, Cambridge University Press, Cambridge, 1907. The latter is now available in Indian reprint or from the Pali Text Society. The stories of Temiya, Janaka and Sāma are also found in Sarah Shaw (trans.), *The Jatakas: Birth Stories of the Bodhisatta*, Penguin Books India, New Delhi, 2006, and the Vessantara is expertly translated in Margaret Cone and Richard F. Gombrich, *The Perfect Generosity of Prince Vessantara*, Pali Text Society, Bristol, 2011.

14 Henry Ginsberg, *Thai Art and Culture: Historic Manuscripts from Western Collections*, British Library, London, 2000, p. 63.

Chapter 3: The final life of the Buddha

1 Gerhard Jaiser, *Thai Mural Painting*, White Lotus Press, Bangkok, 2009, gives a very good general guide for temple murals in Thailand. Kurt F. Leidecker (ed.), *The Life of the Buddha: According to Thai Temple Painting*, Thammasapa, Bangkok, 2011, briefly and lucidly explains each scene with reproductions of mural paintings.

2 Since restorations were done in the Bangkok period, murals of Wat Ratchasittharam, Wat Dusidaram, and Wat Suwannaram are generally dated from the end of eighteenth century in the reign of Rama I (1782–1809). The mural of Wat Thong Thammachat is considered to be the result of expansion by Rama III (1824–51). See Jaiser, *Thai Mural Painting*, pp. 113–20, and Jean Boisselier, *The Wisdom of the Buddha*, Thames and Hudson, London, 1994, pp. 67, 185–8. However, all these dates are uncertain and every mural at present is a result of multiple restorations up to the present day.

3 For a beautifully illustrated Burmese manuscript, see Patricia M. Herbert, *The Life of the Buddha*, Pomegranate/British Library, San Francisco, 2005. Burmese folding-paper manuscripts illustrated with life events of the Buddha have captions for each illustration in the Burmese language. The tradition of illustrated manuscripts in Burma seems to have quite different aspects from that of Thailand. See Chapter 4, n. 13 for additional information.

4 The two events in B10, which respectively happened in the tenth and thirty-seventh year after the enlightenment, should be placed after the following four sequential events in B26–B27 that occurred in the year of the seventh rainy season retreat.

5 A Sanskrit word, '*mudrā*' ('seal' or 'mark') is used as a technical term for symbolic or ritual gestures in Buddhism and Hinduism. Although the *mudrā* terms, influenced by Indian Buddhist art studies, have been used also in the field of Thai art for decades, it is not quite appropriate to explain Thai Buddha images with the terms. It is true that the hand gestures of the images in Thailand are related to *mudrā*s found in other Buddhist traditions. Some gestures are commonly used and may share the

same significance. However, the technical terminology was not used in Thailand before the era of modern art history. The use of the *mudrā* terms in this book is only for the sake of convenience.

6 The term '*pang*' is also used to refer to Buddha images in a specific posture related to a specific event of his life. See Tanya Phonanan, *Buddha Gestures* (ปางพระพุทธรูป): *Mind Map*, Sanuk, Bangkok, 2008, for a popularized guide to the *pang* (and *mudrā*, p. 47) with illustrations. This is a convenient tool to know how Thai Buddhists associate the postures to the events. See also Khaisri Sri-Aroon, *Les Statues du Buddha de la Galerie de Phra Pathom Chedi, Nakhon Pathom, Thailande*, Prince of Songkhla University, Bangkok, 1996. This explains a full variety of Buddha images that are placed in niches that surround the central *cetiya* of the famous Phra Pathom Chedi.

7 Anant Laulertvorakul, 'Paṭhamasambodhi in Nine Languages: Their Relation and Evolution', *Manusya: Journal of Humanities*, vol. 6, no.1, 2003, pp. 11–34 examines various versions transmitted in as many as nine languages and in five countries.

8 In this chapter, the life accounts of the Buddha are described according to Georges Cœdès (ed.), *The Paṭhamasambodhi*, Pali Text Society, Oxford, 2003. This is not yet translated into English. Henry Alabaster, *The Wheel of the Law*, Trübner, London, 1871 is an English translation of a Thai vernacular version of it, which ends in the awakening of the Buddha. For those who want to read English translations of Pāli sources with regard to the Buddha's biography, Bhikkhu Ñāṇamoli, *The Life of the Buddha, According to the Pali Canon*, Buddhist Publication Society, Kandy, 1992, is quite readable. It skilfully presents scattered biographical accounts in one book. A very reliable introduction to the life of the Buddha, John S. Strong, *The Buddha: A Short Biography*, Oneworld, Oxford, 2001, also includes a good guide for the sources in translation (pp. 194–223). A more voluminous survey including Sanskrit and other sources is done by Hajime Nakamura, *Gotama Buddha: A Biography Based on the Most Reliable Text*, 2 vols, Kosei Publishing, Tokyo, 2000–05.

9 This Thai vernacular version is considered to be translated also by Prince Paramānujit, from the Pāli edition compiled by himself. A recent publication of this version with rich illustrations is Paramanujitjinorot, *Paṭhamasambodhikathā* (สมุดภาพ ปฐมสมโพธิกถา), Thammasapa, Bangkok, 2009.

10 Summaries of each chapter are in Jean Boisselier, *Thai Painting*, Kodansha International, Tokyo, 1976, pp. 198–202, and Santi Leksukhum, *Temples of Gold*, River Books, Bangkok, 2000, pp. 244–8.

11 See Vidya Dehejia, *Discourse in Early Buddhist Art*, Munshiram Manoharlal Publishers, New Delhi, 1997, pp. 113–14 for an example of the well-known Sanchi *stūpa*. For several Gandhāran sculptures, see Isao Kurita, *Gandhāran Art I: The Buddha's Life Story*, Nigensha, Tokyo, 1988, pp. 164–6.

12 For the Gandhāran sculptures of the teaching and descent scenes, see Kurita, *Gandhāran Art*, pp. 204–7. Dehejia, *Discourse in Early Buddhist Art*, pp. 12–14 examines the sequence carved on a pillar in Bharhut, India.

13 Interestingly, this could be somehow reflecting mural-painting custom in ancient India. With reference to mural painting, there is an important

passage in the *Mūlasarvāstivāda-vinaya* in Chinese translation (T.24, no.1451, p. 399b–c). According to it, the following scenes from the life of the Buddha were recommended by Mahākassapa for depiction in temple murals to prevent King Ajātasattu's alarm at the news of the Buddha's death: (1) observing the world from Tusita Heaven, (2) entering his mother's womb, (3) the birth, (4) great departure, (5) asceticism for six years, (6) awakening under the bodhi tree, (7) the first sermon to five ascetics in Benares, (8) miracles at Sāvatthi, (9) preaching to his mother at Tāvatiṃsa Heaven, (10) descent by the threefold stairs, (11) miracle of unveiling of the world to the Sankassa people, (12) teaching people in various countries, and (13) *Mahāparinibbāna* at Kusinārā. In this list also, the four serial scenes (8–11) are included. This is indicative of the great importance Buddhists have attached to these related events, at least from the eighth century, when the text was translated into Chinese.

14 See Dehejia, *Discourse in Early Buddhist Art*, pp. 238–41 for a short remark on the eight pilgrimage places with reference to Buddhist art. She refers to these eight great miracles and 'Twelve Acts of a Buddha' as 'two distinct sets of the historic life scenes' featured in later Buddhist art.

15 In the Thai vernacular edition (Paramanujitjinorot, *Paṭhamasambodhi-kathā*), the offering from elephant and monkey is incorporated in Chapter 25: the Nibbāna of Great Disciple (p. 367), and the episode of Nāḷāgiri is incorporated in Chapter 19: Ordination of the Sakyas (pp. 298–9). Therefore chronological order is not considered for the placement of both events in the (later) *Paṭhamasambodhi* either.

16 The following words of the Buddha are recorded in *Itivuttaka* 92: 'Even if one seizes the hem of my robe and walks step by step behind me, if he is covetous in his desires . . . he is far from me. Why? He does not see the Dhamma, and not seeing the Dhamma, he does not see me. Monks, even if one lives a hundred *yojanas* away, if he is not covetous in his desires . . . then indeed, he is near to me and I am near to him. Why? For, he sees the Dhamma, and seeing the Dhamma, he sees me.' In *Saṃyuttanikāya* (3.9.5), Vakkalisutta, there is a passage that also contains the reversed phrase: 'He who sees me sees the Dhamma.'

17 The same simile of the three-stringed instrument is taught by the Buddha to a disciple in Pāli canonical literature. For details, see Toshiya Unebe, 'Two Popular Buddhist Images in Thailand', in Peter Skilling and Justin McDaniel (eds), *Buddhist Narrative in Asia and Beyond*, vol. 2, Institute of Thai Studies, Chulalongkorn University, Bangkok, pp. 121–39.

18 In the context of Buddhist pilgrimage, the episode is related to Vesālī, where the site of a pond used by the monkey remains, although it is not very near to Kosambī.

Chapter 4: The lifestory of a manuscript

1 Richard Salomon, *Ancient Buddhist Scrolls from Gandhāra: The British Library Kharoṣṭhi Fragments*, British Library, London, 1999, p. 109.

2 In *samut khoi* (British Library Or. 14027, for example) we often find simply '*nibbānapaccayo hotu (me anāgate)*'.

3 Jens-Uwe Hartmann, 'From Words to Books: Indian Buddhist Manuscripts in the First Millennium CE', in Stephen Berkwitz, Juliane Schober and Claudia Brown (eds), *Buddhist Manuscript Cultures: Knowledge, Ritual, and Art*, Routledge, London and New York, 2009, pp. 100–101.

4 J.-F. Huang, 'A Technical Examination of 7 Thai Manuscripts in the 18th, 19th , and 20th Centuries', online resource, Harvard University, 2006, p. 7. http://www.ischool.utexas.edu/~anagpic/2006pdf/2006ANAGPIC_ Huang.pdf

5 Ajahn Lart, the last traditionally trained manuscript artist, interviewed in 1967, said that he felt the fineness of the brushes was the key to the delicate manuscript style (Huang, '7 Thai Manuscripts', p. 9).

6 Santi Leksukhum, *Temples of Gold: Seven Centuries of Thai Buddhist Paintings*, River Books, Bangkok, 2000, pp. 26ff.

7 Henry Ginsberg, *Thai Manuscript Painting*, British Library, London, 1989, p. 45.

8 Chris Baker and Pasuk Phongpaichit, *A History of Thailand*, Cambridge University Press, Cambridge, 2005, pp. 19ff; and Leksukhum, *Temples*, pp. 26ff.

9 Leksukhum, *Temples*, pp. 26–49.

10 By the nineteenth century new pigments came from Britain. Chemical analysis of eighteenth-century manuscript pages has revealed huntite, lead white, calcite, indigo, red lead, vermilion, gamboge, ultramarine and red earth, as well as gold leaf (Huang, '7 Thai Manuscripts'). Gamboge and lead white appear to be local.

11 Huang, '7 Thai Manuscripts', p. 8.

12 Patricia M. Herbert, *The Life of the Buddha*, Pomegranate/British Library, San Francisco, 2005, p. 10.

13 After writing this book our attention was drawn to two nineteenth-century *samut khoi*s containing scenes from the final life of the Buddha. These are held in the Chester Beatty Library, Dublin, and we are grateful to Justin McDaniel for providing details of their contents.

14 Henry Ginsberg, *Thai Art and Culture: Historic Manuscripts from Western Collections*, British Library, London, 2000, pp. 72–3; Ginsberg, *Thai Manuscript Painting*, p. 96. One of the 1776 manuscripts is in Berlin; the 1780 manuscript is in the Chester Beatty Library, Dublin.

15 N. Nam and A. Adulyapichet, *Mural Paintings of Wat Khongkaram*, Muang Boram, Bangkok, 2011.

16 Berkwitz notes: 'While the intellectual engagement with manuscript texts may seem limited largely to a literate monastic elite, the use of manuscripts for educational purposes was nonetheless a crucial factor in determining whether the *saṅgha* could be established and sustained in a given area' (Berkwitz, Schober and Brown, *Buddhist Manuscript Cultures*, p. 6).

17 Thanks to Dr Kate Crosby for this information.

18 Berkwitz, Schober and Brown, *Buddhist Manuscript Cultures*, p. 38; John Davy, *An Account of the Interior of Ceylon and its Inhabitants: With Travels in that Island*, Longman, London, 1821, p. 238.

19 The version here is somewhat different from the standard Pali Text Society version, in C.A.F. Rhys Davids, *A Buddhist Manual of Psychological Ethics (Dhammasaṅgaṇi)*, Pali Text Society, London and Boston, 1974, pp. 83–7. The *Samatha Chanting Book*, Samatha Trust, 2008 (http://www.

samatha.org/texts/samatha-buddhist-meditation-texts) has an edition of a version of this text under the title *Lokuttarajhānapāṭha* (pp. 40–42).

20 In the instructions for practising the recollection of the Buddha, Buddhaghosa notes that life events from the Buddha should be brought to mind (*Visuddhimagga* VII 2–67: Bhikkhu Ñāṇamoli (trans.), *The Path of Purification*, 5th edn, Buddhist Publication Society, Kandy, 1991, pp. 192–209).

21 Buddhaghosa's fifth-century *Path of Purification* (*Visuddhimagga* VII) and Upatissa's possibly earlier *Path to Freedom* (*Vimuttimagga* VI). For the current use of the recollection of the Triple Gem, including a translation, see *Samatha Chanting Book*, pp. 3, 70–71.

22 Other versions of this text are discussed in Peter Skilling, 'Pieces in the Puzzle: Sanskrit Literature in Pre-Modern Siam', in Claudio Cicuzza (ed.), *Buddhism and Buddhist Literature of South-East Asia: Selected Papers by Peter Skilling*, Fragile Palm Leaves, Bangkok and Lumbini, 2009.

23 A comparable episode is found in Chinese translations of the *Uṣṇīṣavijaya-sūtra*, narrating the origin of the *Uṣṇīṣavijaya-dhāraṇī*, the most popular chanting charm in esoteric Buddhism, one of the first series of the texts edited and published by Max Müller and Nanjio Bunyiu at the Bodleian Library, Clarendon Press (1880s). Based on Sanskrit manuscripts from Japan, this research initiated modern Buddhist Sanskrit studies.

24 Ajahn Phra Mahālaow, abbot of Bromley Buddhavihāra, England, said in support of this that the presence of some element representing the Buddha would be considered crucial to the revival of Buddhism in a particular region (discussion, January 2012).

25 See Ginsberg, *Thai Art*, pp. 74, 90.

26 See Bilinda Devage Nandadeva, 'Flowers for the *Dhamma*: Painted Buddhist Palm Leaf Manuscript Covers (*Kamba*) of Sri Lanka', in Berkwitz, Schober and Brown, *Buddhist Manuscript Cultures*, pp. 159–71.

27 Steve van Beek and Luca Invernizzi Tettoni, *The Arts of Thailand*, Thames and Hudson, London, 1991, pp. 155ff.

28 Ginsberg, *Thai Art*, p. 65.

29 See, for instance, British Library, MS. Or. 14372: this division is reasonably frequent. On the subject of spatial hierarchy, see James S. Duncan, *The City as Text: The Politics of Landscape Interpretation in the Kandyan Kingdom*, Cambridge University Press, Cambridge, 1990, p. 116.

30 A close counterpart to this in Western art is in pictures for the 'Book of Job' by William Blake (1826).

31 Water is poured into the hands of a recipient when making a gift, signifying the gift's irreversibility.

32 Duncan, *The City as Text*, p. 140.

33 Duncan, *The City as Text*, pp. 72–3.

34 The works *Kirala Sandesaya* and *Ahalepola Varnanava* were commissioned by Ahalepola in the years after the king's removal (Duncan, *The City as Text*, p.165).

35 Other manuscripts may have been bought several stages down the line, such as one in the British Library, the label of which said it was bought

by a Liverpudlian sea captain from a Malayan sailor (British Library ADD15347).

36 Berkwitz notes that most 'extant Sri Lankan Buddhist manuscripts in temple libraries are un-catalogued, neglected and even sometimes broken up and sold' (Berkwitz, Schober and Brown, *Buddhist Manuscript Cultures*, p. 40).

37 Thanks are due to Dr Elizabeth Harris for this information and for her generous help in interpreting this material.

38 Elizabeth Harris, *Theravada Buddhism and the British Encounter: Religious, Missionary and Colonial Experience in Nineteenth-Century Sri Lanka*, Routledge, London, 2006, p. 3. She gives a full study of British understanding of Buddhism in nineteenth-century Ceylon.

39 William Carmichael Gibson was born in Edinburgh on 23 November 1768, and married Margaret Sharpe in Ceylon (Holmes-a-Court family history, http://holmesacourt.org, accessed 2010).

40 W.M. Harvard, *A Narrative of the Establishment and Progress of the Christian Missions to Ceylon and India*, self-published, 1823. Harvard records numerous conversions. Monks and laity handed over Buddhist accoutrements publicly as a symbol of their new allegiance.

41 Harvard, *Narrative*, p. lxix.

42 I am grateful to Professor Pamela Clemit for help in reading the letter. The absence of an address is unsurprising for a tiny British community, but probably indicates the two were in the same neighbourhood when the letter was sent, and that the letter was sent by messenger or a mutual friend.

43 Elu is the ancient form of the language from which Sinhala developed.

44 Harvard notes that the 'sacred books' of the Buddhists are called 'Banna' (Harvard, *Narrative*, p. lviii); *tālapaṇṇa* is a palm leaf and taken to refer to palm-leaf manuscripts.

45 At the time this letter was written Westerners knew the major events of the Buddha's life, that he had spent a number of lifetimes preparing to teach and that the goal of the Buddhist path was nirvana (see Charles Allen, *The Buddha and the Sahibs: The Men who Discovered India's Lost Religion*, John Murray, London, 2002, pp. 94ff).

46 The story given here is recounted in *Visuddhimagga* XII 80: Ñāṇamoli, *The Path of Purification*, p. 388. I am grateful to the anonymous reader of this chapter who brought my attention to the *Visuddhimagga* account and for reading the letter: Tallagaroo = Talaṅgara; Dharma..dissana = Dhammadinna(na). The other temple mentioned is Tissamahāvihāra/Tissārāma, near Mahāgāma, one of the larger monasteries of ancient Ceylon. The illegible Trōōnadāns is perhaps Taḷaṅgaravāsī. The monk concerned is described speaking on the *Apaṇṇaka-Sutta*, the 'sure course', (F.L. Woodward, *The Book of the Gradual Sayings*, vol. 1, Pali Text Society, London, Henley and Boston, 1979). His discourse however, as described by Buddhaghosa, describes the audience as entering stages of enlightenment at the end.

47 Another word probably preceded the word 'delivered': the page is torn at the top left-hand corner by the seal or wafer.

48 Professor Grevel and Amanda Lindop helped in deciphering this word and reading this letter. It fits in with 'Chatties': a chatty is a clay bowl.

Clough had presumably seen them mentioned in the papers he was examining. The lowest hell of the Buddhists is described; it differs from Christian hells in that rebirth here is impermanent.

49 The Brahmaloka is the heaven in which those who have practised meditation are said to be reborn. It is 'higher' than the six heaven (*deva*) realms, being the rebirth for those who practise *samatha* meditation, whereas the sense-sphere *deva* heavens are for those who maintain the five precepts of Buddhist ethical conduct, practise generosity, faith and investigation. All are considered fortunate, as is the human realm.

50 *Sādhu, sādhu:* literally, 'very good, very good', the traditional lay response at the close of chants and blessings.

51 It is odd that the comment 'inexplicably rich' is in quotation marks: it could be a reference to an earlier letter that had described the book to the writer.

52 Robert Bluck, *British Buddhism: Teachings, Practice and Development*, Routledge, London and New York, 2006, p. 5.

53 Davy, *An Account*, pp. 190–235. Davy notes that most monks could read Pāli well, observing with favour their 'books' as more durable than paper ones.

54 Harris, *Theravāda Buddhism*, pp. 20–34.

55 See Allen, *Buddha and the Sahibs*, pp. 104–6. The first Pāli–English dictionary was compiled by R.C. Childers (1872–75).

56 The picture of the *Nemi-Jātaka* and the hells might have reinforced this wish.

57 Davy, *An Account*, p. 239.

58 Filliozat reads, as most would, 'Mr' here (Jacqueline Filliozat, *Survey of the Pāli Manuscript Collection in the Bodleian Library*, École Française d'Extrême-Orient/Pali Text Society, Oxford, 1994–6). I am grateful to Pamela Clemit for noticing that the letters look more like the early nineteenth-century way of writing Messrs, or, possibly, 'Mrs'. Filliozat's account of the manuscript and its attendant paper work is excellent. We have deviated from her account only in this regard, in putting a final 'h' in Edinburgh, and in the address of the letter, which we read as B. Clough Ceylon. Instead of M.C. Gibson, we read W.C. Gibson. There is no transliteration of the letter in her catalogue entry.

59 'Messrs Thomson' became a renowned Edinburgh shipping company, the precursors to BenLine. Although they did not extend their range to China and Japan, via Galle, until 1859, some family connection seems probable.

60 F. Madan, *A Summary Catalogue of Western Manuscripts in the Bodleian Library at Oxford . . . with References to the Oriental and Other Manuscripts*, vols IV–VII (1897–1953), 29897w (Lot 758).

61 The Bodleian manuscript, while from Siam, is written in Pāli in Khom script.

62 Madan, *A Summary Catalogue*, 29897u.

Bibliography

Alabaster, Henry, *The Wheel of the Law*, Trübner, London, 1871.

Allen, Charles, *The Buddha and the Sahibs: The Men who Discovered India's Lost Religion*, John Murray, London, 2002.

Anon., *The Book of Chants, A Compilation (Being the Romanized Edition of the Royal Thai Chanting Book)*, Mahāmakut Rājavidyālaya Press, Bangkok, 1975.

Appleton, Naomi, *Jātaka Stories in Theravāda Buddhism: Narrating the Bodhisatta Path*, Ashgate, Farnham, 2010.

Baker, Chris and Pasuk Phongpaichit, *A History of Thailand*, Cambridge University Press, Cambridge, 2005.

Beek, Steve van and Luca Invernizzi Tettoni, *The Arts of Thailand*, Thames and Hudson, London, 1991.

Berkwitz, Stephen C., Juliane Schober and Claudia Brown (eds), *Buddhist Manuscript Cultures: Knowledge, Ritual, and Art*, Routledge, London and New York, 2009.

Bluck, Robert, *British Buddhism: Teachings, Practice and Development*, Routledge, London and New York, 2006.

Boisselier, Jean, *Thai Painting*, Kodansha International, Tokyo, 1976. Translated into English by Janet Seligman from *La peinture en Thailande*, Office du Livre, Fribourg, 1976.

Boisselier, Jean, *The Wisdom of the Buddha*, Thames and Hudson, London, 1994. Translated into English by Carey Loverace from *La Sagesse du Bouddha*, Gallimard, Paris, 1993.

Boskovits, Miklós, Richard Offner and Klara Steinwig, *The Fourteenth Century: The Painters of the Miniaturist Tendency*, Giunti, Florence, 1984.

Brereton, Bonnie P., *Thai Tellings of Phra Malai: Texts and Rituals Concerning a Popular Buddhist Saint*, Arizona State University, Tempe, 1995.

Buddhaghosa, Bhadantācariya, *The Path of Purification (Visuddhimagga)*, trans. Ñāṇamoli, Bhikkhu, 5th edn, Buddhist Publication Society, Kandy, 1991.

Burlingame, Eugene Watson (trans.), *Buddhist Legends, Translated from the Original Pali Text of the Dhammapada Commentary*, 3 vols, published for the Pali Text Society by Luzac, London, 1921.

Clough, Benjamin, *Compendious Pali Grammar, with a Copious Vocabulary in the Same Language*, Wesleyan Mission Press, Colombo, 1824.

Cœdès, Georges (edition prepared by Jacqueline Filliozat), *The Paṭhamasambodhi*, Pali Text Society, Oxford, 2003.

Cone, Margaret and Richard F. Gombrich, *The Perfect Generosity of Prince Vessantara*, 2nd revised edn, Pali Text Society, Bristol, 2011; 1st edn, Oxford University Press, Oxford, 1977.

Cowell, E.B. et al. (trans.), *The Jātaka, or Stories of the Buddha's Former Births*, 6 vols, Cambridge University Press, Cambridge, 1895–1907.

Davy, John, *An Account of the Interior of Ceylon and its Inhabitants: With Travels in that Island*, Longman, Hunt, Rees, Orme, and Brown, London, 1821.

Dehejia, Vidya, *Discourse in Early Buddhist Art: Visual Narratives of India*, Munshiram Manoharlal Publishers, New Delhi, 1997.

Duncan, James S., *The City as Text: The Politics of Landscape Interpretation in the Kandyan Kingdom*, Cambridge University Press, Cambridge, 1990.

Eoseewong, Nidhi, *Pen and Sail: Literature and History in Early Bangkok*, Silkworm, Chiang Mai, 2005.

Fausbøll, V. (ed.), *The Jātaka Together with its Commentary Being Tales of the Anterior Births of Gotama Buddha*, 6 vols, Trübner and Co., London, 1877–96.

Fickle, Dorothy H., *Life of the Buddha Murals in the Buddhaisawan Chapel, National Museum, Bangkok, Thailand*, Fine Arts Department, Bangkok, 1979.

Filliozat, Jacqueline, *Survey of the Pāli Manuscript Collection in the Bodleian Library*, Ecole Française d'Extrême-Orient/Pali Text Society, Oxford, 1994–96.

Filliozat, Jacqueline (with the collaboration of Venerable T. Dhammaratana), 'Une nouvelle lecture du Syamasandesa de 1756 A.D. conservé au Malvatte Viharaya de Kandy, Sri Lanka', in Bhikkhu Tampalawela Dhammaratana and Bhikkhu Pasadika (eds), *Dharmaduta, Mélanges offerts au Vénérable Thioh Huyên-Vi à l'occasion de son 70è anniversaire*, Editions You Feng, Paris, 1997, pp. 95–113.

Filliozat, Jacqueline (with the collaboration of Venerable T. Dhammaratana), 'A New Reading of the Syamasandesa of 1756 A.D. Preserved in the Malvatte Viharaya of Kandy, Sri Lanka' (English translation of the above article), in Peter Skilling (ed.), *Palm Leaf and Stone I*, Manuscript House, Northaburi, Bangkok, 2003.

Gethin, Rupert, 'The Mātikās: Memorization, Mindfulness, and the List', in Janet Gyatso (ed.), *In the Mirror of Memory: Reflections on Mindfulness and Remembrance in Indian and Tibetan Buddhism*, State University of New York Press, New York, 1992, pp. 149–72.

Gibson Craig, James T., *The Very Extensive Library of James T. Gibson Craig*, Dryden Press, J. Davy and Sons, London, 1887–88.

Ginsberg, Henry, *Thai Manuscript Painting*, British Library, London, 1989.

Ginsberg, Henry, *Thai Art and Culture: Historic Manuscripts from Western Collections*, British Library, London, 2000.

Ginsberg, Henry, 'Ayutthaya Painting', in Forrest McGill (ed.), *The Kingdom of Siam: The Art of Central Thailand, 1350–1800*, Asian Art Museum, San Francisco, 2005, pp. 94–109.

Ginsberg, Henry, 'Thai Painting in the Walters Art Museum', *Journal of the Walters Art Museum: A Curator's Choice: Essays in Honor of Hiram W. Woodward, Jnr.*, vol. 64/65, 2006–07, pp. 99–148.

Gosling, Betty, *Origins of Thai Art*, River Books, Bangkok, 2004.

Harris, Elizabeth, *Theravada Buddhism and the British Encounter: Religious, Missionary and Colonial Experience in Nineteenth-Century Sri Lanka*, Routledge, London, 2006.

Hartmann, Jens-Uwe, 'From Words to Books: Indian Buddhist Manuscripts in the First Millennium CE', in Stephen C. Berkwitz, Juliane Schober and Claudia Brown (eds), *Buddhist Manuscript Cultures: Knowledge, Ritual, and Art*, Routledge, London and New York, 2009, pp. 95–105.

Harvard, W.M., *A Narrative of the Establishment and Progress of the Christian Missions to Ceylon and India*, self-published, 1823.

Herbert, Patricia M., *The Life of the Buddha*, Pomegranate, in association with the British Library, San Francisco, 2005.

Horner, I.B. and Padmanabh S. Jaini (trans.), *Apocryphal Birth Stories (Paññāsa-Jātaka)*, vol. 1, Pali Text Society, Oxford, 2001.

Huang, J.-F., 'A Technical Examination of 7 Thai Manuscripts in the 18th, 19th, and 20th Centuries', online resource, Harvard University, 2006: http://www.ischool.utexas.edu/~anagpic/2006pdf/2006ANAGPIC_Huang.pdf.

Jaiser, Gerhard, *Thai Mural Painting*, 2 vols, White Lotus Press, Bangkok, 2009–10.

Khrongkan Supsan Moradok Watthanatham Thai, *Samut Khoi*, Khrongkan Supsan Moradok Watthanatham Thai, Bangkok, 1999.

Kurita, Isao, *Gandhāran Art I: The Buddha's Life Story*, Nigensha, Tokyo, 1988.

Laulertvorakul, Anant, 'Paṭhamasambodhi in Nine Languages: Their Relation and Evolution', *Manusya: Journal of Humanities*, vol. 6, no. 1, 2003, pp. 11–34.

Lefferts, H. Leedom, 'Village as Stage: Imaginative Space and Time in Rural Northeast Thai Lives', *Journal of the Siam Society*, vol. 92, 2004, pp. 129–44.

Leidecker, Kurt F. (ed.), *The Life of the Buddha: According to Thai Temple Painting*, Thammasapa, Bangkok: 2011. First published by the United States Information Service in 1957 (BE 2500).

Leksukhum, Santi, *Temples of Gold: Seven Centuries of Thai Buddhist Paintings*, River Books, Bangkok, 2000.

Madan, F., *A Summary Catalogue of Western Manuscripts in the Bodleian Library at Oxford . . . with References to the Oriental and Other Manuscripts*, vols IV–VII, 1897–1953.

Matics, K.I., *Gestures of the Buddha*, Mahachulalongkorn Press, Bangkok, 2004.

McGill, Forrest (ed.), *The Kingdom of Siam: The Art of Central Thailand, 1350–1800*, Asian Art Museum, San Francisco, 2005.

Mori, Shoji, Tsunao Motozawa and Shogo Iwai, *A Study of the Biography of Sakyamuni Based on the Early Buddhist Scriptural Sources, Part 3: Documentary Sources II [source material 3]: Sources by Topics of the Buddha's Biographies and Related Documents*, Memoirs of the Chuo Academic Research Institute, Monograph Series no. 3, 2000 (in Japanese).

Nakamura, Hajime, *Gotama Buddha: A Biography Based on the Most Reliable Text*, 2 vols, Kosei Publishing, Tokyo, 2000–05. Translated by Gaynor Sekimori from *Gotama Buddha*, Shunjūsha, Tokyo, 1992.

Nam, N. and A. Adulyapichet, *Mural Paintings of Wat Khongkaram*, Muang Boram, Bangkok, 2011.

Ñāṇamoli, Bhikkhu, *The Life of the Buddha, According to the Pali Canon*, Buddhist Publication Society, Kandy, 1992.

Nandadeva, Bilinda Devage, 'Flowers for the *Dhamma*: Painted Buddhist Palm Leaf Manuscript Covers *(Kamba)* of Sri Lanka', in Stephen C. Berkwitz, Juliane Schober and Claudia Brown (eds), *Buddhist Manuscript Cultures: Knowledge, Ritual, and Art*, Routledge, London and New York, 2009, pp. 159–71.

Paramanujitjinorot, *Paṭhamasambodhikathā* (สมุดภาพ ปฐมสมโพธิกถา), Thammasapa, Bangkok, 2009 (in Tai).

Phonanan, Tanya, *Buddha Gestures* (ปางพระพุทธรูป): *Mind Map*, Sanuk, Bangkok, 2008.

Powell, Geoffrey, *The Kandyan Wars: The British Army in Ceylon, 1803–1818*, Leo Cooper, London, 1973.

Rhys Davids, C.A.F. (trans.), *A Buddhist Manual of Psychological Ethics (Dhammasaṅgaṇi)*, Pali Text Society, London and Boston, 1974.

Rhys Davids, T.W. and C.A.F. Rhys Davids, *Buddhist Birth-Stories (Jataka Tales): The Commentarial Introduction Entitled Nidāna-kathā*, George Routledge, London, 1925.

Rhys Davids, T.W. and C.A.F. Rhys Davids, *Dialogues of the Buddha: Translated from the Pali of the Dīgha Nikāya*, 3 vols, H. Frowde, Oxford University Press, London, 1899–1910.

Roebuck, Valerie (trans.), *The Dhammapada*, Penguin, London, 2010.

Salomon, Richard, *Ancient Buddhist Scrolls from Gandhāra: The British Library Kharoṣṭhi Fragments*, British Library, London, 1999.

Shaw, Sarah (trans.), *The Jatakas: Birth Stories of the Bodhisatta*, Penguin Books India, New Delhi, 2006.

Shaw, Sarah, *An Introduction to Buddhist Meditation*, Routledge, London, 2008.

Sheravanichkul, Arthid, 'Self Sacrifice of the Bodhisatta in the Paññāsa Jātaka', *Religion Compass*, vol. 2, no. 5, 2008, pp. 769–87.

Sheravanichkul, Arthid, 'From a Jataka Character to an Amulet: The Cult of Jujaka Worship in Thailand', paper presented at the 6th EuroSEAS Conference, 26–28 August 2010, University of Gothenburg, Sweden.

Skilling, Peter (ed.), *Past Lives of the Buddha: Wat Si Chum – Art, Architecture and Inscriptions*, River Books, Bangkok, 2008.

Skilling, Peter, 'Pieces in the Puzzle: Sanskrit Literature in Pre-Modern Siam', in Claudio Cicuzza (ed.), *Buddhism and Buddhist Literature of South-East Asia: Selected Papers by Peter Skilling*, Fragile Palm Leaves, Bangkok and Lumbini, 2009.

Sri-Aroon, Khaisri, *Les statues du Buddha de la Galerie de Phra Pathom Chedi, Nakhon Pathom, Thailande*, Prince of Songkhla University, Bangkok, 1996.

Strong, John S., *The Buddha: A Short Biography*, Oneworld, Oxford, 2001.

Swearer, D.K., *Becoming the Buddha: the Ritual of Image Consecration in Thailand*, Princeton University Press, Princeton, 2004.

Tanabe, Kazuko, 'Siricuḍāmaṇi-jātaka of Paññāsa Jātaka', in *Studies in Buddhism and Culture: In Honour of Professor Dr. Egaku Maeda on his Sixty-fifth Birthday*, Sankibo Busshorin, Tokyo, 1991, pp. 267–74.

Unebe, Toshiya, 'Two Popular Buddhist Images in Thailand', in Peter Skilling and Justin McDaniel (eds), *Buddhist Narrative in Asia and Beyond*, Institute of Thai Studies, Chulalongkorn University, Bangkok, 2012, pp. 121–39.

Upham, E., *The History and Doctrine of Budhism, Popularly Illustrated: With Notices of the Kappooism, or Demon Worship, and of the Bali, or Planetary Incantations, of Ceylon*, Ackermann, London, 1829.

Wind, Edgar, *Pagan Mysteries in the Renaissance*, enlarged and revised edn, Penguin, Harmondsworth, Middlesex, 1967.

Woodward, F.L. (trans.), *The Book of the Gradual Sayings*, vol. 1, Pali Text Society, London, Henley and Boston, 1979.

Wray, Elizabeth, Clare Rosenfield, Dorothy Bailey and Joe D. Wray, *Ten Lives of the Buddha: Siamese Temple Painting and Jataka Tales*, Weatherhill, New York and Tokyo, 1972; revised paperback edn, 1996.

Wyatt, David K., *Thailand: A Short History*, 2nd edn, Silkworm, Chiang Mai, 2003.

Wyatt, David K., *Reading Thai Murals*, Silkworm, Chiang Mai, 2004.

Yates, Frances A., *The Art of Memory*, Penguin, Harmondsworth, Middlesex, 1966.

Chanting

The following modern chanting manuals have been consulted:

Anon., *The Book of Chants: A Compilation (Being the Romanized Edition of the Royal Thai Chanting Book)*, Mahāmakut Rājavidyālaya Press, Bangkok, 1975.

'A Chanting Guide' by the Dhammayut Order in the United States of America, 2011, http://www.accesstoinsight.org/lib/authors/dhammayut/chanting.html.

Phra Maha Laow, Buddhavihara Temple, King's Bromley, UK, chanting manual.

Oxford Buddha Vihara, chanting manual (undated).

Samatha Trust, *Samatha Chanting Book*, 2008, http://www.samatha.org/texts/samatha-buddhist-meditation-texts.

Samnak Wimuttidhamaram, Ngao Lampang, Thailand, 2011, http://methika.com/chanting book.

Glossary of key terms and figures

Titles of texts and foreign terms that have not entered the English language have been italicized. Anglicized terms and names are not italicized.

Abhidhamma – the 'higher teaching', the third collection of the Buddha's teaching.

Ānanda – the Buddha's carer and attendant in his last life, frequently reborn with him in earlier lives too.

añjali – a gesture of respect made by raising one's hands with palms together and fingers pointing upwards.

awakening (*bodhi*) – the attainment of liberation from the cycle of rebirth and redeath (*saṃsāra*). This attainment characterizes the transformation from Bodhisatta to Buddha.

bodhi – see awakening.

Bodhisatta – 'Awakening Being', the Buddha-to-be, both in his past lives and in his final life up to the attainment of awakening, at which point he becomes Buddha.

Brahmā – a god of the Brahmā heaven realms, where those who practise calm (*samatha*) meditation are reborn. The lord of one of these, Great Brahmā, often visited and presided over important events in the Buddha's life.

brahmin – a member of the Indian priestly caste. Brahmins often play a villainous role in *jātaka* stories.

Buddha – 'Awakened One', a human being who found release from the cycle of existence, and a way to teach others to find it for themselves. The most recent was Gotama Buddha (fifth century BCE), but other past and future *buddha*s are recorded, including the next *buddha* Metteyya. The Buddha is the first element in the 'Triple Gem', and the object of a popular meditation (*Buddhānussati*).

cetiya – see *stūpa*.

community (*saṅgha*) – the community of those that have achieved one of the four stages of awakening; the third aspect of the Triple Gem. This community is represented by the order of monks and is an object of meditation in Southern Buddhism (*saṅghānussati*).

Devadatta – the Buddha's cousin, who tried to cause a split in the Buddha's community. He was often reborn with him in past lives too, where he frequently tried to undermine the work the Bodhisatta was undertaking to develop the perfections.

dhamma – the teaching of the Buddha, and the second aspect of the Triple Gem.

jātaka – a story about a past life of the Buddha, when he is known as the Bodhisatta. (See also *Jātakatthavaṇṇanā, Paññāsa Jātaka*)

Jātakatthavaṇṇanā – a large collection of *jātaka* stories preserved in Pāli verse and prose. The final ten stories are depicted in this manuscript.

karma – 'action'; the doctrine that actions have results that affect one's experiences in present and future lives.

Māra – a being who tried to undermine practices leading to salvation, and made several attempts to prevent the Bodhisatta becoming Buddha. He was routed by the Buddha on the night of the awakening.

merit (*puñña*) – the result of good karma, or actions, that will bring good fortune both in this life and the next. Merit can be transferred to others, both alive and dead, at chanting and blessing ceremonies, so that they benefit too.

nāga – a snake-deity who lives under the water and guards hidden treasures.

nibbāna, nirvana – the goal of the Buddhist path, release from the cycle of existence.

Pāli – the scriptural and liturgical language of Southern Buddhism.

Paññāsa Jātaka – a series of *jātaka* texts found in Southeast Asia that are modelled on the *Jātakatthavaṇṇanā* but contain stories not known in the latter collection.

parinibbāna – the 'complete' *nibbāna*, death with no more rebirth. Usually this refers to the death of the Buddha, who attained *nibbāna* at the moment of his awakening.

Paṭhamasambodhi – an extra-canonical biography of the Buddha composed in Pāli, which has also circulated in vernacular languages in many Southeast Asian countries. It is an important complete biography, despite its anthological nature. Neither date nor author are known.

perfections (*pāramī* or *pāramitā*) – the ten qualities the Bodhisatta had to cultivate in order to attain Buddhahood. They are:

1. generosity (*dāna*)
2. morality (*sīla*)
3. renunciation (*nekkhamma*)
4. wisdom (*paññā*)
5. vigour (*viriya*)
6. forbearance (*khanti*)
7. truthfulness (*sacca*)
8. resolve (*adhiṭṭhāna*)
9. loving kindness (*mettā*)
10. equanimity (*upekkhā*)

puñña – see merit.

Sakka (Sanskrit: Śakra) – king of the Tāvatiṃsa Heaven. Also known as Inda (Sanskrit: Indra). He often intercedes in the realm of humans to help them when they are performing acts of morality and generosity to others, as he did in the life of the Buddha.

saṃsāra – 'wandering', the cycle of rebirths.

samut khoi – a '*khoi* book', a folding paper book made from leaves of the *khoi* tree (*Streblus asper*).

saṅgha – see community

Southern Buddhism – the type of Buddhism, often termed Theravāda (doctrine of the elders), that is predominant in Sri Lanka and Southeast Asia. Although regional variations can be significant, the tradition is unified by an acceptance of the Pāli scriptures.

stūpa (Pāli: *thūpa*) – a dome-shaped monument or shrine, usually containing some relics of the Buddha or his monks or teachings. The term *cetiya* (Tai: *chedi*), which traditionally refers to smaller shrines and monuments that do not contain relics, is more often used in Thai Buddhism.

Sutta – a discourse of the Buddha. Collectively, the *Sutta*s make up one of the three divisions of the Buddha's teaching.

Tāvatiṃsa Heaven ('heaven of the thirty-three') – a heaven in which beings are reborn as gods on the basis of generosity, morality, faith and investigation. Such gods have beautiful bodies and happy experiences, but although their lifespans are very long by human standards, their rebirth there is impermanent. Sakka is the king of this realm. The Buddha's mother, although in a higher heaven, visited this realm to hear her son teach the *Abhidhamma*.

Triple Gem – the three aspects of the Buddha, the *dhamma* (teaching) and the community (*saṅgha*). Taking refuge in these three is a declaration of Buddhist identity.

universal monarch (Pāli: *cakkavattin*; Sanskrit: *cakravartin*) – a great emperor whose rule is unbounded and whose reign brings peace and prosperity to all his subjects.

uposatha – the holy day of the full and new moon. Laypeople often take on extra religious observances, and the monastic communities assemble to reaffirm their commitment to the *vinaya*. The temple building in which the latter takes place is known as the *uposatha* hall.

vinaya – the monastic code, one of the three divisions of the Buddha's teaching.

yakkha – a demon or spirit deity who sometimes causes problems to humans.

Yasodharā, or Bimbā – the Buddha's wife in his last life, frequently reborn with him in earlier lives, most notably as Maddī in the *Vessantara-Jātaka*.

Index